Sports Illustrated

HOTSHOTS

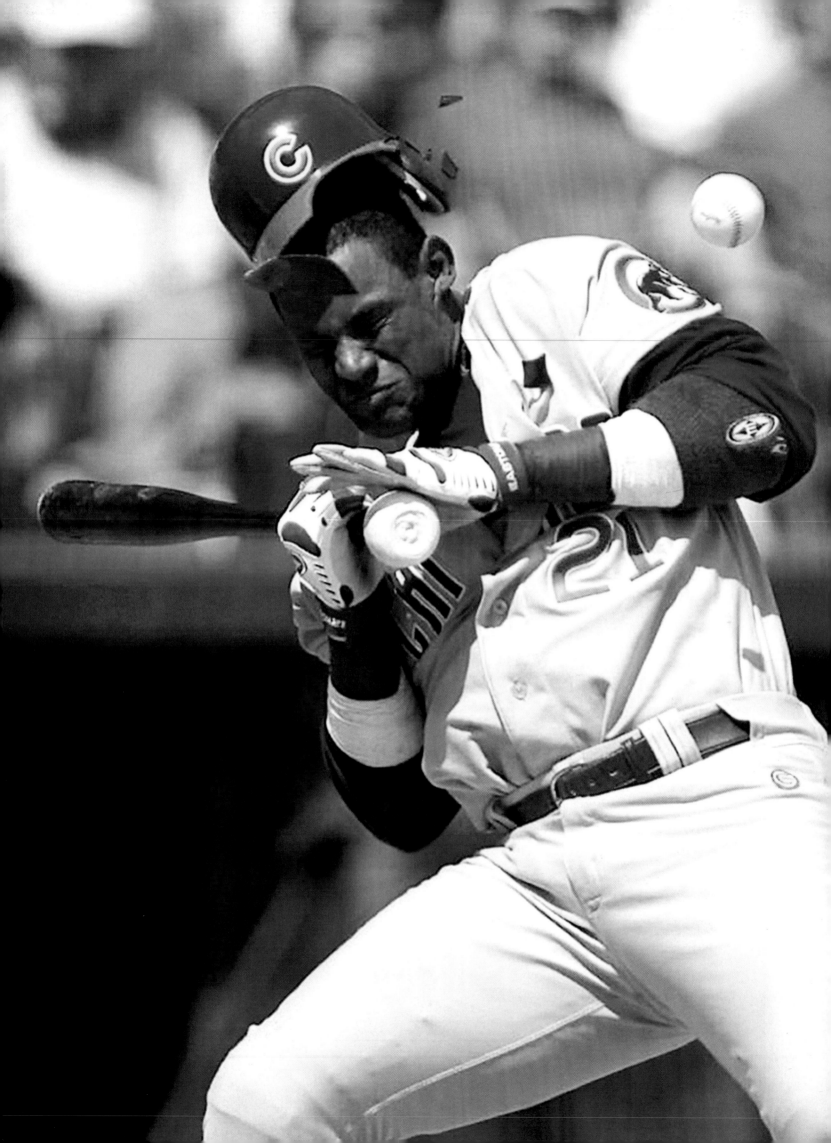

HOT
SHOTS

FOREWORD BY TERRY MCDONELL

Cubs slugger Sammy Sosa had his hat shattered in 2003 by Pirates pitcher Salomon Torres. PHOTOGRAPH BY MIKE LONGO / AP

This book is dedicated to the staff photographers and regular freelance contributors who have called SPORTS ILLUSTRATED home over the last 50 years—and in so doing, made the magazine what it is.

ROB FLEDER *Editor* STEVEN HOFFMAN *Creative Director*

JAMES KEN COLTON *Photo Editor*

BOB ROE *Senior Editor*

KEVIN KERR *Copy Editor* JULIA MORRILL *Reporter*

JOSH DENKIN *Assistant Designer*

TIME INC. HOME ENTERTAINMENT

President / Rob Gursha
Vice President, Branded Businesses / David Arfine Executive Director, Marketing Services / Carol Pittard
Director, Retail and Special Sales / Tom Mifsud Director of Finance / Tricia Griffin
Assistant Marketing Director / Niki Whelan Prepress Manager / Emily Rabin
Marketing Manager / Michelle Kuhr Associate Book Production Manager / Suzanne Janso
Director, New Product Development / Bruce Kaufman

Copyright 2004 Time Inc. Home Entertainment

Published by Sports Illustrated Books

Time Inc. 1271 Avenue of the Americas New York, New York 10020

ISBN 1-932273-18-2

Blues wing Keith Tkachuk tangled with Avalanche defenseman Rob Blake in '03. PHOTOGRAPH BY DAVID E. KLUTHO

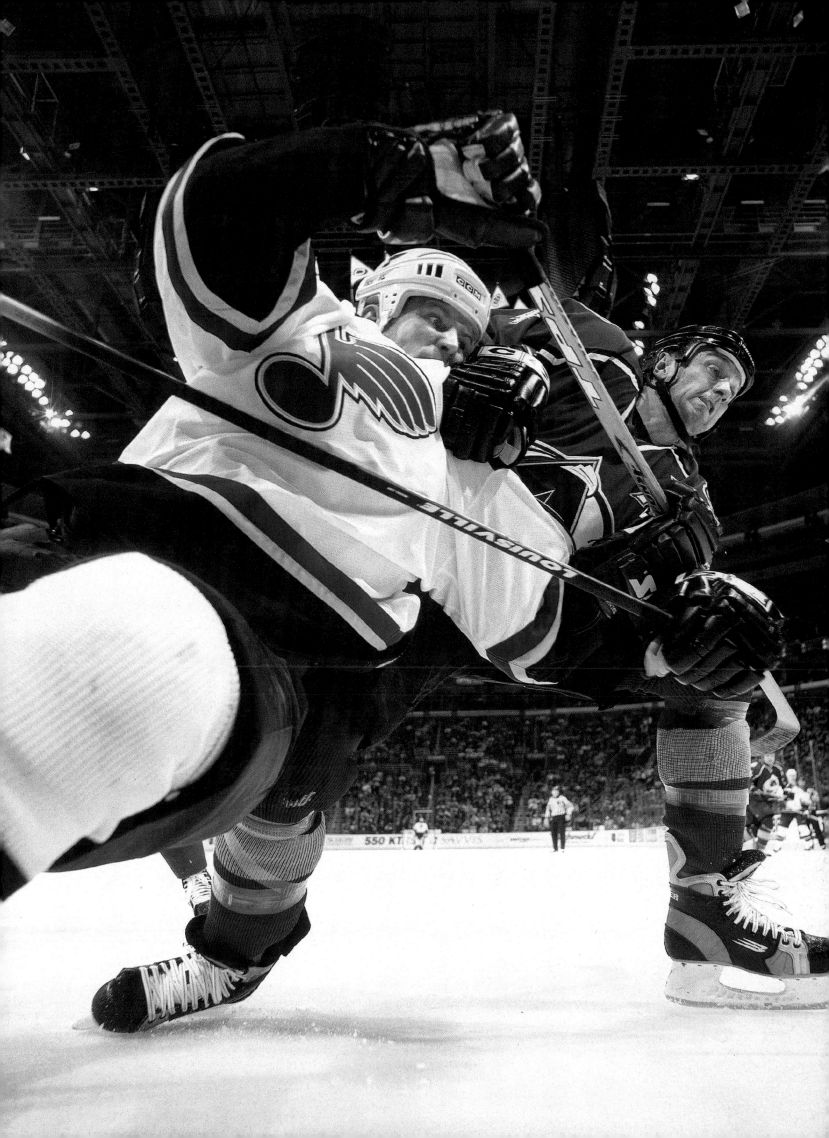

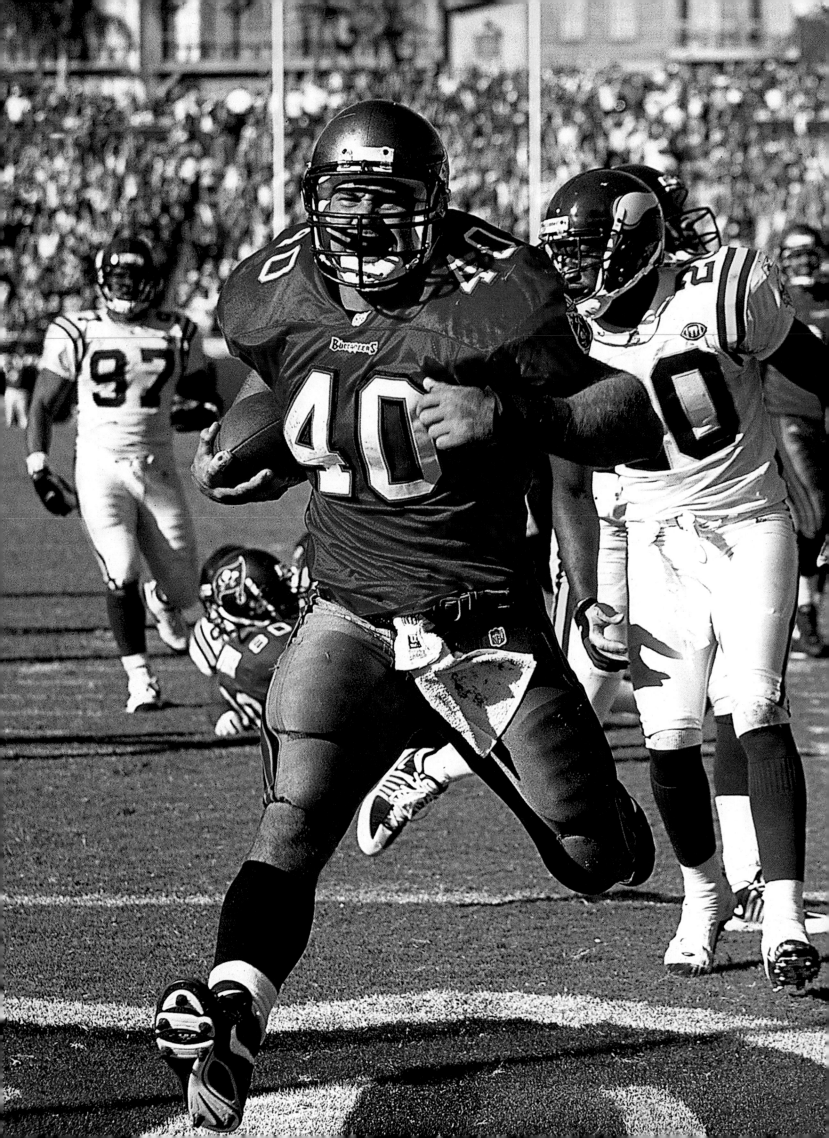

INTRODUCTION

HERE IS ONLY A MOMENT, a heartbeat, when the perfect image is there to be captured. SPORTS ILLUSTRATED has been about getting that perfect picture since the magazine was launched in 1954. Back then, to shoot for SI was to fight for position—the front row, the perfect angle—and to move with the action, to do whatever it took to catch that moment. ❧ Once, covering a Dodgers game at Ebbets Field, SI's irrepressible shooter Hy Peskin jumped out of the photographer's box next to the first base dugout and raced across the diamond to get a better look at a close play at third as a hitter tried to stretch a double into a triple. He got the picture. Not long after, SI's most innovative photographer, John G. Zimmerman, started putting remote cameras behind the glass back-boards at NBA games and inside the goals of the NHL. It was such doggedness and new techniques that put SI readers inside the game—whatever game (or race) it was—captivating them with the images of a raging Muhammad Ali taunting Sonny Listen to get up off the canvas, or the towering Wilt Chamberlain smiling through a thunderous dunk. To see those photographs was to feel the emotion that drives the drama of all sport. ❧ And it still is. ❧ The photographs in this collection were all taken since the year 2000, but they are connected by more than their 21st century dateline. It was true at the birth of the magazine and it is true today: A photographer has to know a sport to cover it. For the

Mike Alstott scored during a Bucs' rout of the Vikings in '01. PHOTOGRAPH BY BOB ROSATO

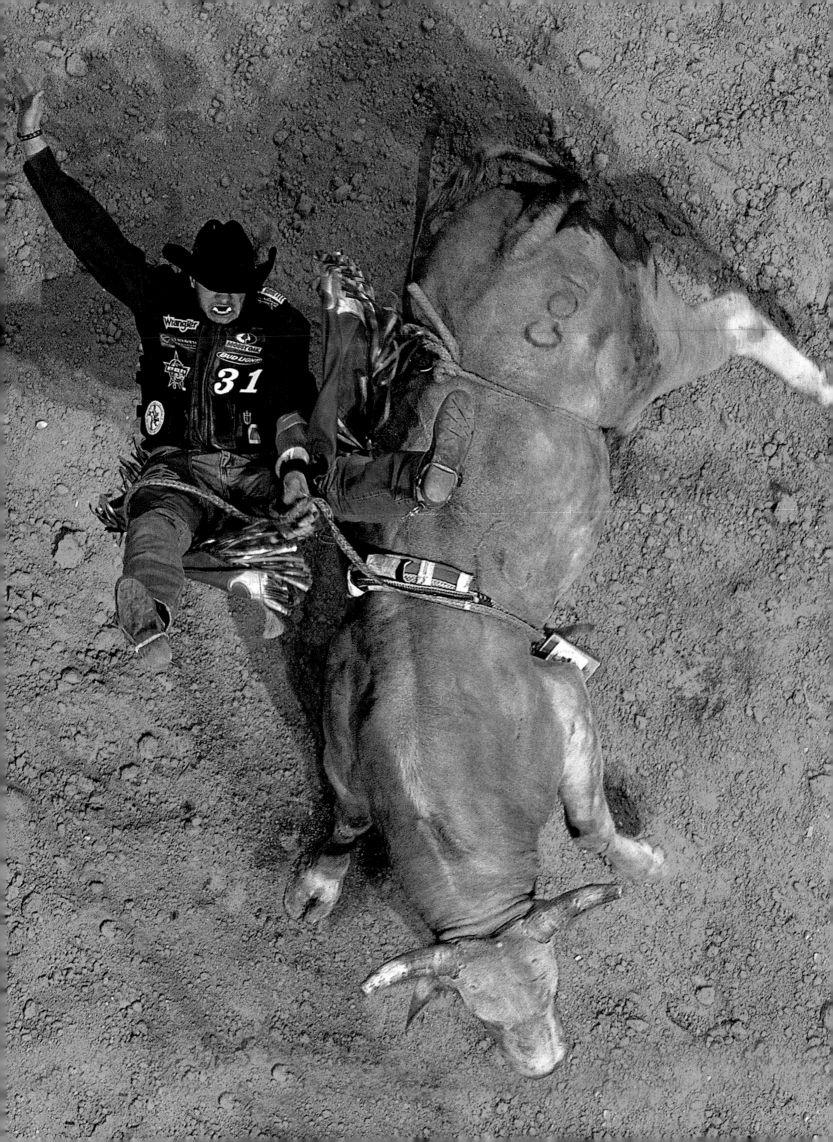

athlete and the photographer alike, it's all about timing and execution, being in the right place at the right instant, anticipating the action and then reacting perfectly in order to make the play—or to capture it. Auto-focus and motor-drive help, but there is always the split-second delay between the image's hitting your optical nerve and the shutter's closing. ("If you see the action, you missed it," as the old lament goes.) SI photographers sometimes talk about luck, but they don't really believe in it. They get to the events early and stay late.

MANY OF THE PHOTOGRAPHS IN THIS COLLECTION show us the face of the athlete within that moment. This is where the story-telling gets intimate. Look at the determination of Lance Armstrong pushing himself through the rain for his fifth consecutive Tour de France victory, the chagrin of Phil Mickelson as he peeks from behind a tree at the Ryder Cup, or the anguish of a mud-covered Holy Cross lineman as he watches the clock run out. ❧ Photo editors like to sort sports photographs: Some are "crunch" (J.T. Snow plowing into Pudge Rodriguez at home plate); others are "grace" (Miami Dolphins tight end Randy McMichael flying into the end zone for a touchdown, on the cover of this book). There are plenty of both types here, but every picture also has what photo editors call the "the wow"—a viewer's predictable reaction to the image. ❧ The "wow" is what we're always looking for, but it isn't easy to find. SI runs at least 100 photographs a week. What does it take to get these pictures? Until quite recently, SI photographers shot more than 1,500 rolls of film a week, or roughly 2.5 million frames a year. Now, they shoot up to 40,000 digital frames a week—about 2 million a year—and another 50 rolls of film, still close to 2.5 million frames a year. At last year's Super Bowl alone, 12 photographers shot 13,800 digital frames, of which the magazine used 14. ❧ That's what it takes to find moments like those on the following pages.

—TERRY McDONELL

Wiley Petersen made a quick exit from the back of After Blaster. PHOTOGRAPH BY DARREN CARROLL

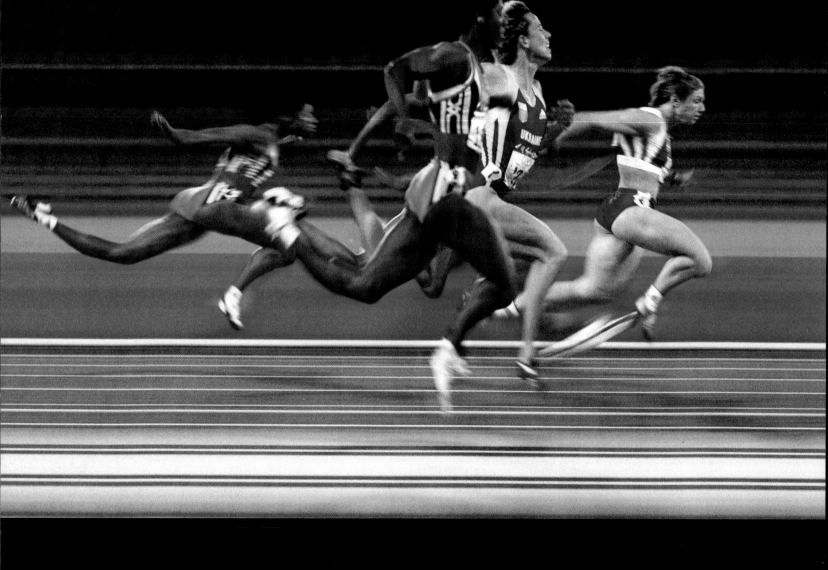

Marion Jones dominated the 100m finals at the 2000 Summer Olympics. PHOTOGRAPH BY BILL FRAKES / DAVID CALLOW

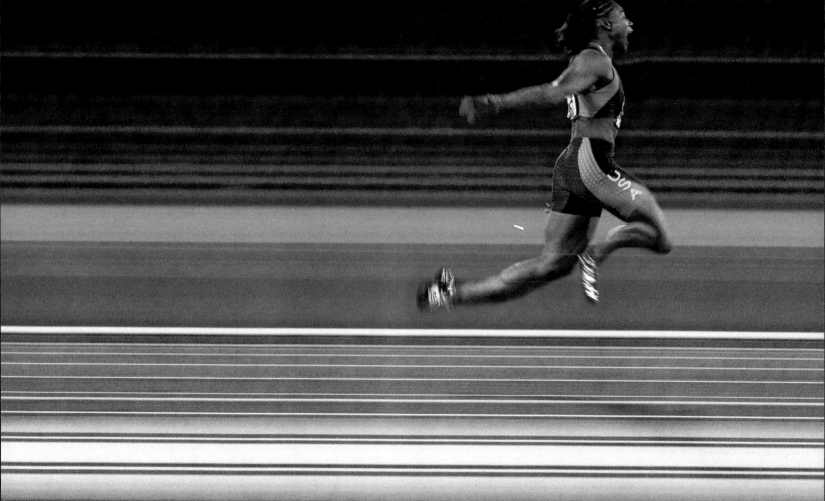

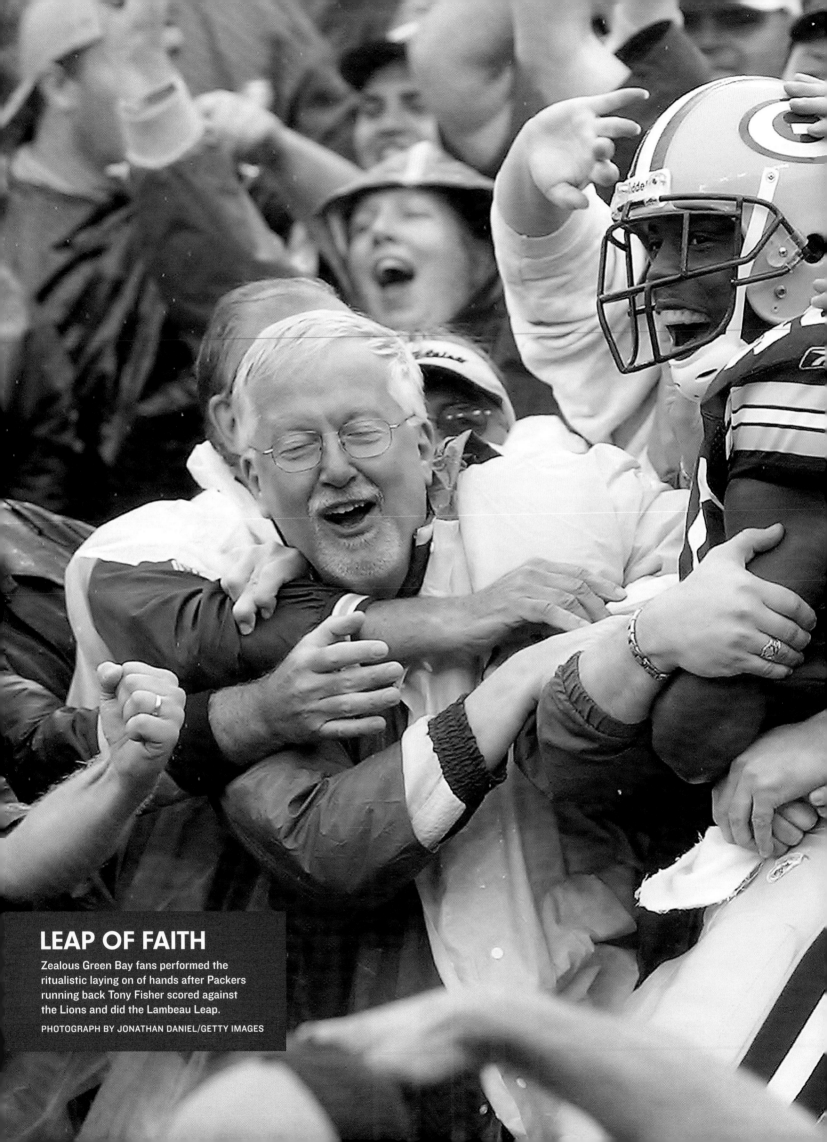

LEAP OF FAITH

Zealous Green Bay fans performed the ritualistic laying on of hands after Packers running back Tony Fisher scored against the Lions and did the Lambeau Leap.

PHOTOGRAPH BY JONATHAN DANIEL/GETTY IMAGES

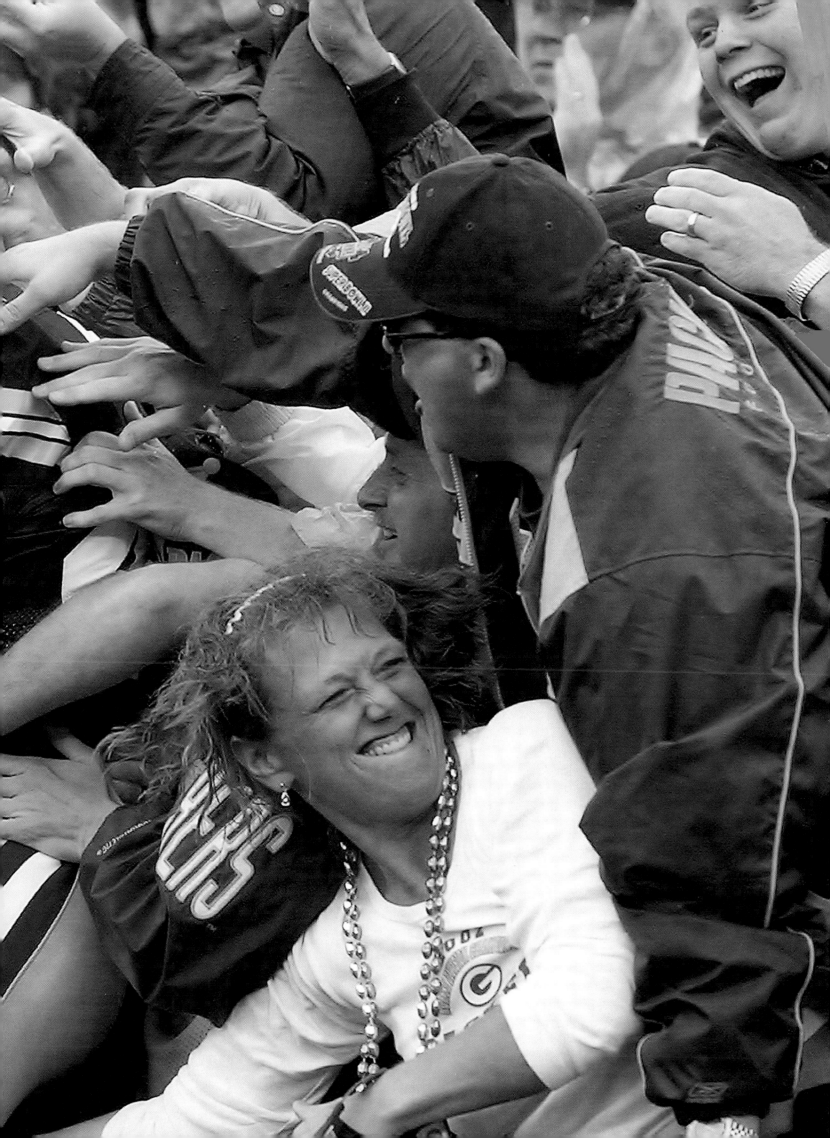

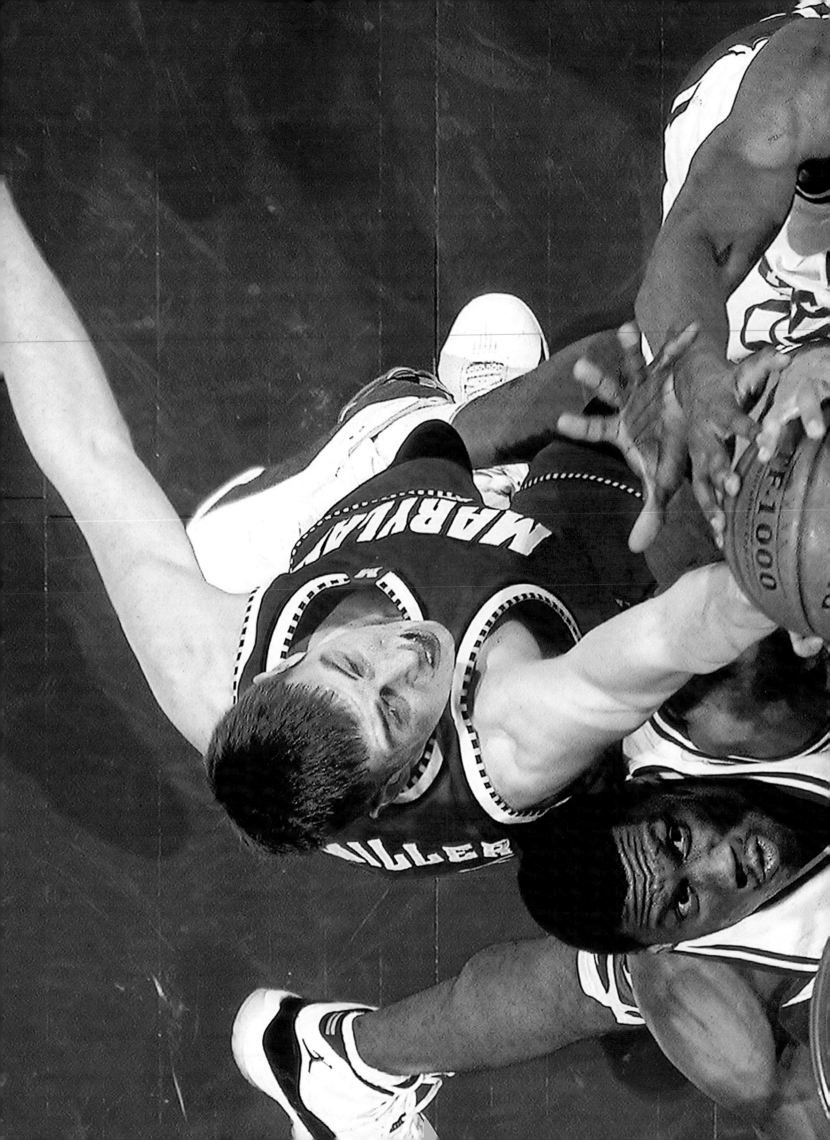

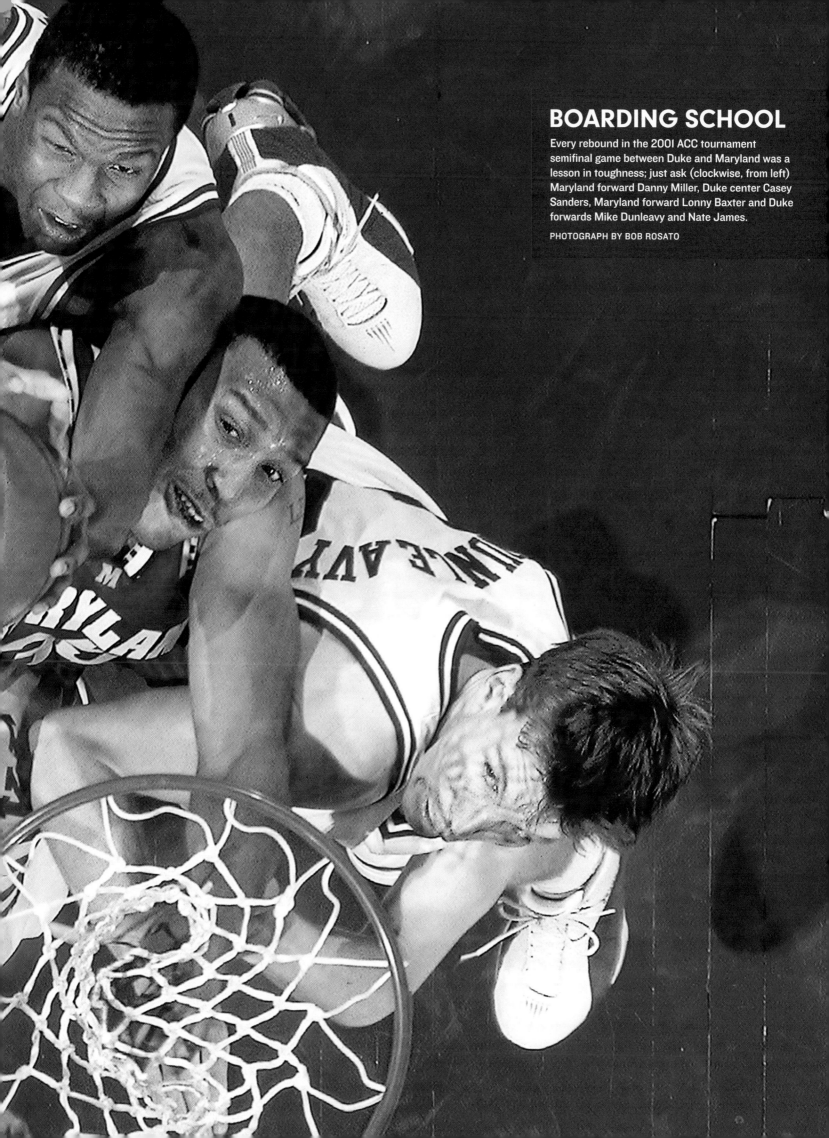

BOARDING SCHOOL

Every rebound in the 2001 ACC tournament semifinal game between Duke and Maryland was a lesson in toughness; just ask (clockwise, from left) Maryland forward Danny Miller, Duke center Casey Sanders, Maryland forward Lonny Baxter and Duke forwards Mike Dunleavy and Nate James.

PHOTOGRAPH BY BOB ROSATO

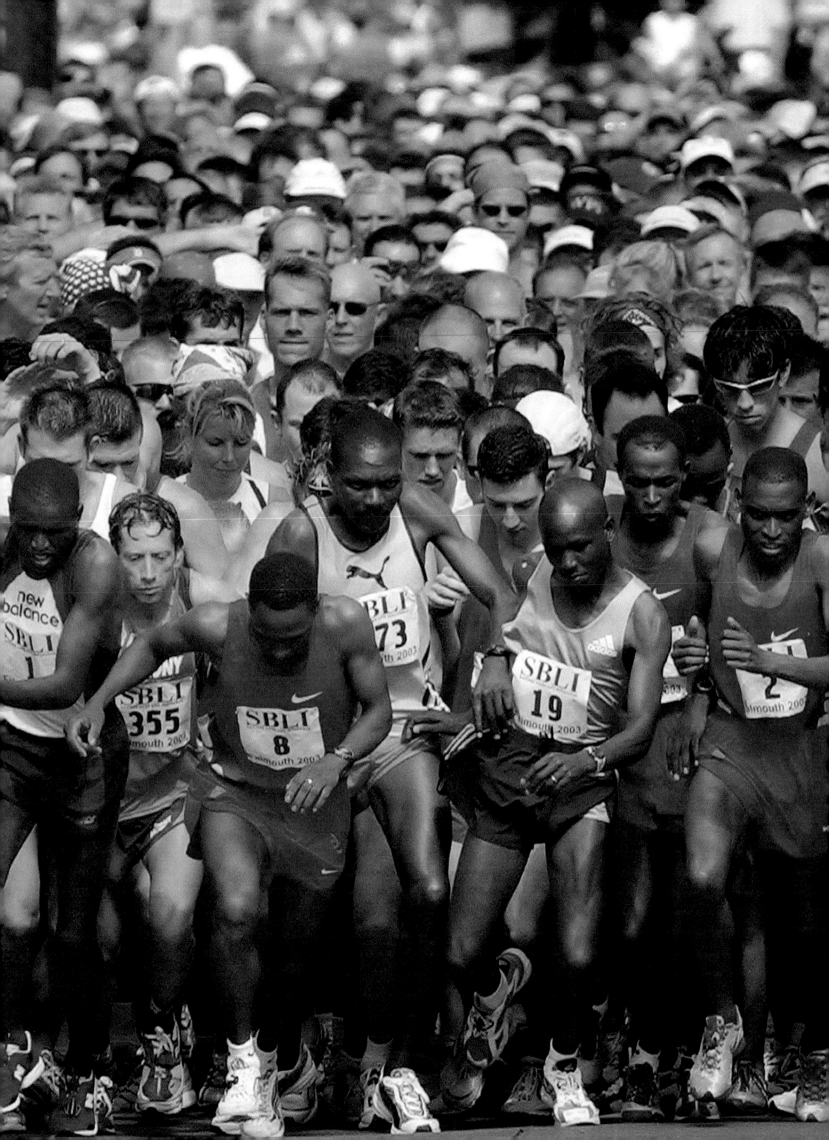

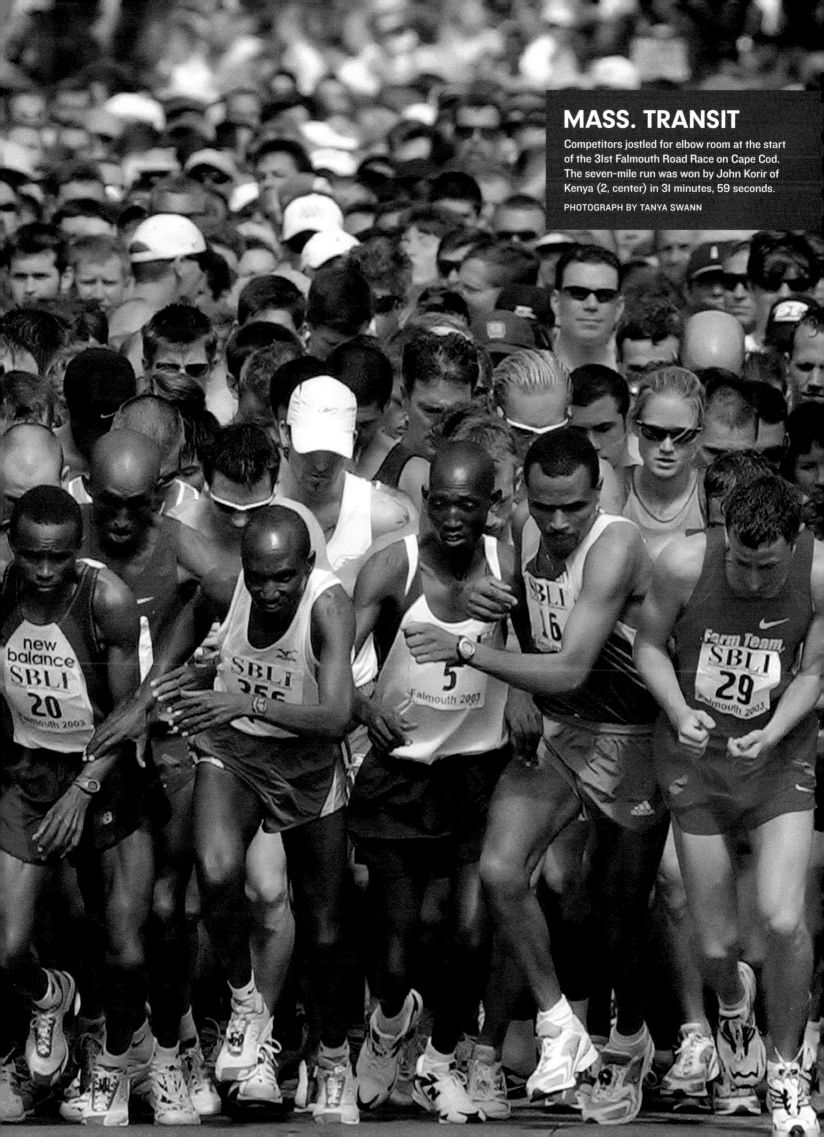

MASS. TRANSIT

Competitors jostled for elbow room at the start of the 3lst Falmouth Road Race on Cape Cod. The seven-mile run was won by John Korir of Kenya (2, center) in 3l minutes, 59 seconds.

PHOTOGRAPH BY TANYA SWANN

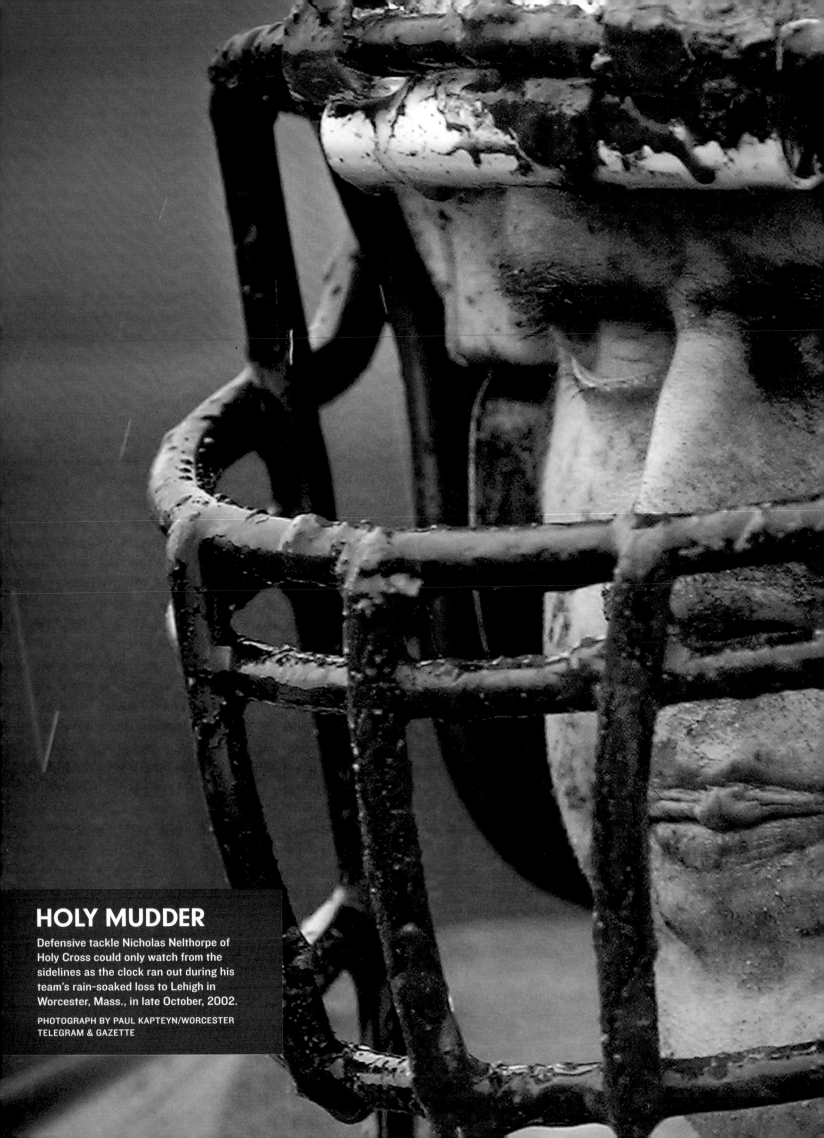

HOLY MUDDER

Defensive tackle Nicholas Nelthorpe of Holy Cross could only watch from the sidelines as the clock ran out during his team's rain-soaked loss to Lehigh in Worcester, Mass., in late October, 2002.

PHOTOGRAPH BY PAUL KAPTEYN/WORCESTER TELEGRAM & GAZETTE

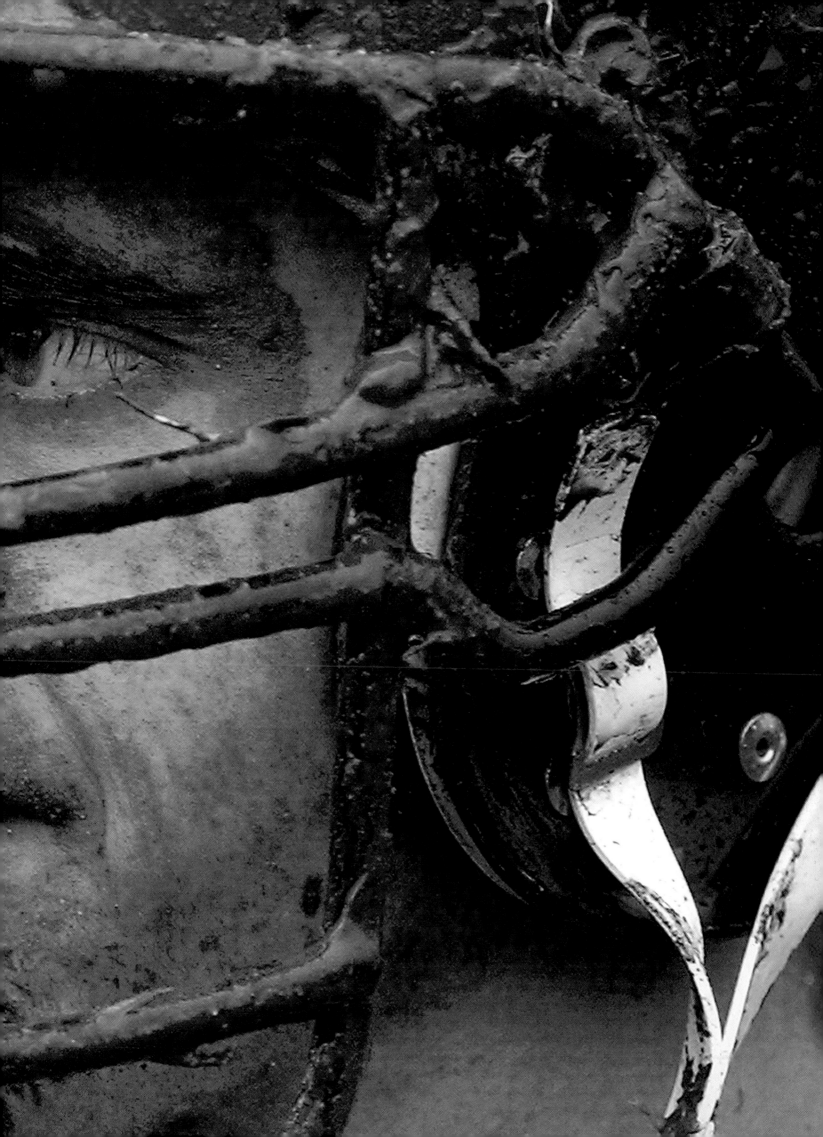

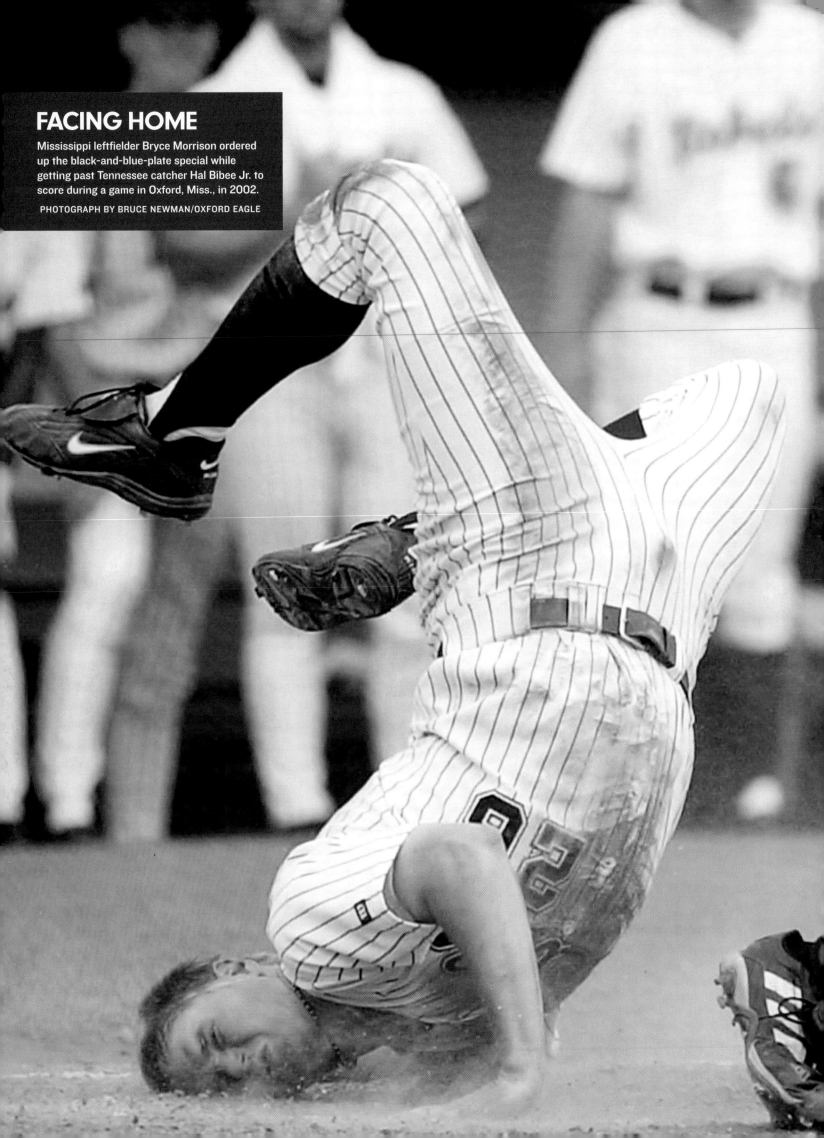

FACING HOME

Mississippi leftfielder Bryce Morrison ordered up the black-and-blue-plate special while getting past Tennessee catcher Hal Bibee Jr. to score during a game in Oxford, Miss., in 2002.

PHOTOGRAPH BY BRUCE NEWMAN/OXFORD EAGLE

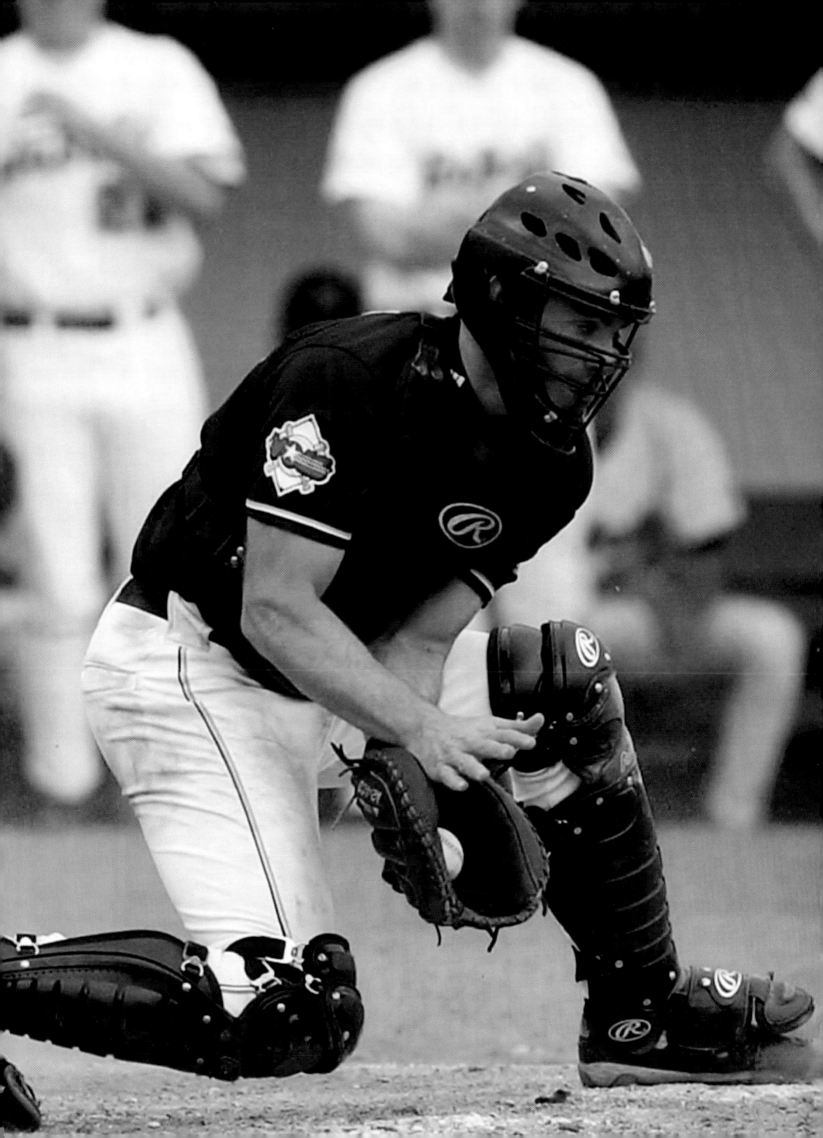

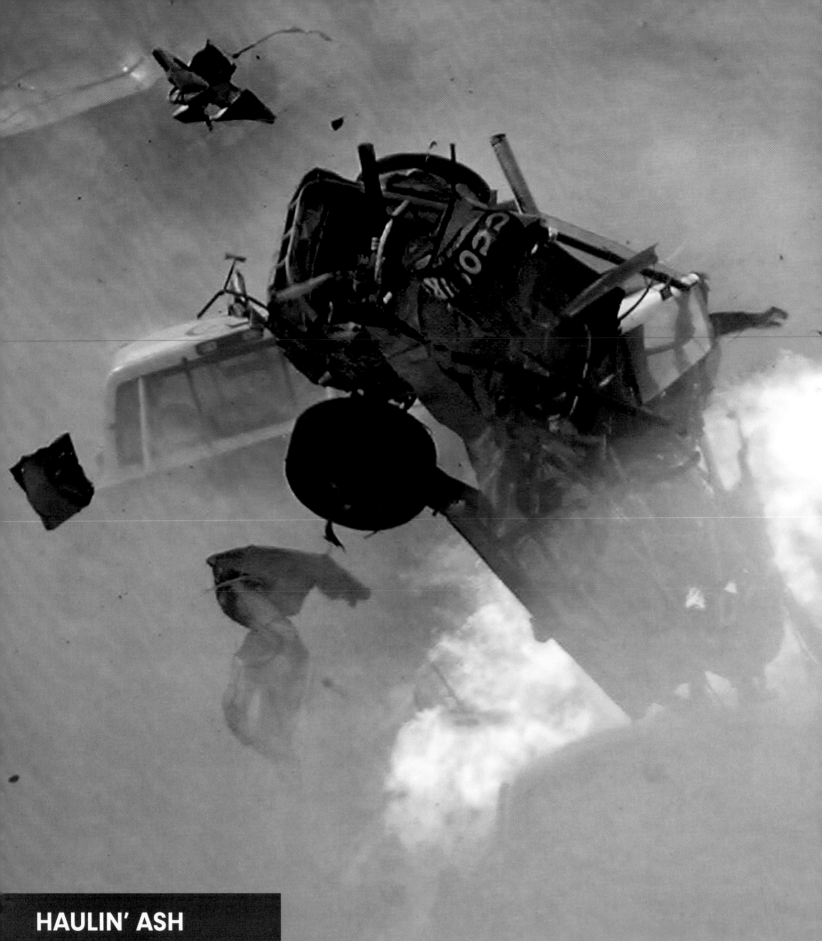

HAULIN' ASH

Geoff Bodine's Ford went airborne and burst
into flames during the first running of the
Craftsman Truck Series Daytona 250 in 2000.
The accident left Bodine with a concussion, a
fractured right wrist and a cracked vertebrae.

PHOTOGRAPH BY PHIL COALE/AP

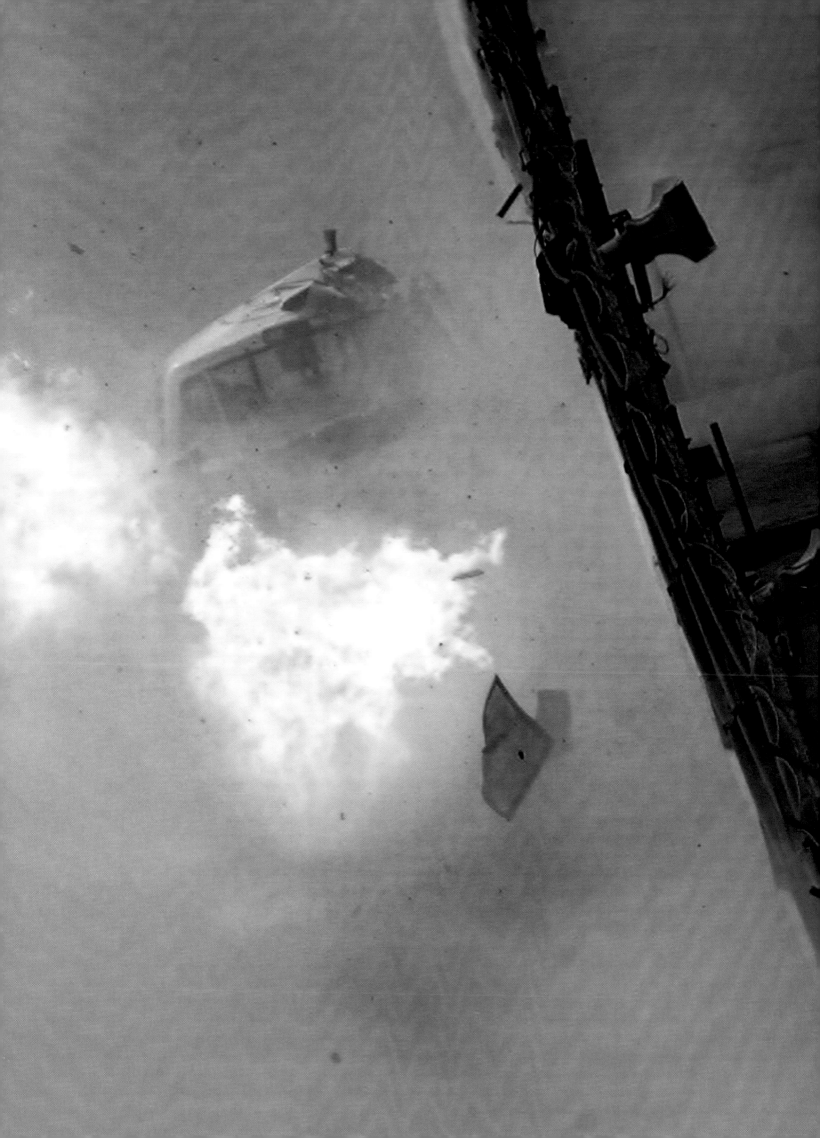

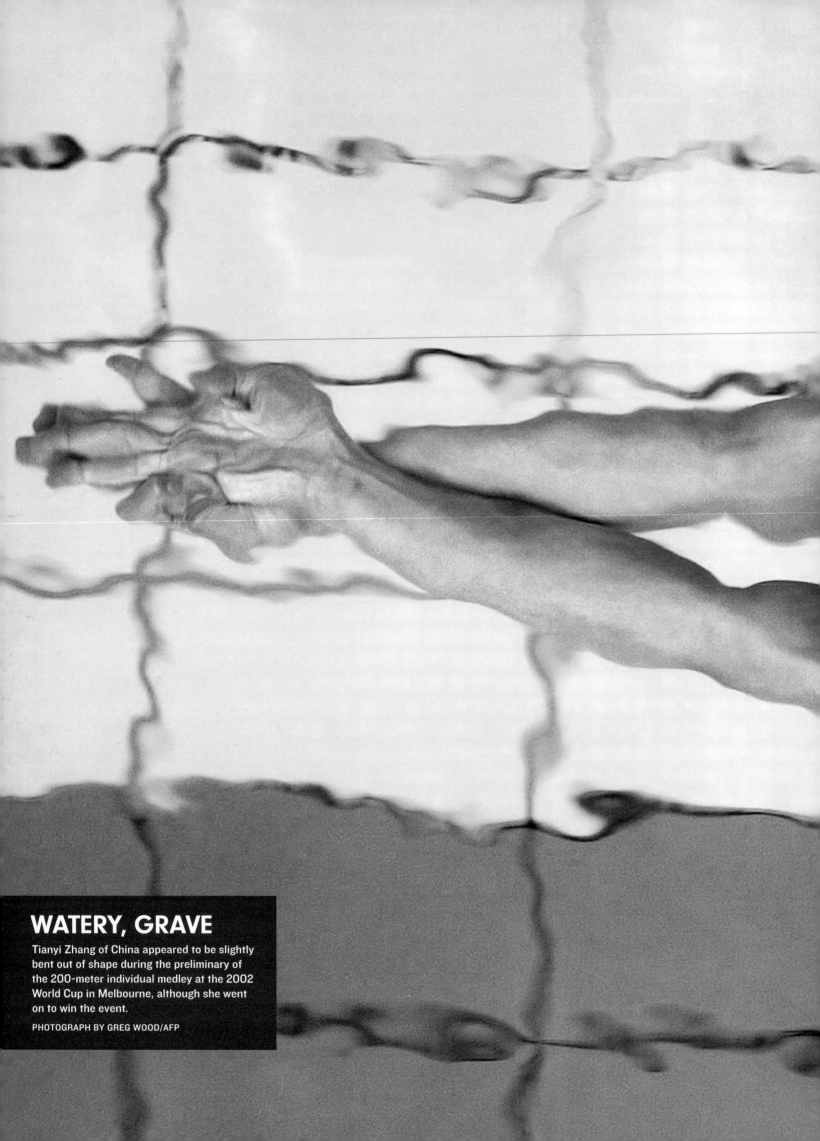

WATERY, GRAVE

Tianyi Zhang of China appeared to be slightly bent out of shape during the preliminary of the 200-meter individual medley at the 2002 World Cup in Melbourne, although she went on to win the event.

PHOTOGRAPH BY GREG WOOD/AFP

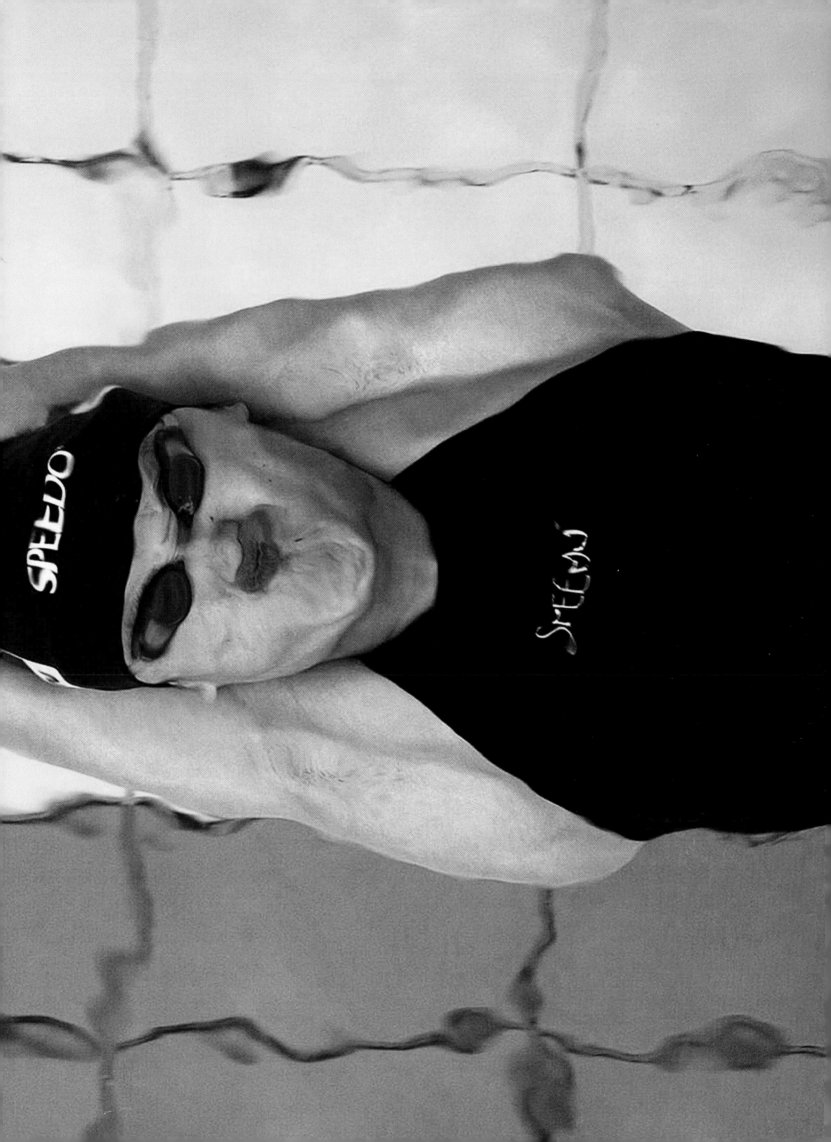

—BY MICHAEL FARBER *Sports Illustrated 6/19/00*

NEW JERSEY'S STANLEY CUP FINALS victory over the Dallas Stars stands as a take-your-teeth-out-and-go-to-work triumph of dated virtues, one that imposed order after a chaotic spring. The heretofore stolid Devils suddenly had been winging it. The team was being sold; it was guided by Larry Robinson, who wasn't sure he wanted to be its coach when asked to take over with eight games remaining in the season; and it was being captained by a bodychecking assassin, Scott Stevens, who suffered a pinched nerve in his shoulder in the opening round so severe that he now struggled to lift the 35-pound Stanley Cup over his head. The Devils had earned the right to play for the Cup after coming back from a 3–1 series deficit in the conference finals, something no team had done that late since 1967. They won the Cup with a 2–1 double-overtime road victory that dethroned the Stars. "We did it the hard way," goalie Martin Brodeur said. "It's nice to win with all that adversity. . . . "

Martin Brodeur is feeling pretty high as his Devils clinch the Stanley Cup. PHOTOGRAPH BY DAVID E. KLUTHO

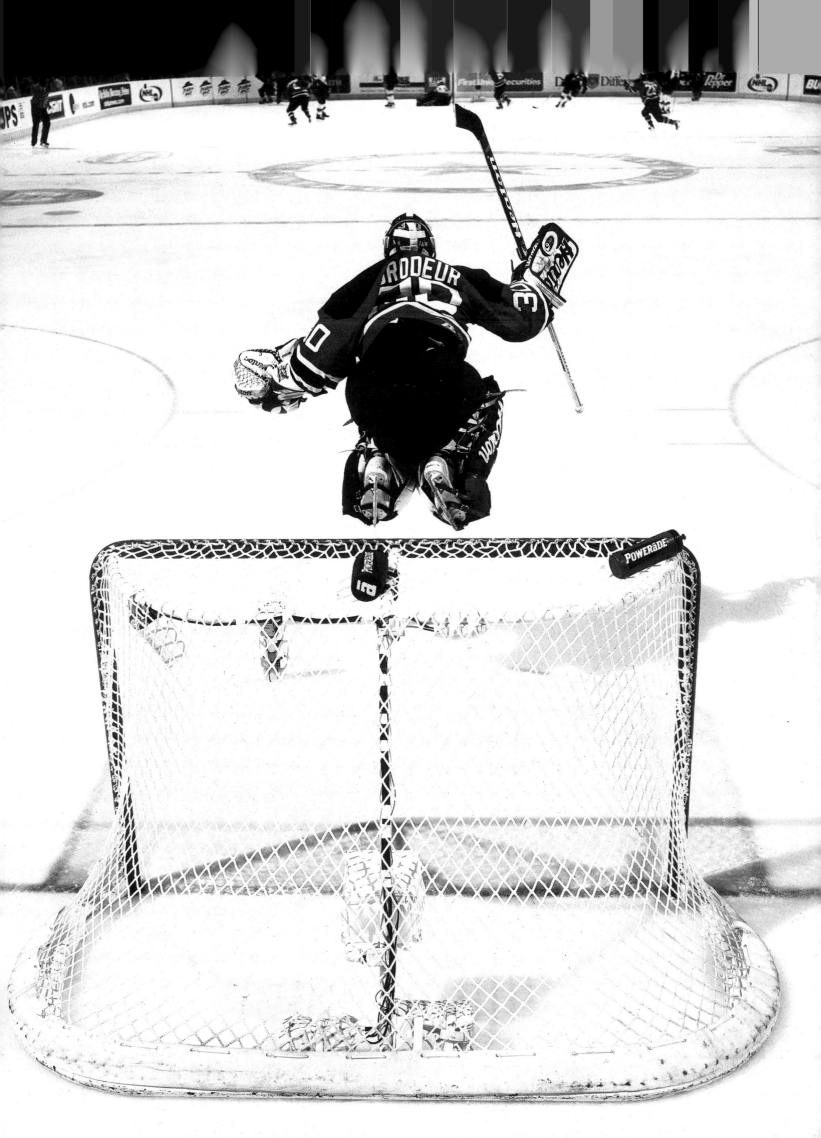

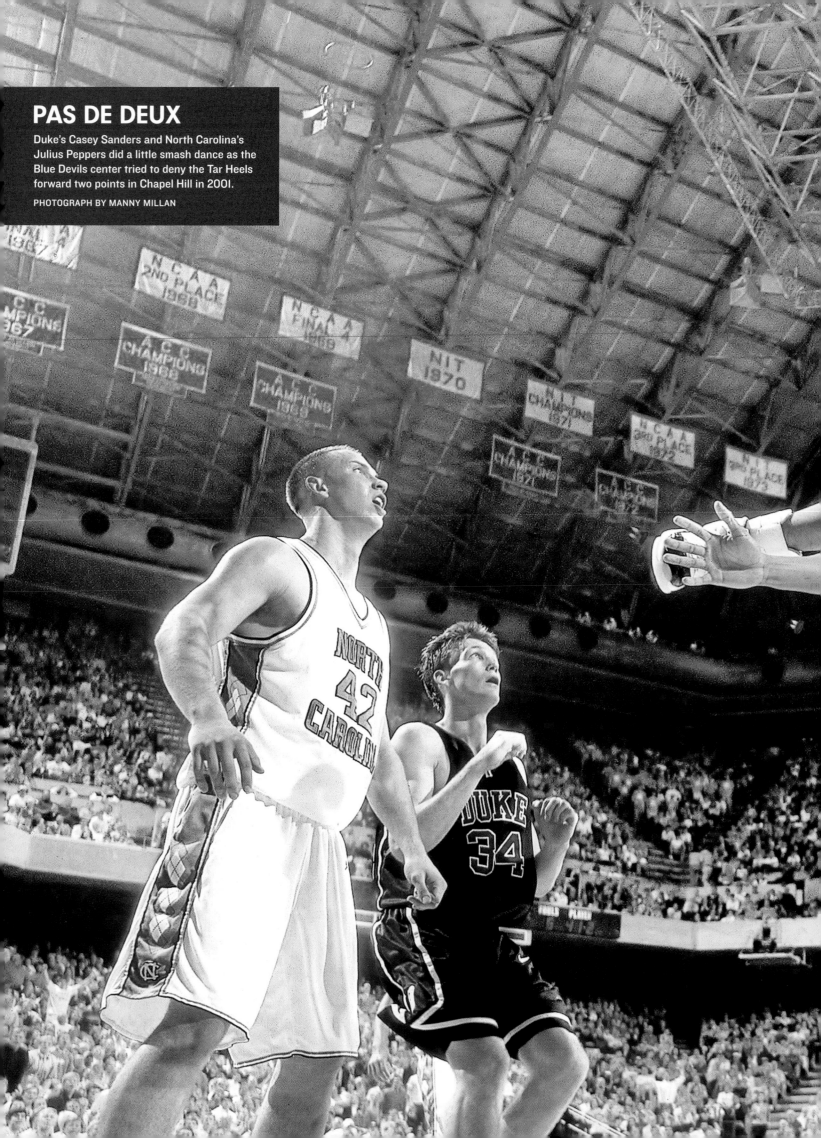

PAS DE DEUX

Duke's Casey Sanders and North Carolina's Julius Peppers did a little smash dance as the Blue Devils center tried to deny the Tar Heels forward two points in Chapel Hill in 2001.

PHOTOGRAPH BY MANNY MILLAN

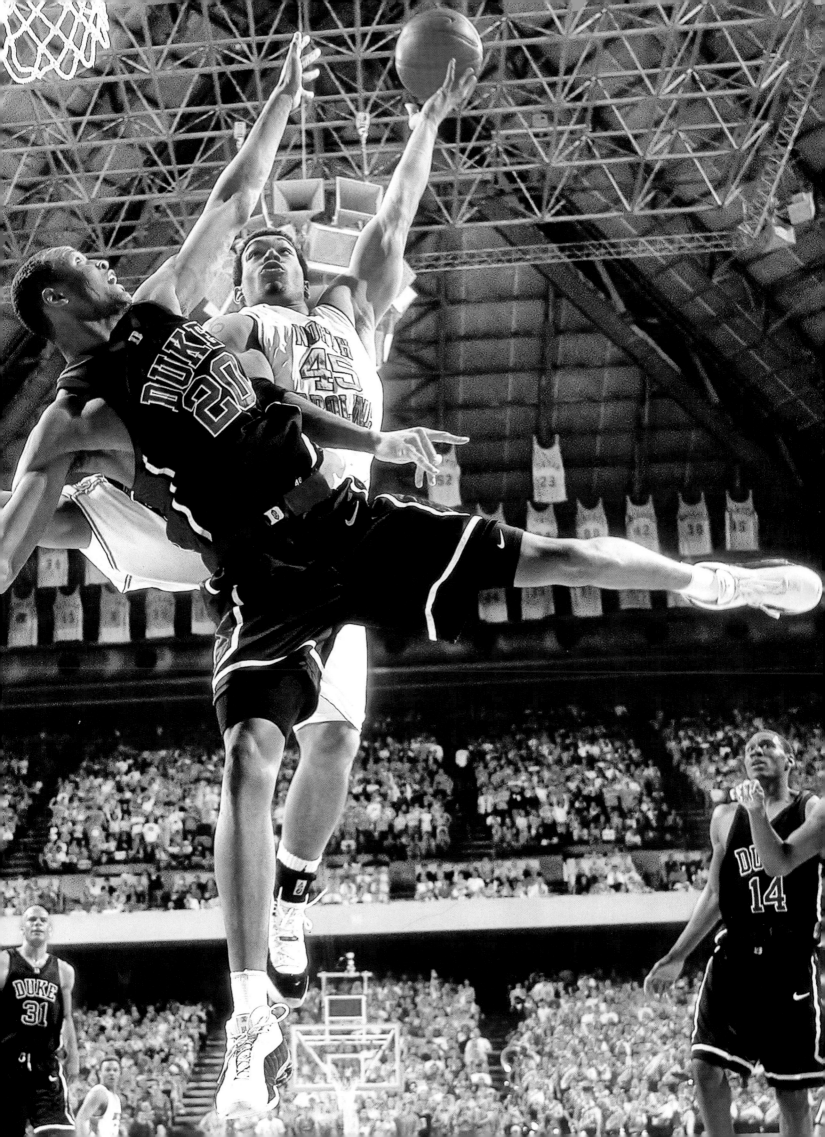

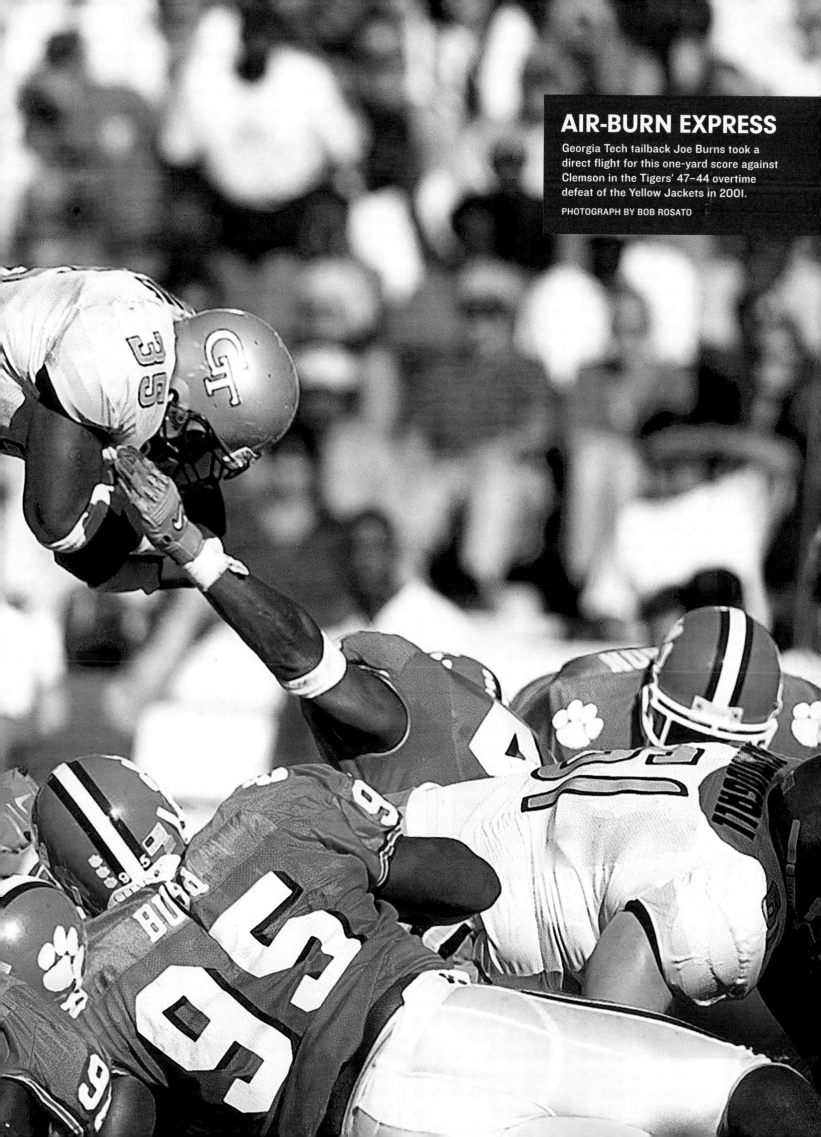

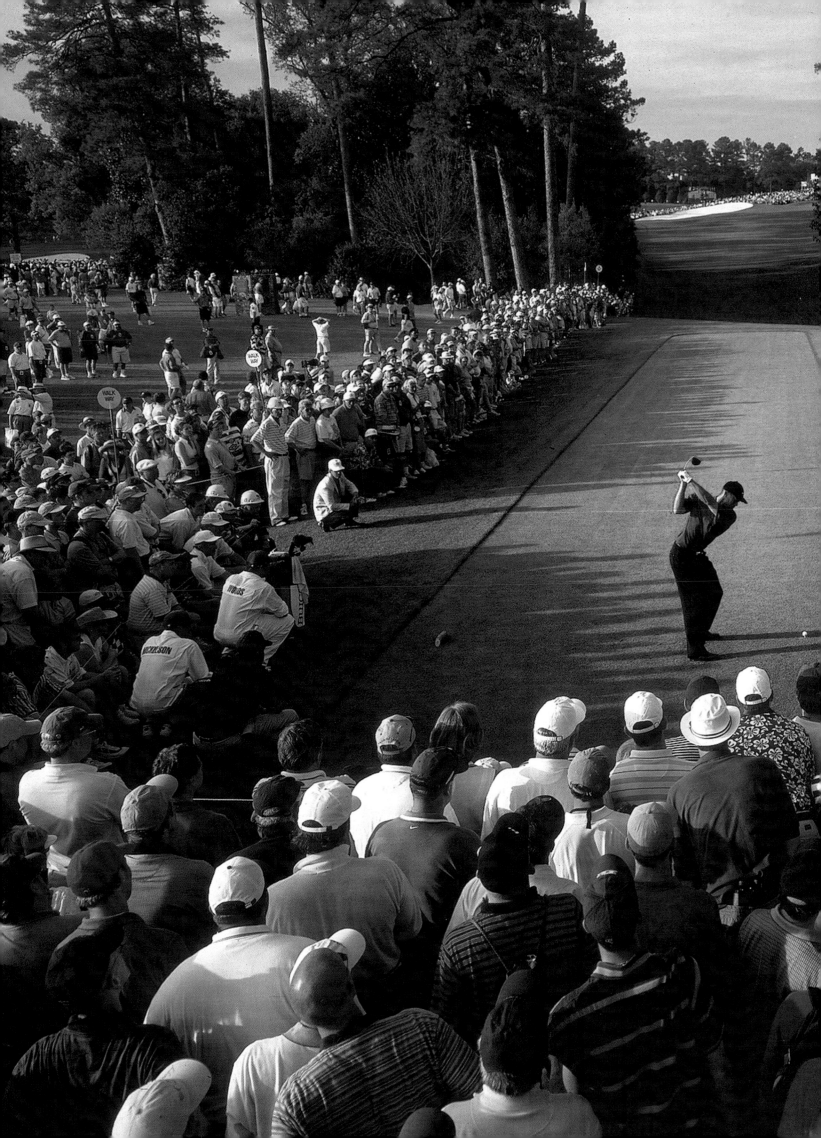

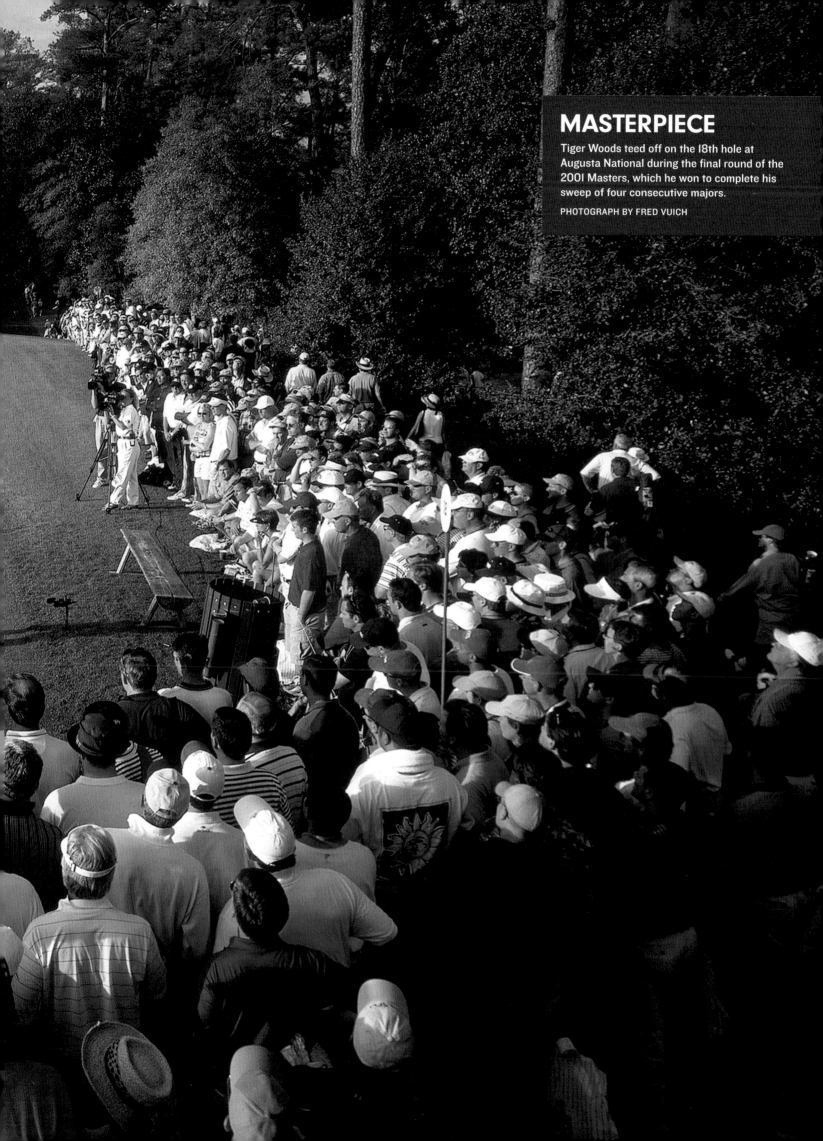

MASTERPIECE

Tiger Woods teed off on the 18th hole at Augusta National during the final round of the 2001 Masters, which he won to complete his sweep of four consecutive majors.

PHOTOGRAPH BY FRED VUICH

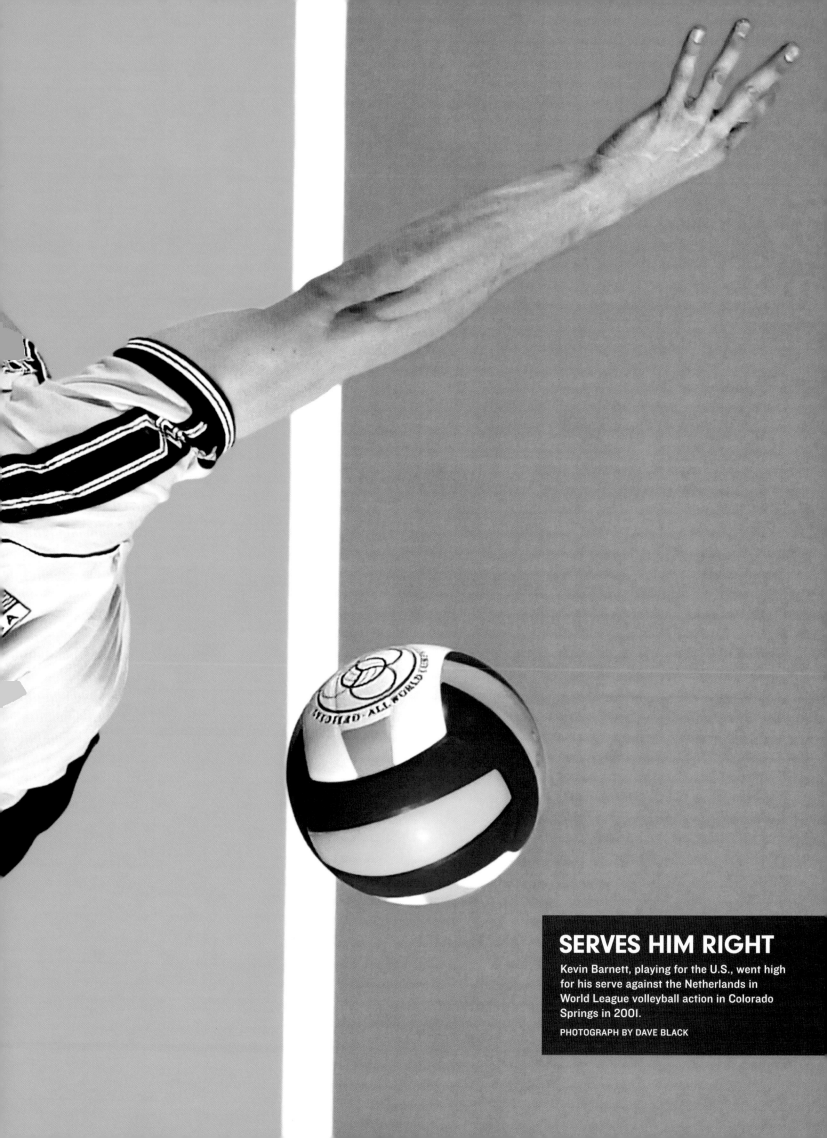

SERVES HIM RIGHT

Kevin Barnett, playing for the U.S., went high for his serve against the Netherlands in World League volleyball action in Colorado Springs in 2001.

PHOTOGRAPH BY DAVE BLACK

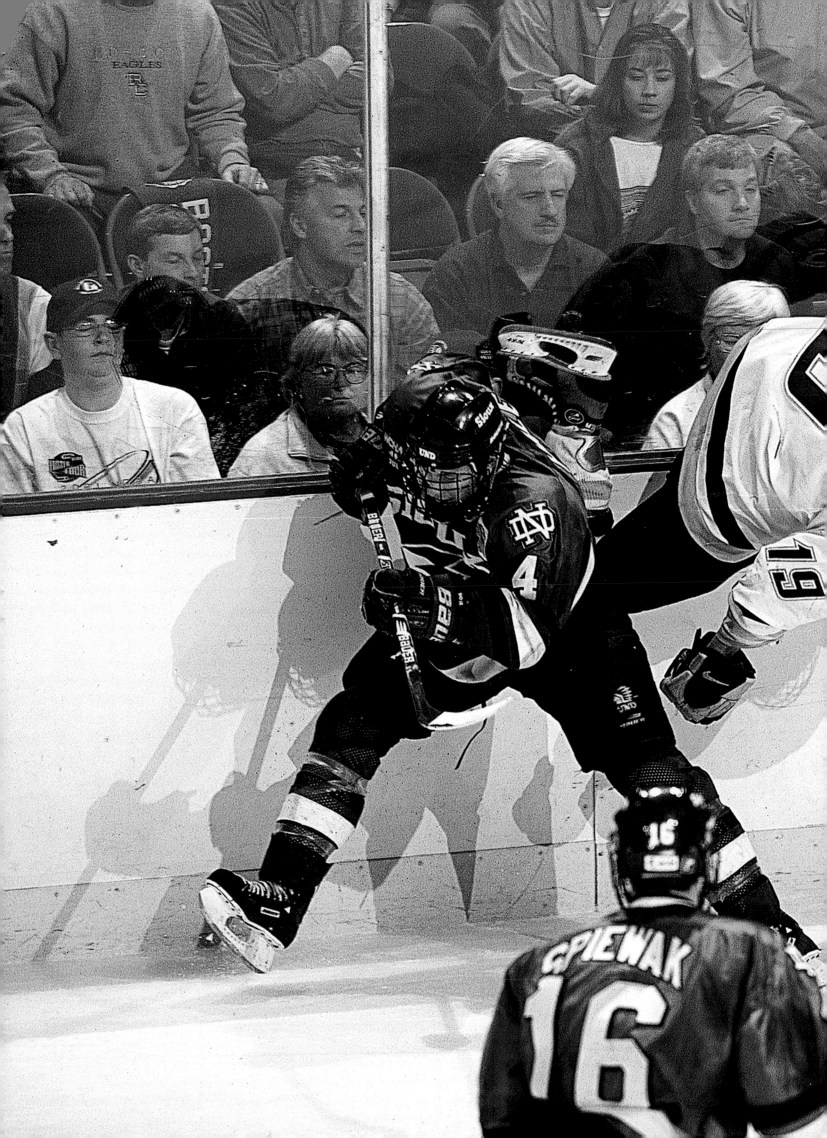

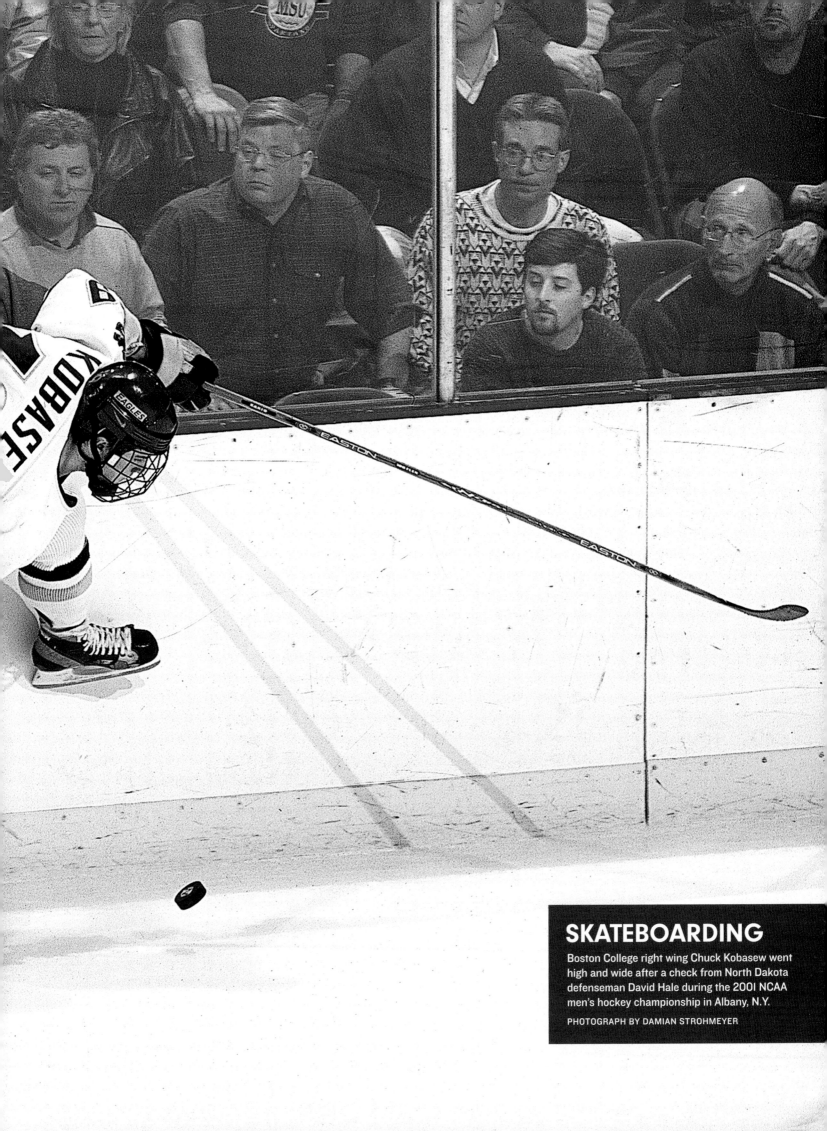

SKATEBOARDING

Boston College right wing Chuck Kobasew went high and wide after a check from North Dakota defenseman David Hale during the 2001 NCAA men's hockey championship in Albany, N.Y.

PHOTOGRAPH BY DAMIAN STROHMEYER

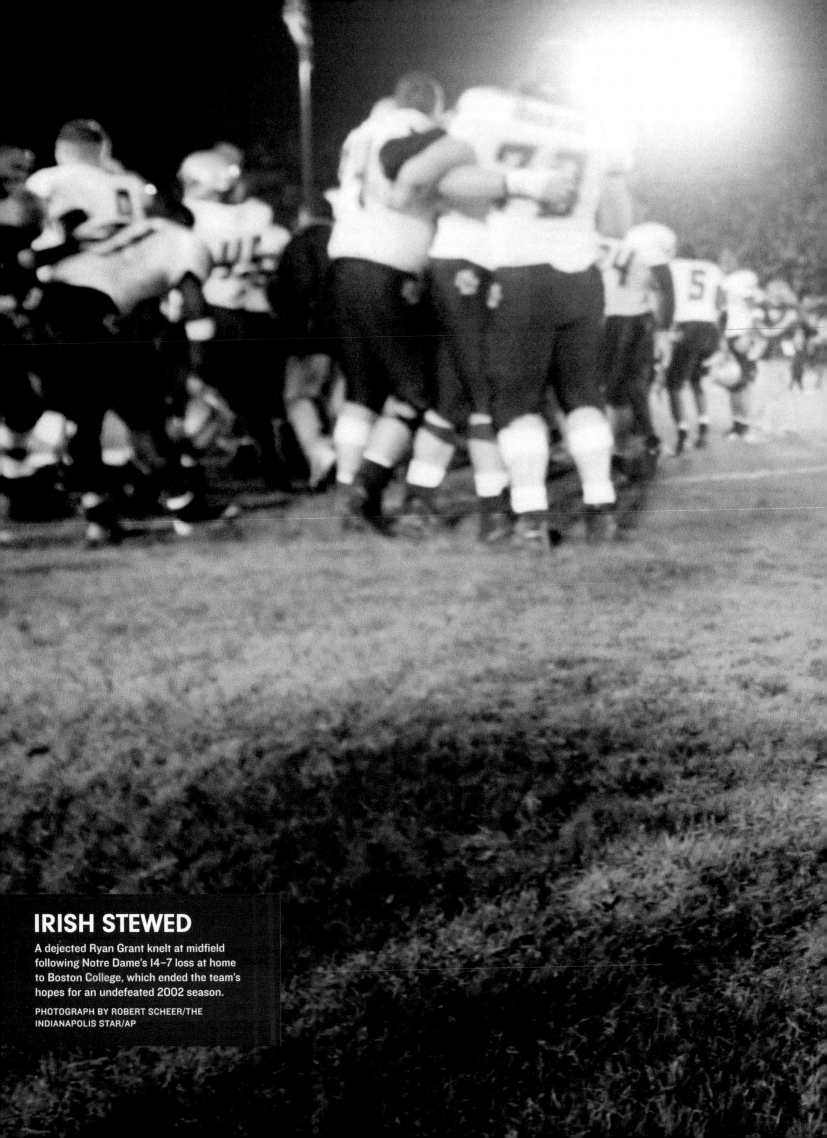

IRISH STEWED

A dejected Ryan Grant knelt at midfield following Notre Dame's 14–7 loss at home to Boston College, which ended the team's hopes for an undefeated 2002 season.

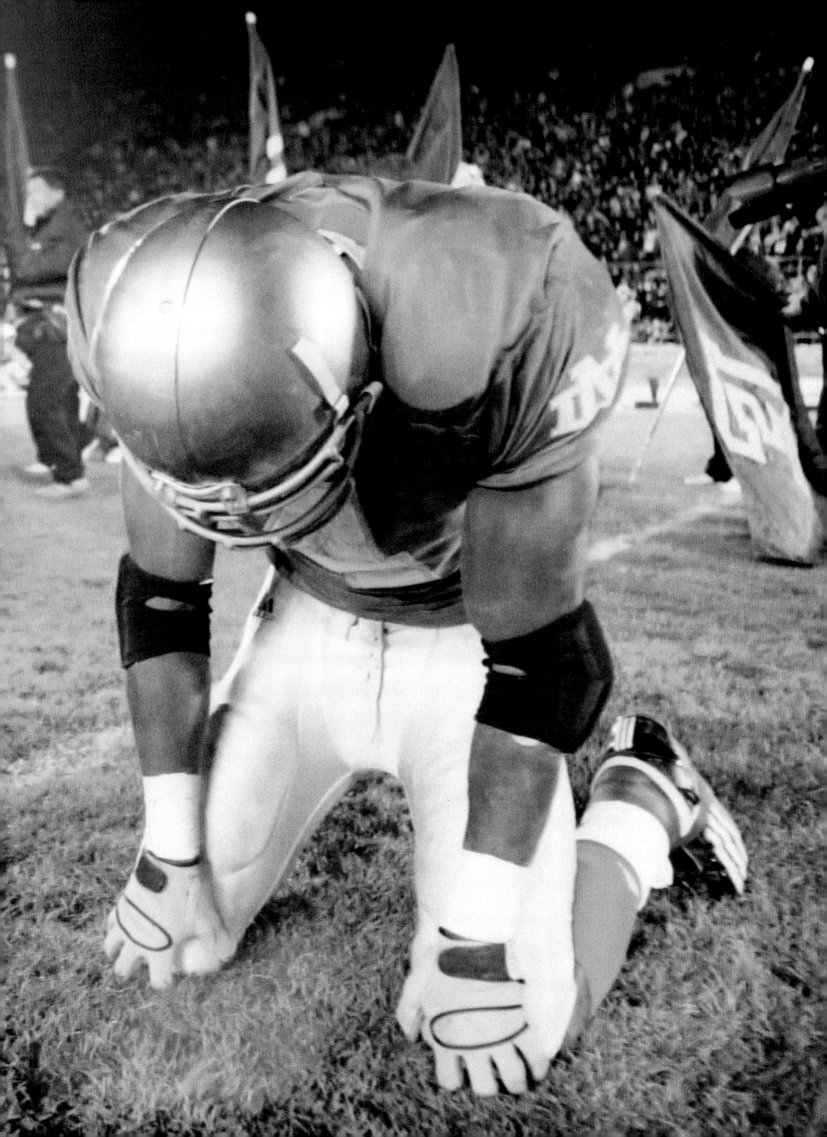

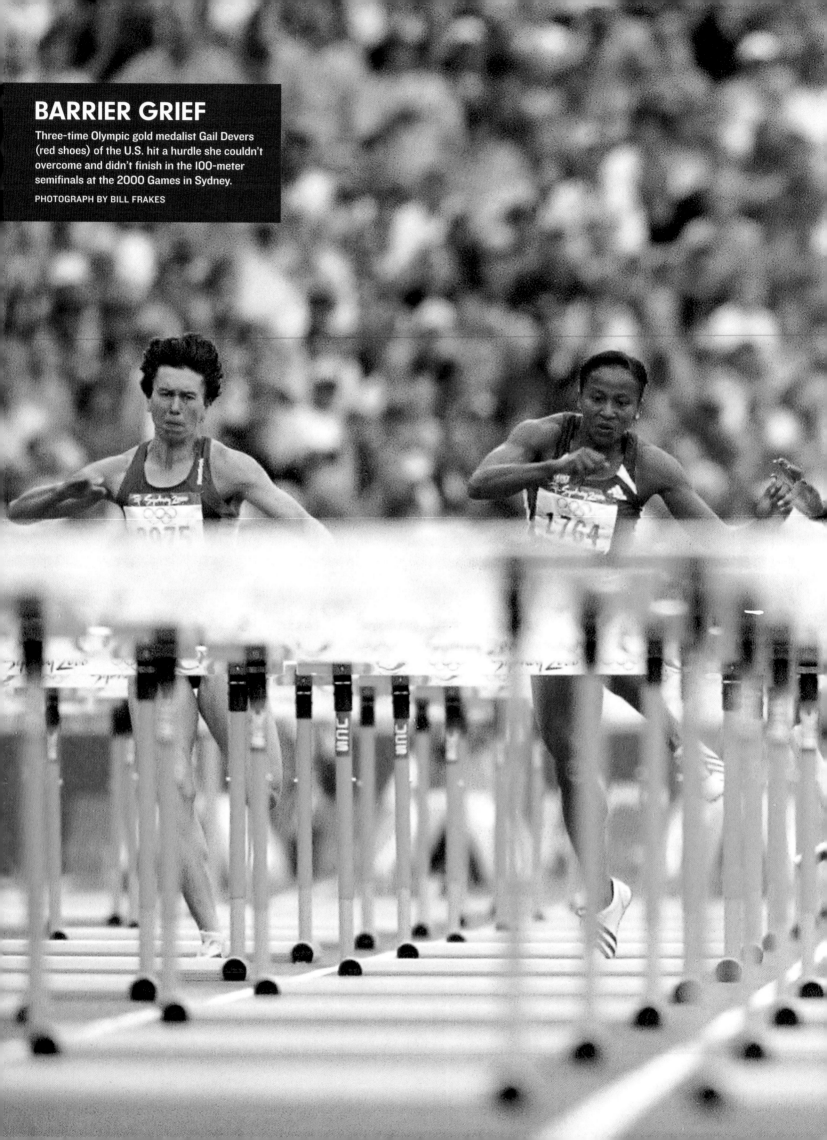

BARRIER GRIEF

Three-time Olympic gold medalist Gail Devers (red shoes) of the U.S. hit a hurdle she couldn't overcome and didn't finish in the 100-meter semifinals at the 2000 Games in Sydney.

PHOTOGRAPH BY BILL FRAKES

—BY RICHARD HOFFER *Sports Illustrated 9/24/01*

THE CRAWL ON THE BOTTOM OF OUR screens, reserved in better days for pitching matchups, leader boards and starting times, now announced building failures, death tolls, the discovery of flight recorders. It was disorienting to see this new shorthand of catastrophe replace the familiar ticker of our *SportsCenter*-ed lives. Where BONDS 3 HR was once comfortable minutiae, there was now a creeping ribbon of deepening disaster: MAYOR REQUESTS 6,000 BODY BAGS. It didn't take long to make the adjustment, though, and by the time the commissioners, owners and athletes had agreed to stop play for a week, it seemed so appropriate that not even a sports-talk crank could mount an objection. Two days after jetliners sliced through America's totems of capitalism and military might, sports closed down. With the exception of some high school and lower-division college sports, not one game was played. Our stadiums were quiet and dark, parking lots empty, the games just . . . gone. . . .

Packer Darren Sharper takes the field 13 days after the 9/11 attacks. PHOTOGRAPH BY MORRY GASH/AP

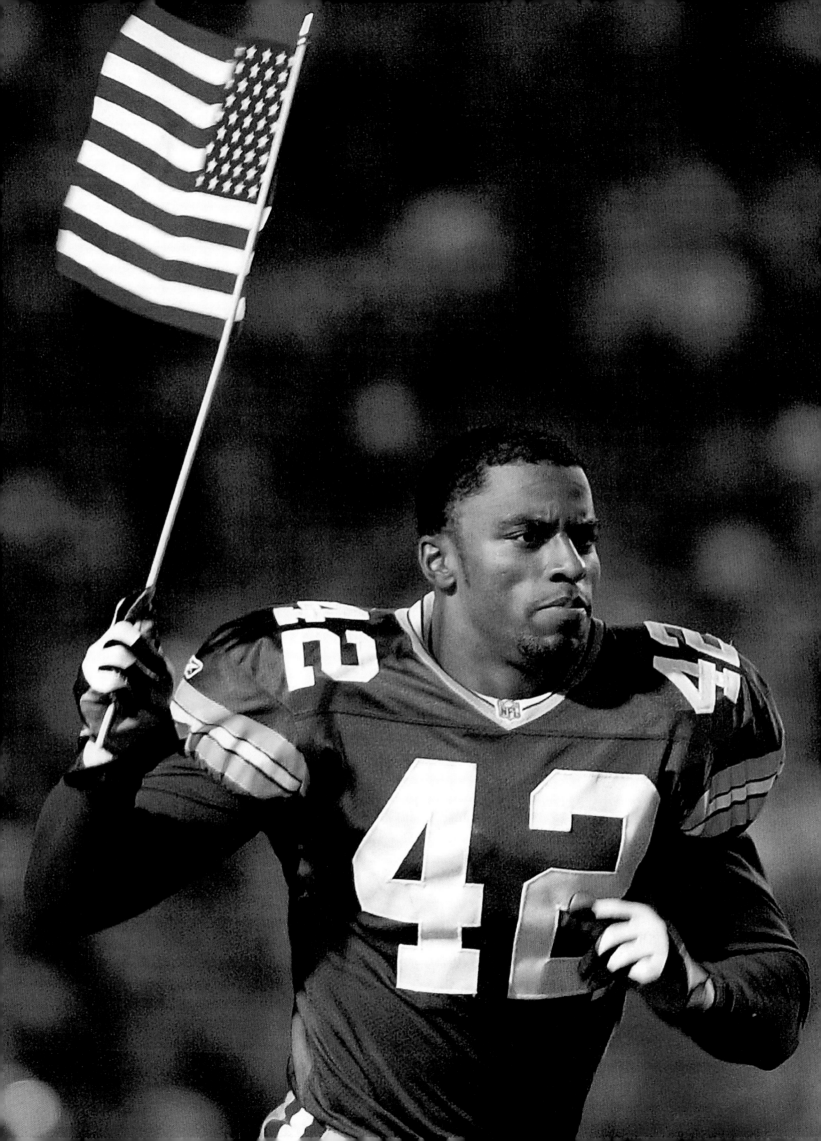

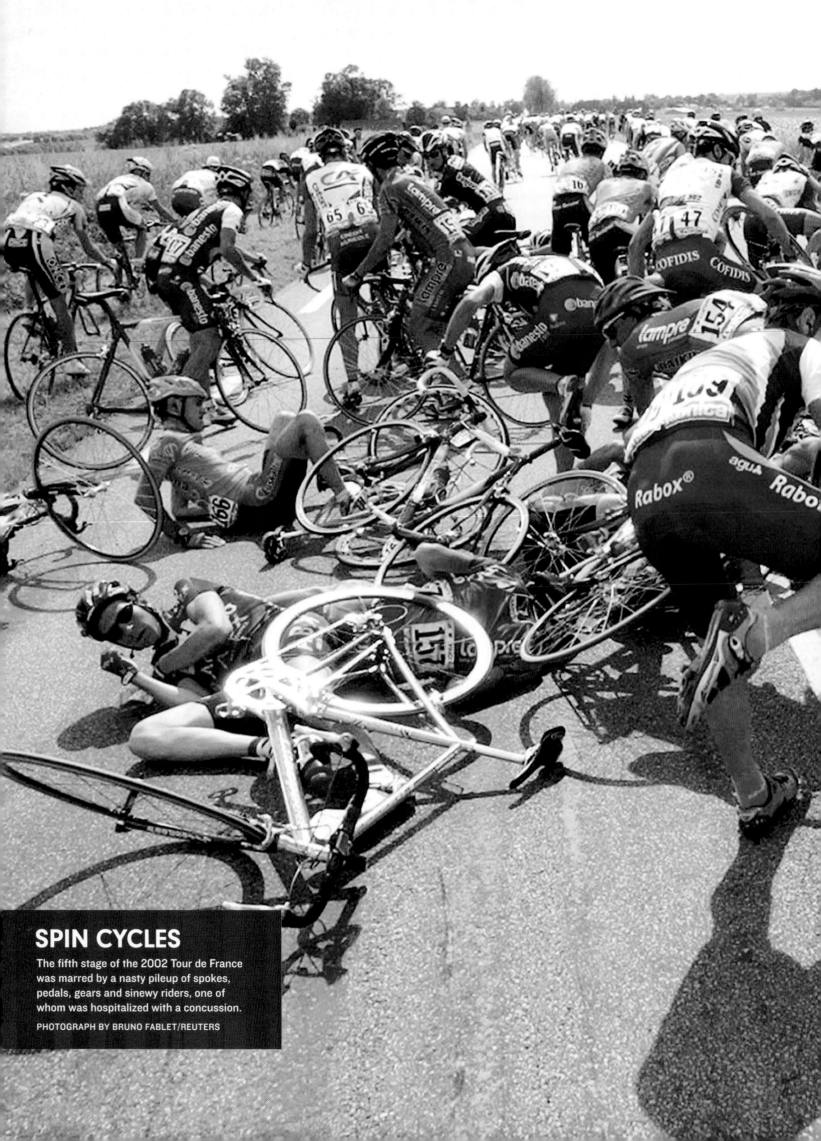

SPIN CYCLES

The fifth stage of the 2002 Tour de France
was marred by a nasty pileup of spokes,
pedals, gears and sinewy riders, one of
whom was hospitalized with a concussion.

PHOTOGRAPH BY BRUNO FABLET/REUTERS

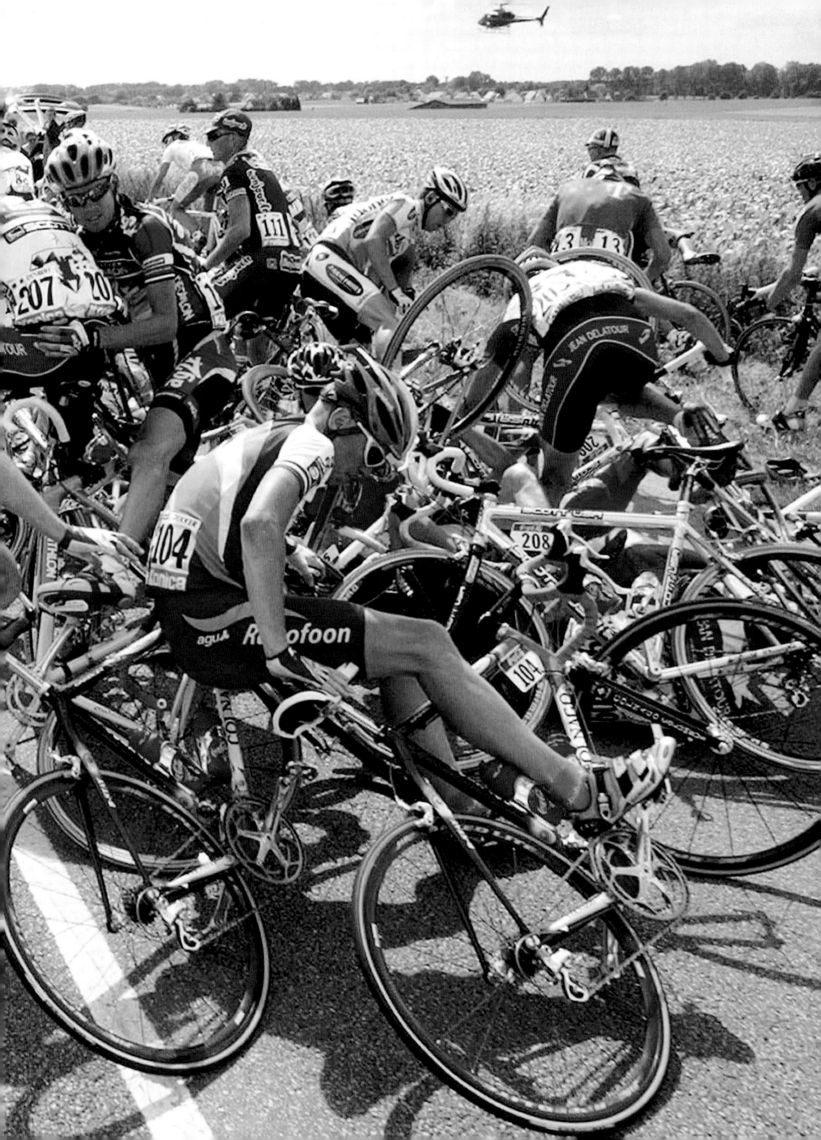

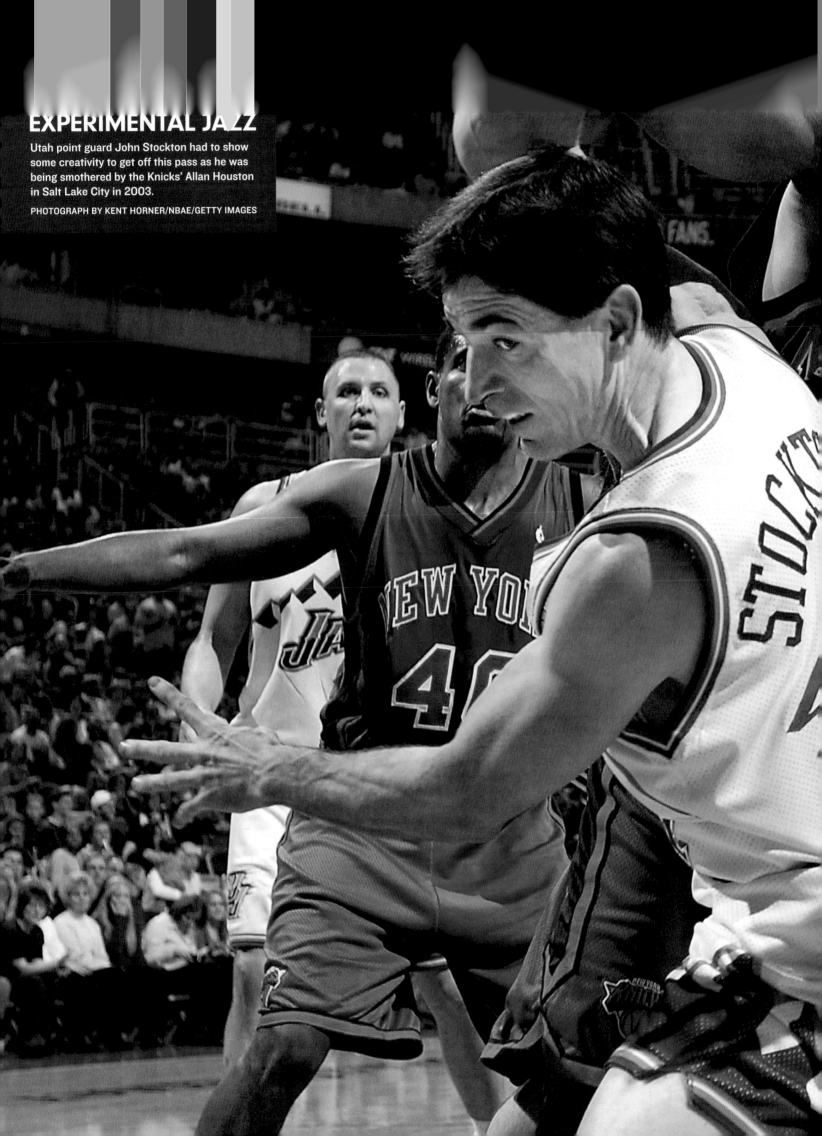

EXPERIMENTAL JAZZ

Utah point guard John Stockton had to show some creativity to get off this pass as he was being smothered by the Knicks' Allan Houston in Salt Lake City in 2003.

PHOTOGRAPH BY KENT HORNER/NBAE/GETTY IMAGES

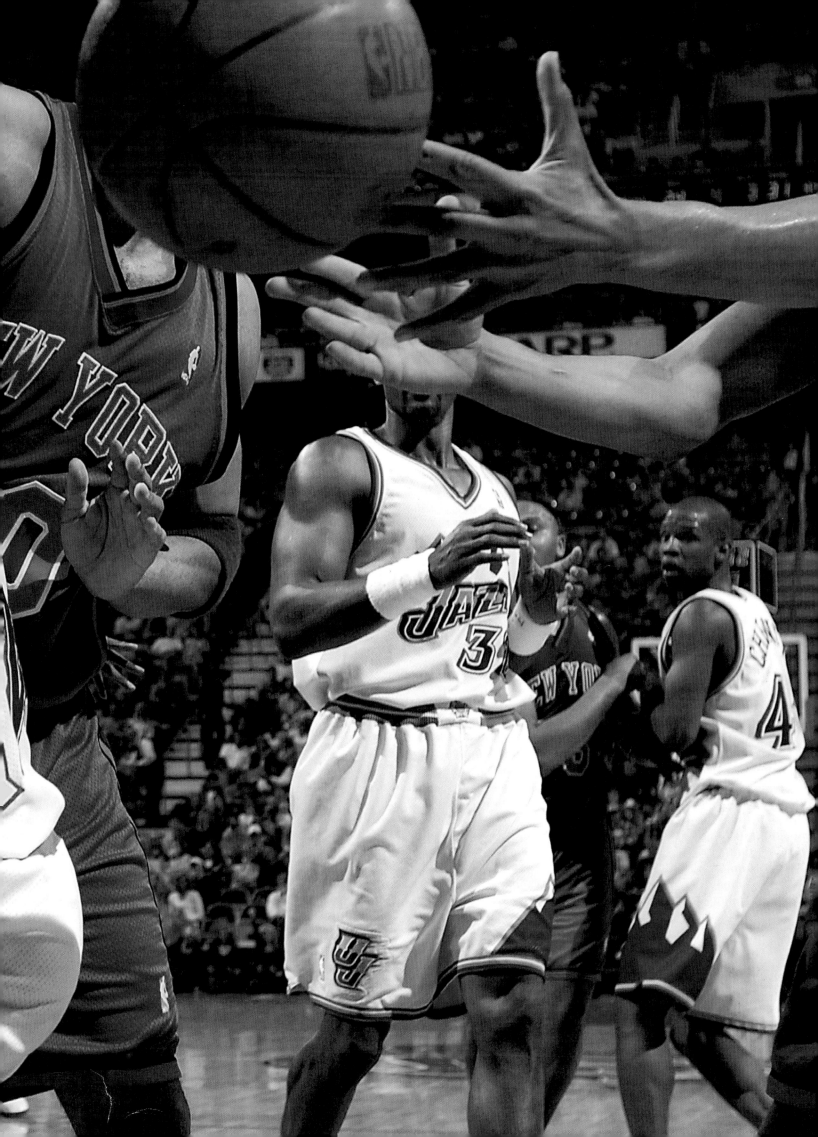

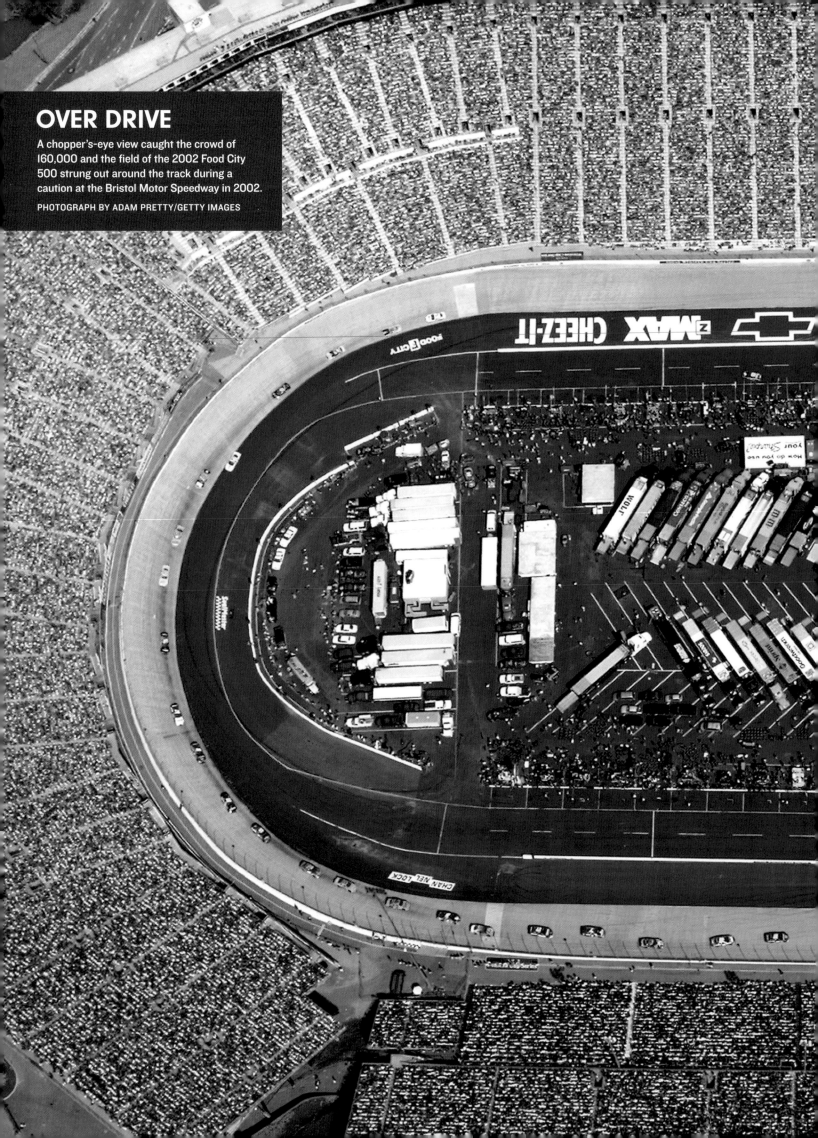

OVER DRIVE

A chopper's-eye view caught the crowd of 160,000 and the field of the 2002 Food City 500 strung out around the track during a caution at the Bristol Motor Speedway in 2002.

PHOTOGRAPH BY ADAM PRETTY/GETTY IMAGES

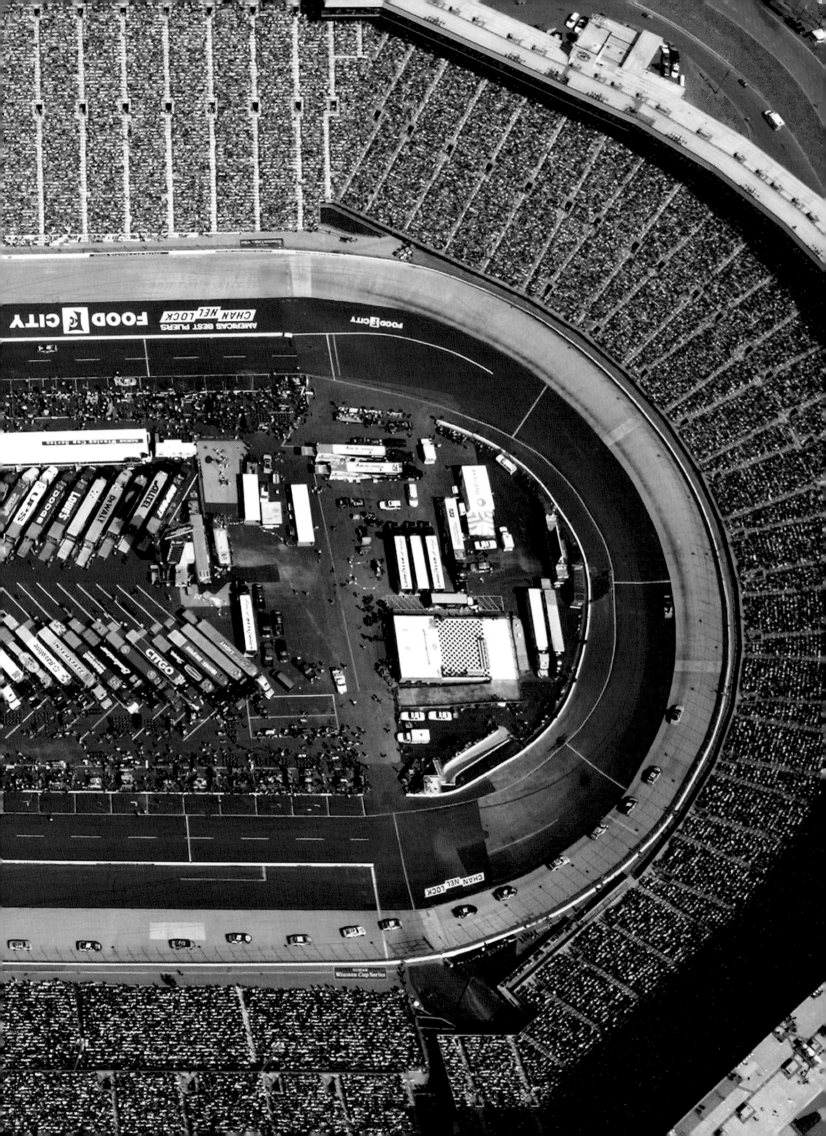

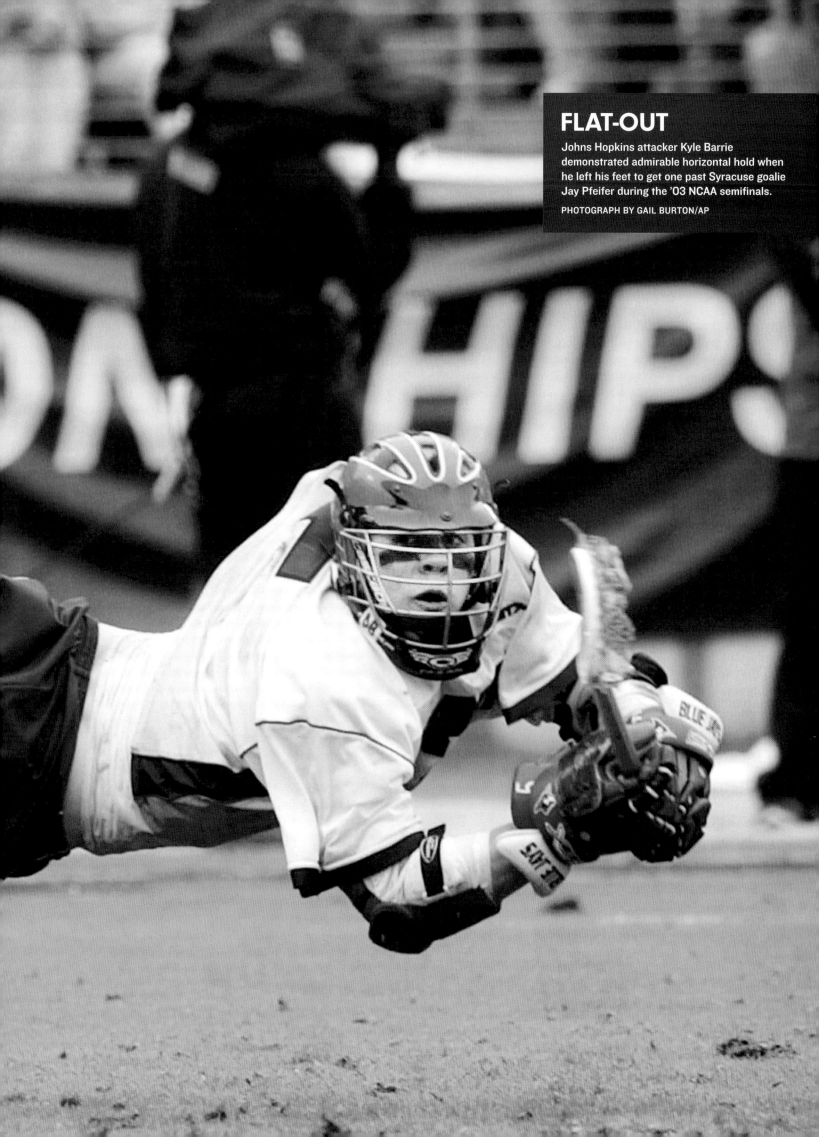

FLAT-OUT

Johns Hopkins attacker Kyle Barrie demonstrated admirable horizontal hold when he left his feet to get one past Syracuse goalie Jay Pfeifer during the '03 NCAA semifinals.

PHOTOGRAPH BY GAIL BURTON/AP

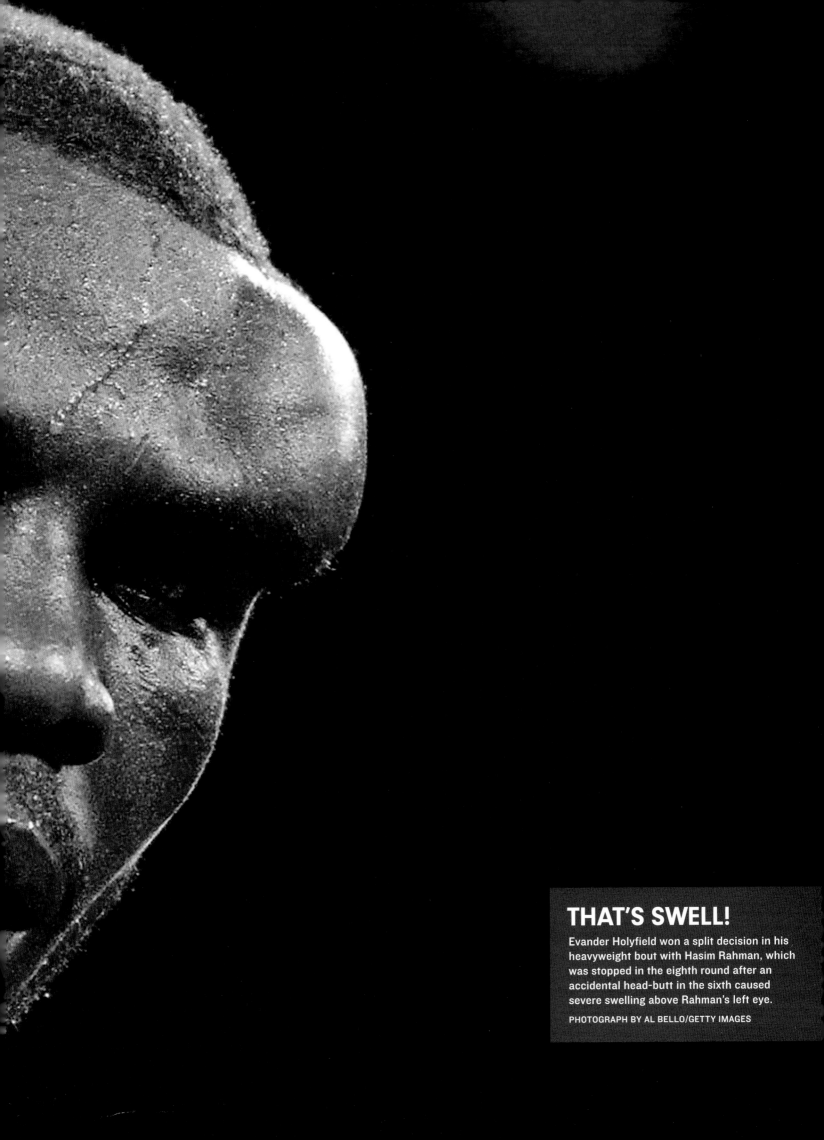

THAT'S SWELL!

Evander Holyfield won a split decision in his heavyweight bout with Hasim Rahman, which was stopped in the eighth round after an accidental head-butt in the sixth caused severe swelling above Rahman's left eye.

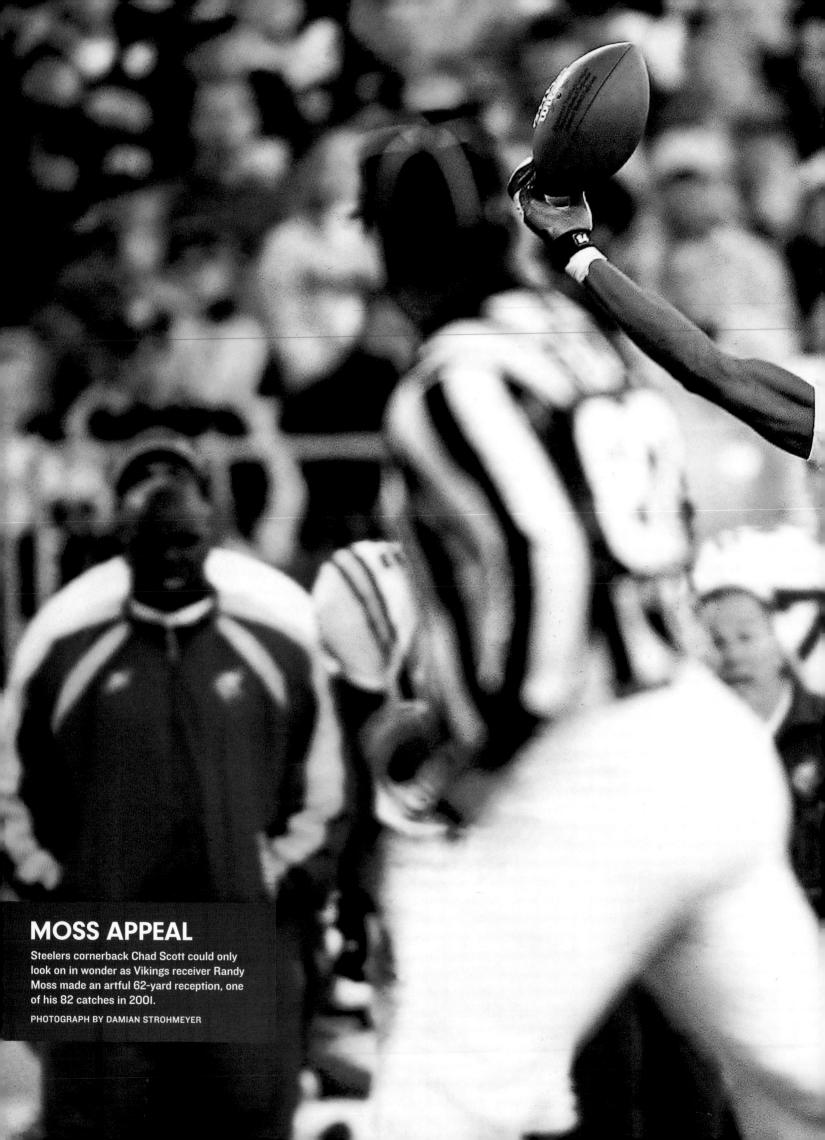

MOSS APPEAL

Steelers cornerback Chad Scott could only look on in wonder as Vikings receiver Randy Moss made an artful 62-yard reception, one of his 82 catches in 2001.

PHOTOGRAPH BY DAMIAN STROHMEYER

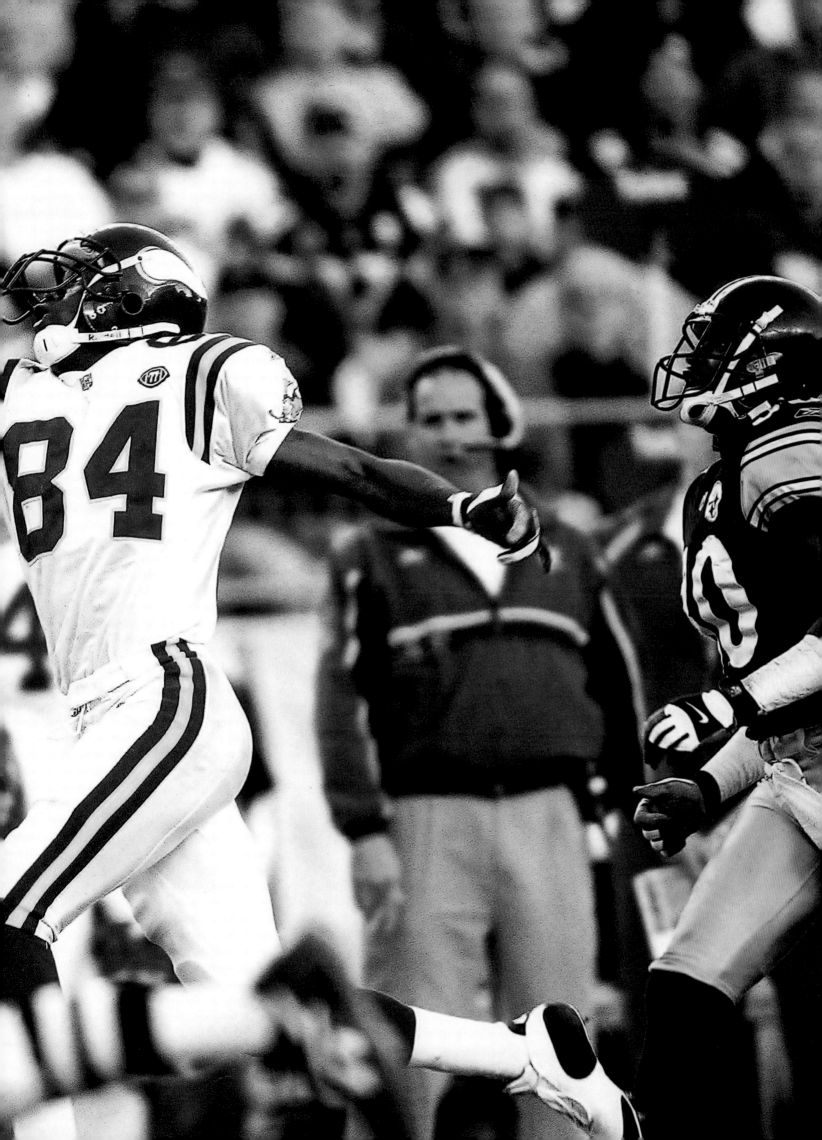

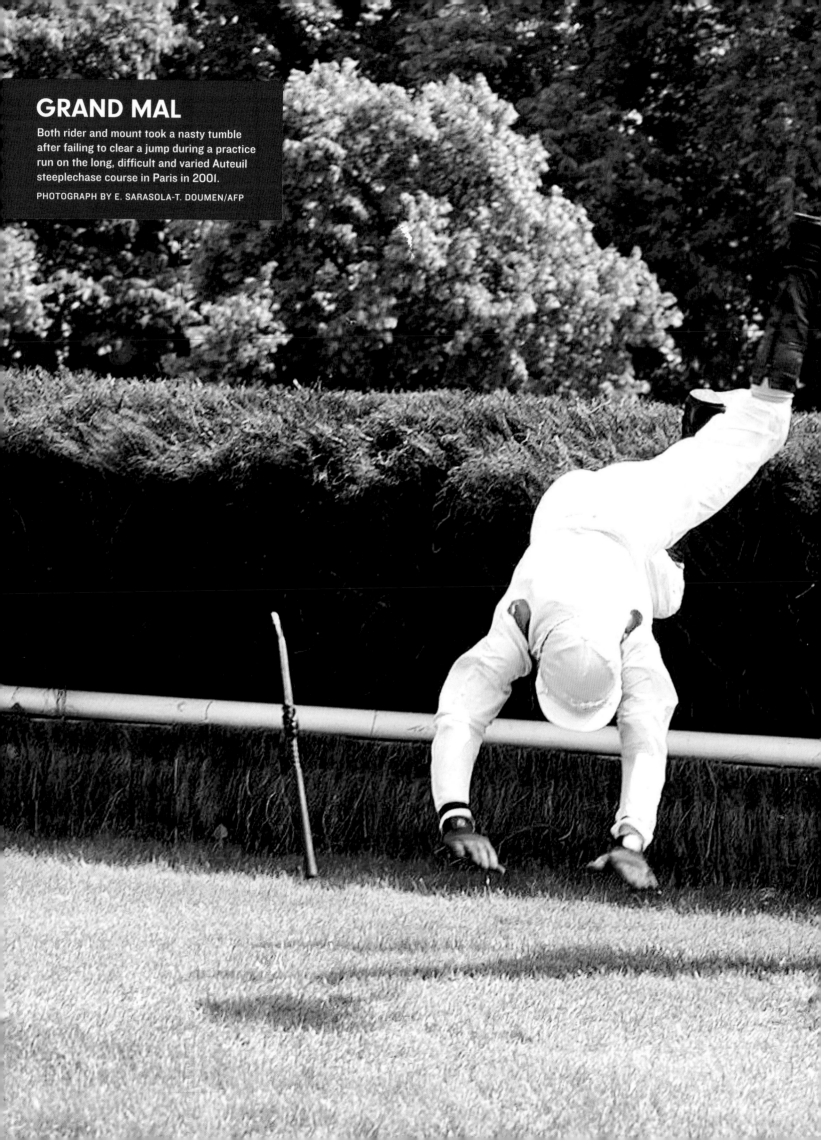

GRAND MAL

Both rider and mount took a nasty tumble after failing to clear a jump during a practice run on the long, difficult and varied Auteuil steeplechase course in Paris in 2001.

PHOTOGRAPH BY E. SARASOLA-T. DOUMEN/AFP

—BY JEFF PEARLMAN *Sports Illustrated 10/15/01*

BARRY BONDS, CAPPING PERHAPS the greatest offensive season in baseball history, had done something special—and breaking the home run record was only a part of it. In the Giants' three-game set against the Houston Astros, Bonds, who entered the series with 69 homers, was walked eight times in 14 plate appearances. The ultimate disgrace came in the third game when, with his team trailing 8–1, Astros manager Larry Dierker ordered that Bonds be intentionally walked. The move enraged San Francisco's players, many of whom, despite their dislike of Bonds, wanted to see him break the single-season home run mark. . . . At last, in the ninth, with San Francisco leading 9–2, Houston rookie Wilfredo Rodriguez challenged Bonds, who swung and missed at the first offering, a 95-mph fastball. After missing high with another fastball, Rodriguez threw Bonds a 93-mph meatball, and Bonds pounced, and the ball exploded off his bat. . . .

Barry Bonds watches his 73rd homer take flight. PHOTOGRAPH BY HEINZ KLUETMEIER

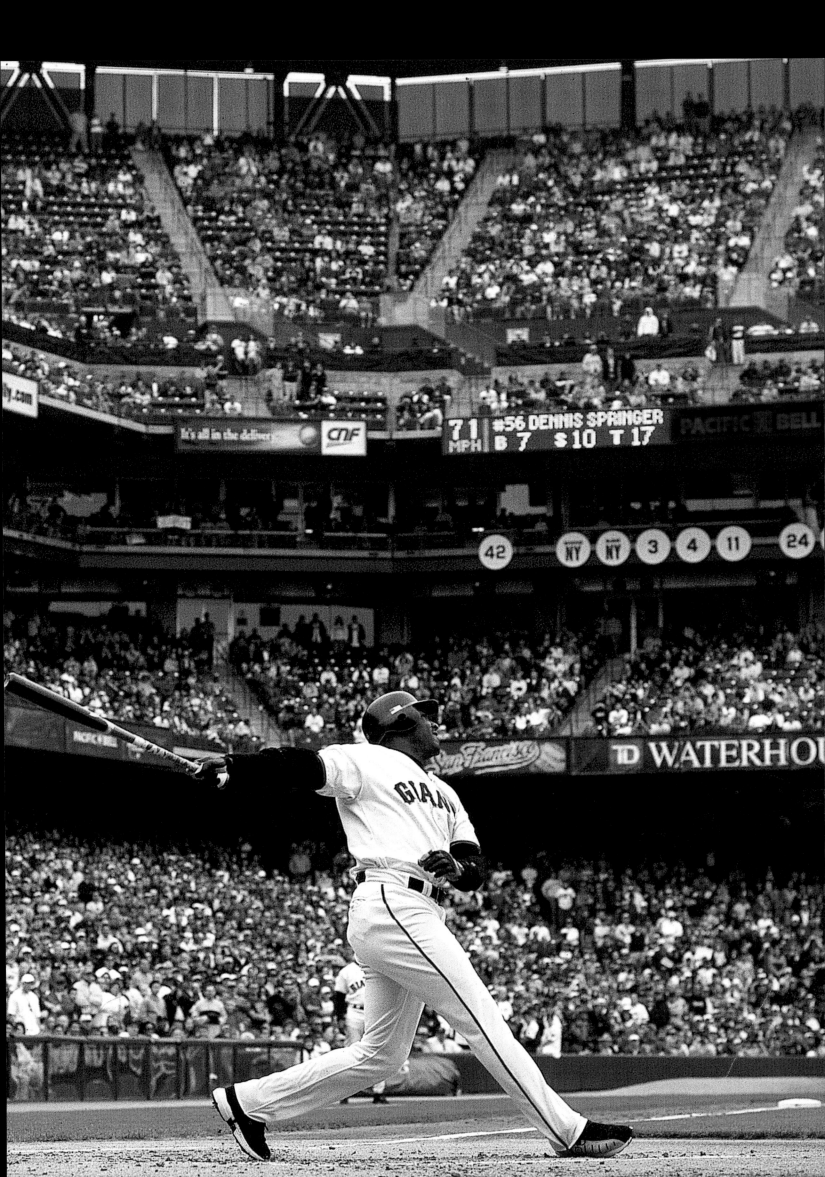

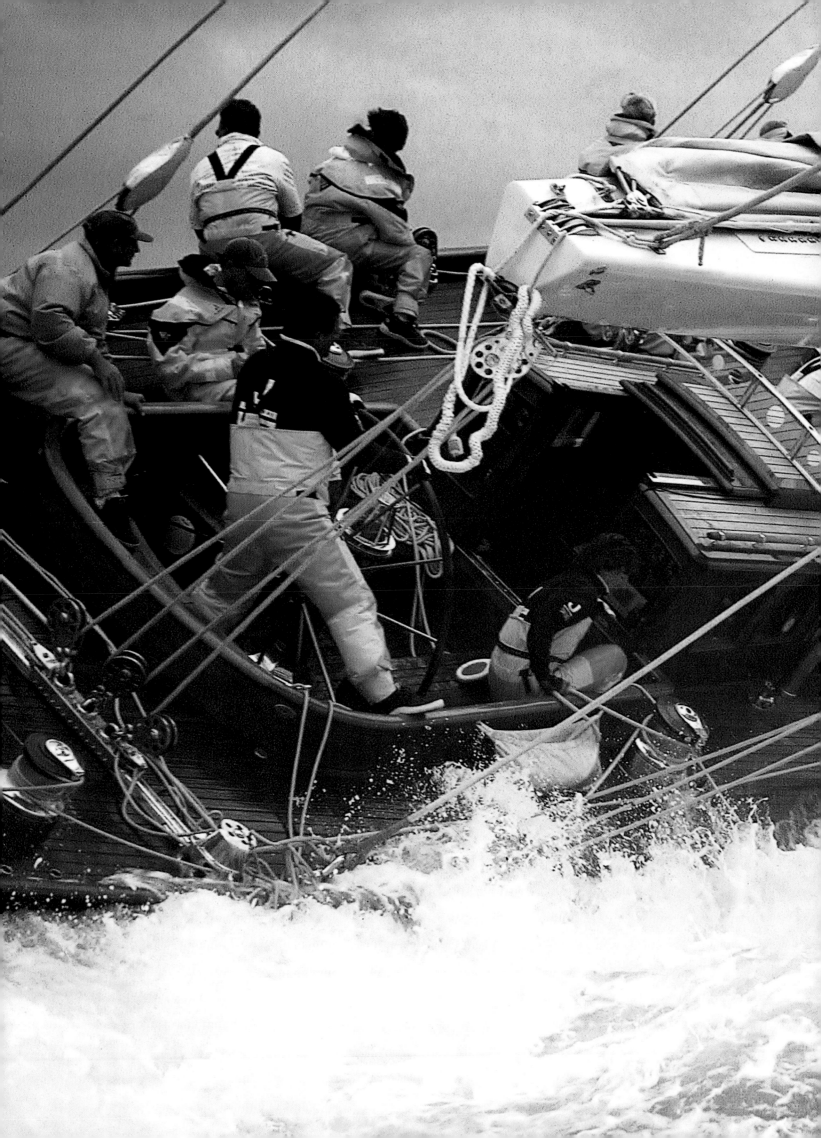

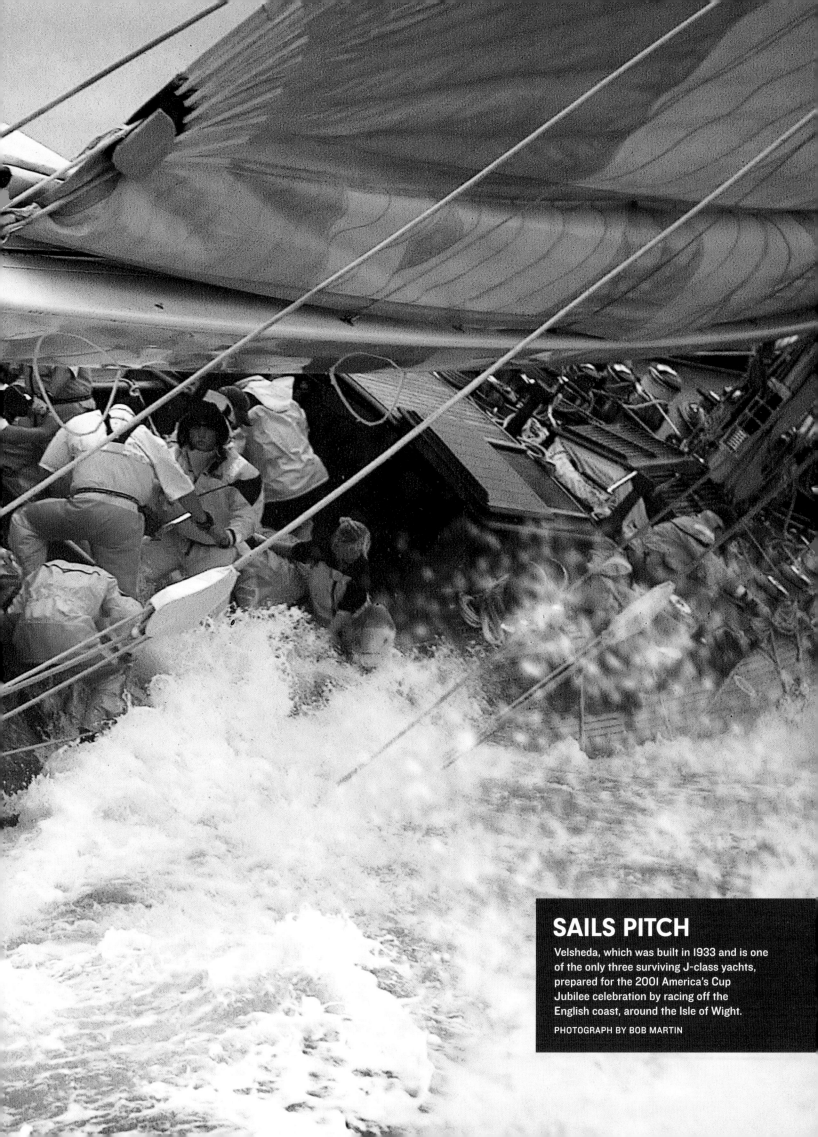

SAILS PITCH

Velsheda, which was built in 1933 and is one of the only three surviving J-class yachts, prepared for the 2001 America's Cup Jubilee celebration by racing off the English coast, around the Isle of Wight.

PHOTOGRAPH BY BOB MARTIN

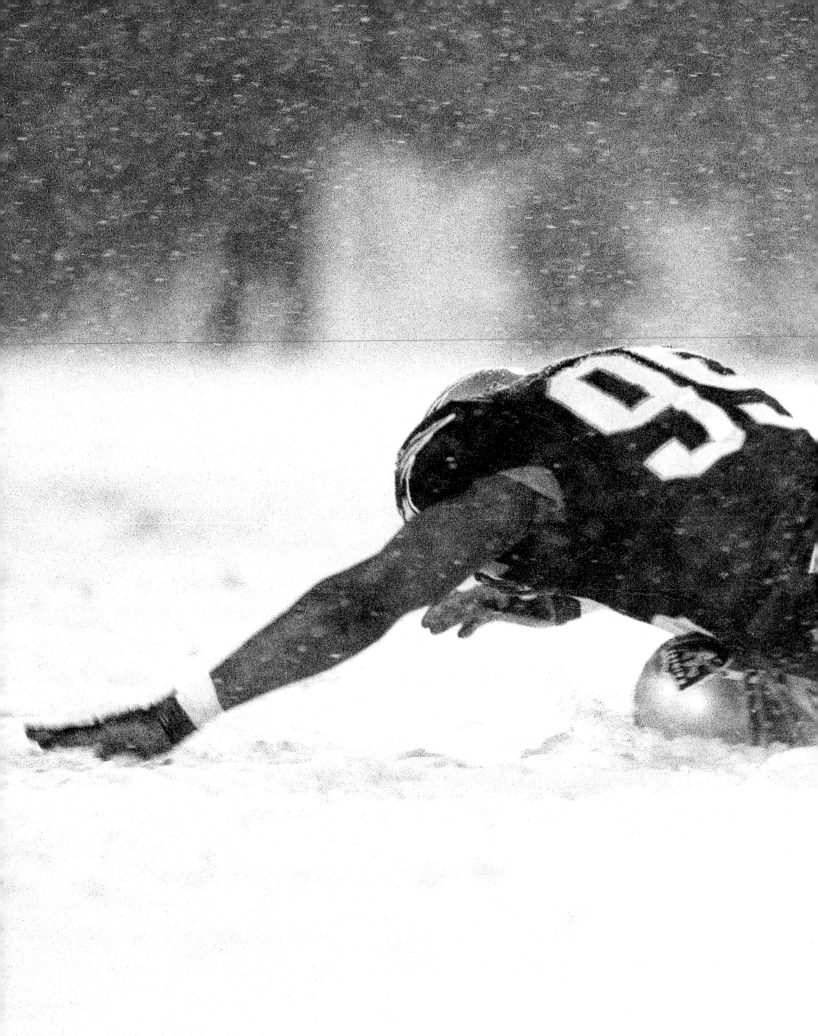

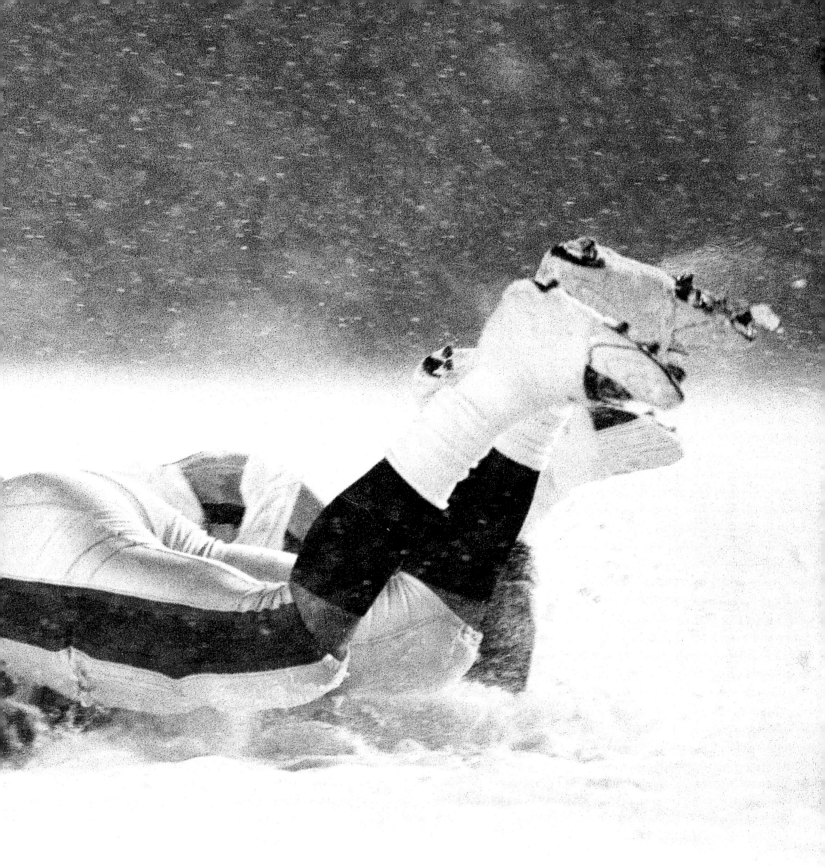

GET MY DRIFT?

Patriots linebacker Roman Phifer used Raiders running back Charlie Garner to measure the accumulation of snow in Foxboro during their 2002 AFC divisional playoff game.

PHOTOGRAPH BY DAMIAN STROHMEYER

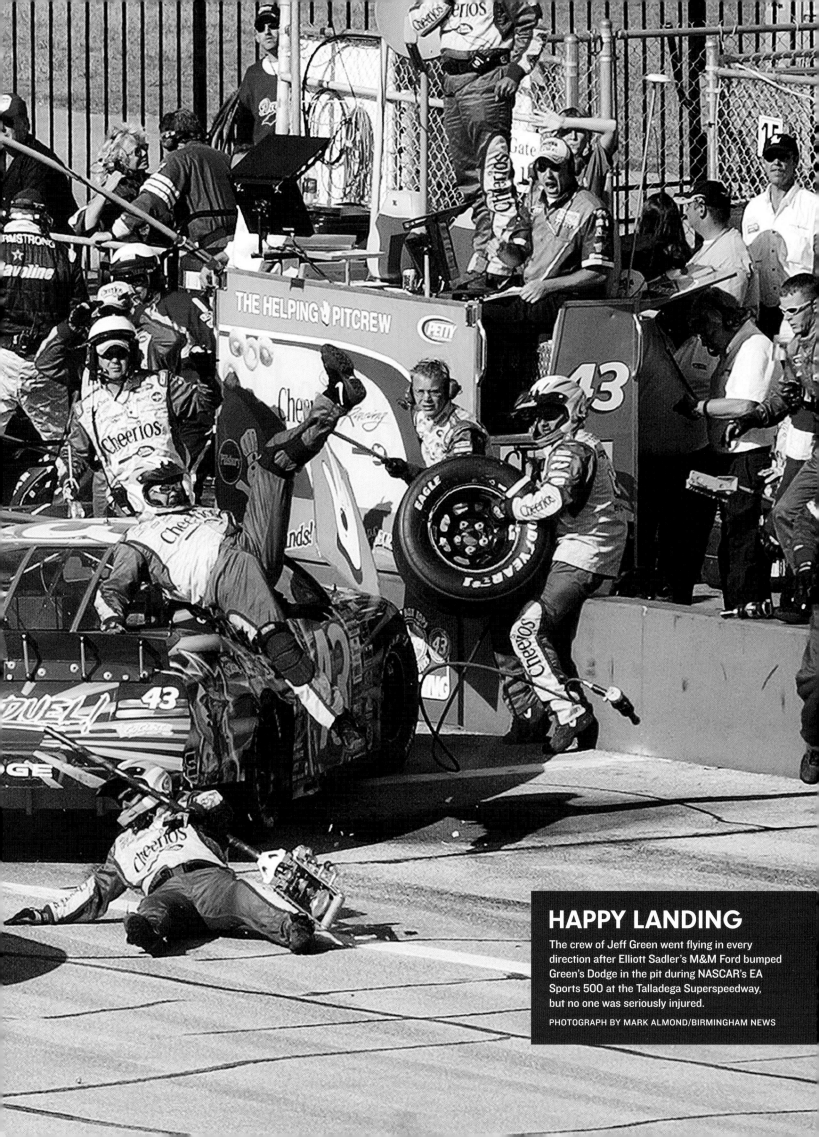

HAPPY LANDING

The crew of Jeff Green went flying in every direction after Elliott Sadler's M&M Ford bumped Green's Dodge in the pit during NASCAR's EA Sports 500 at the Talladega Superspeedway, but no one was seriously injured.

PHOTOGRAPH BY MARK ALMOND/BIRMINGHAM NEWS

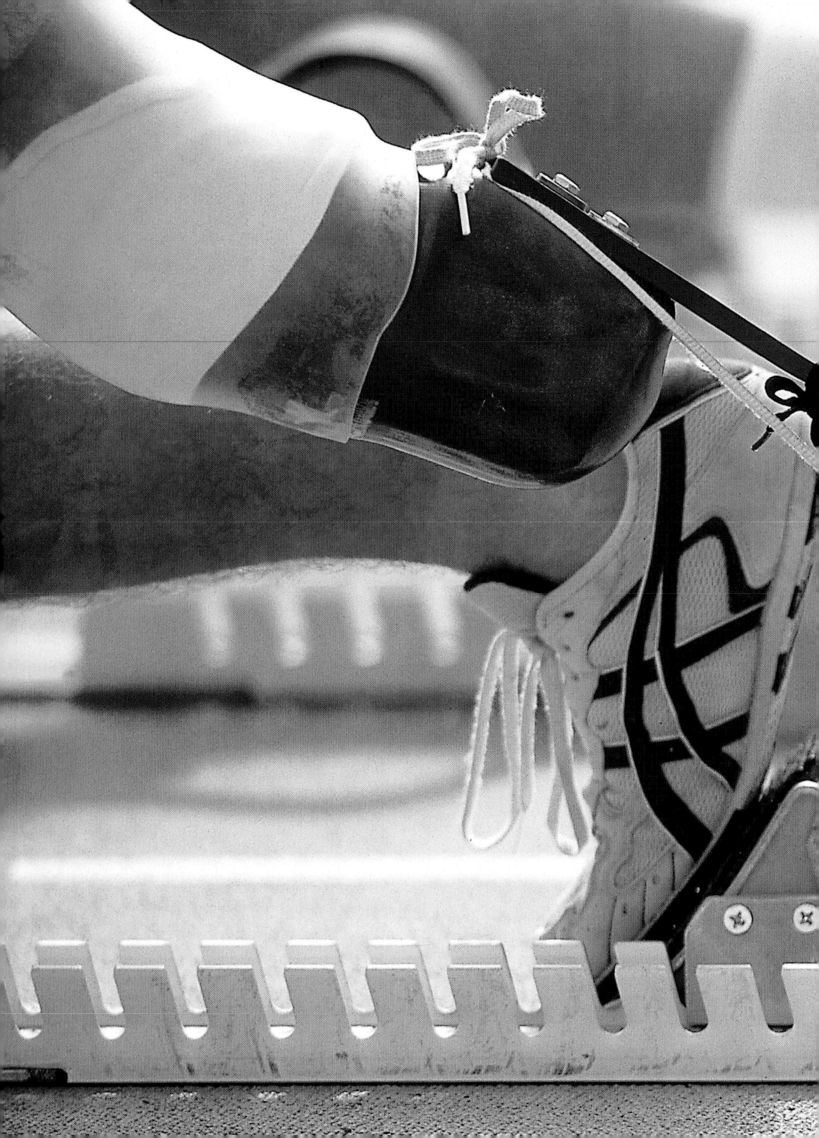

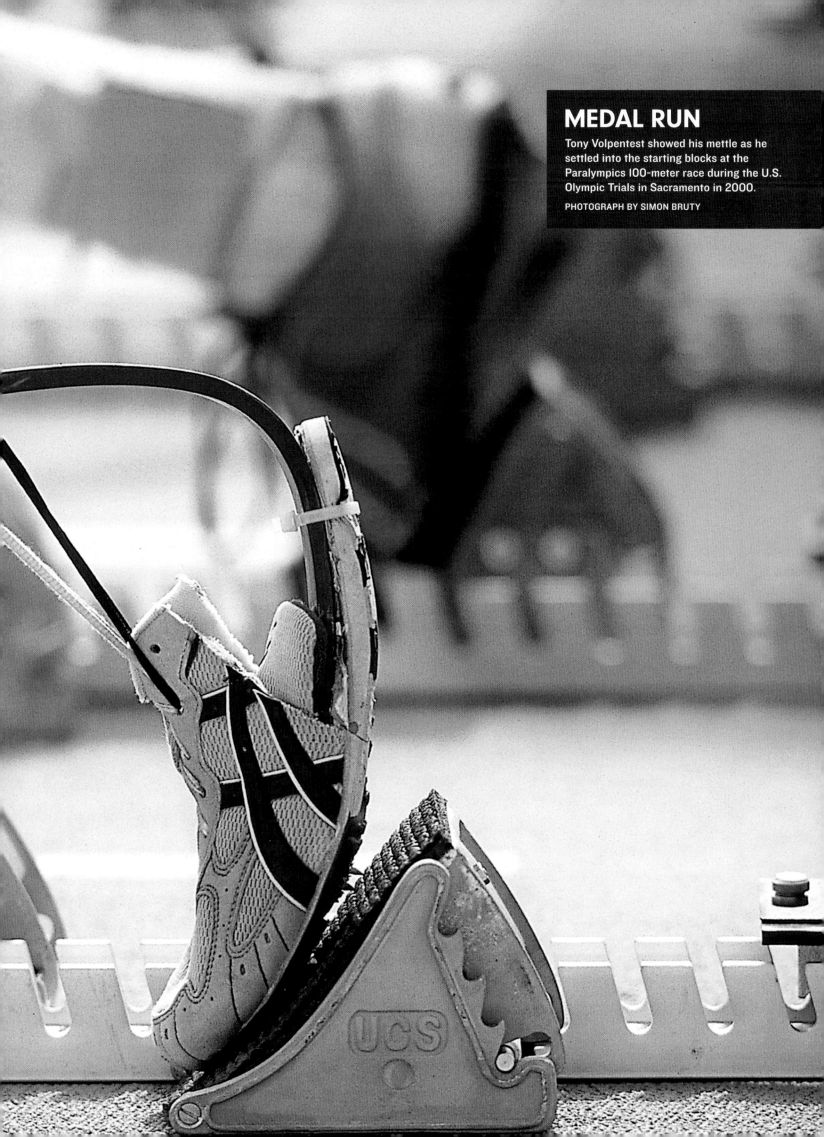

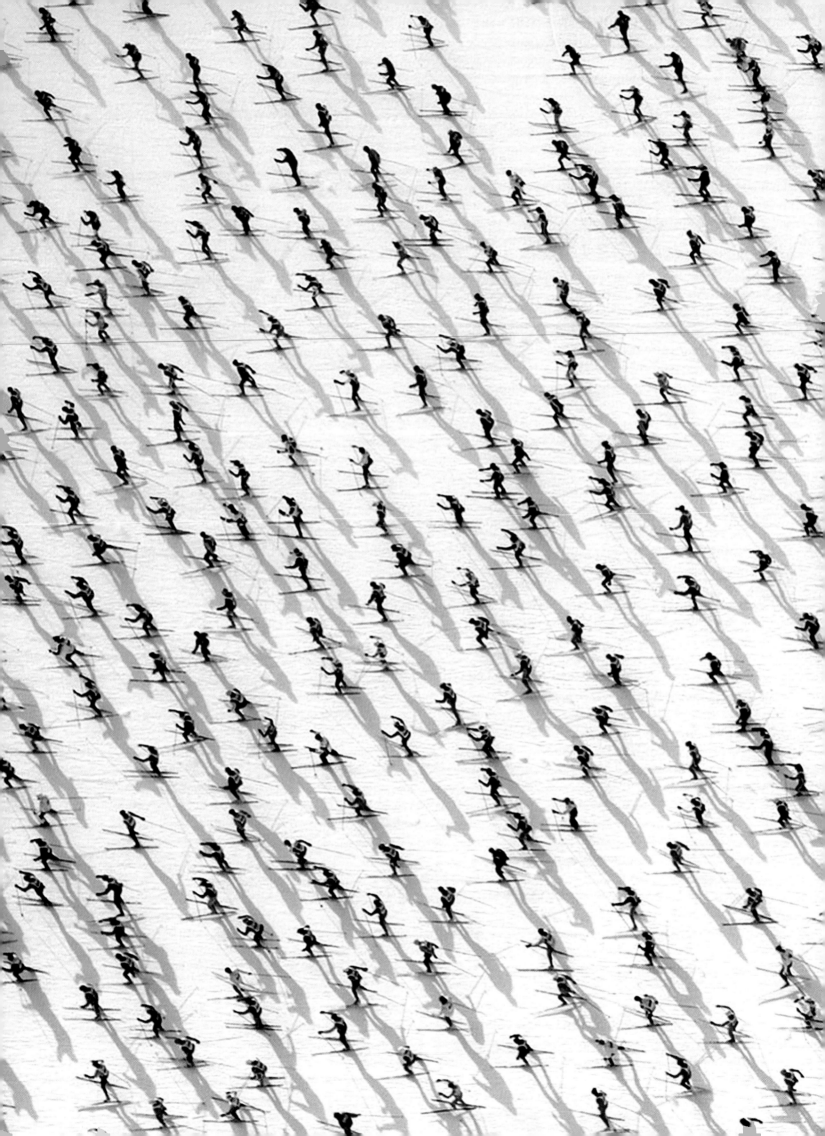

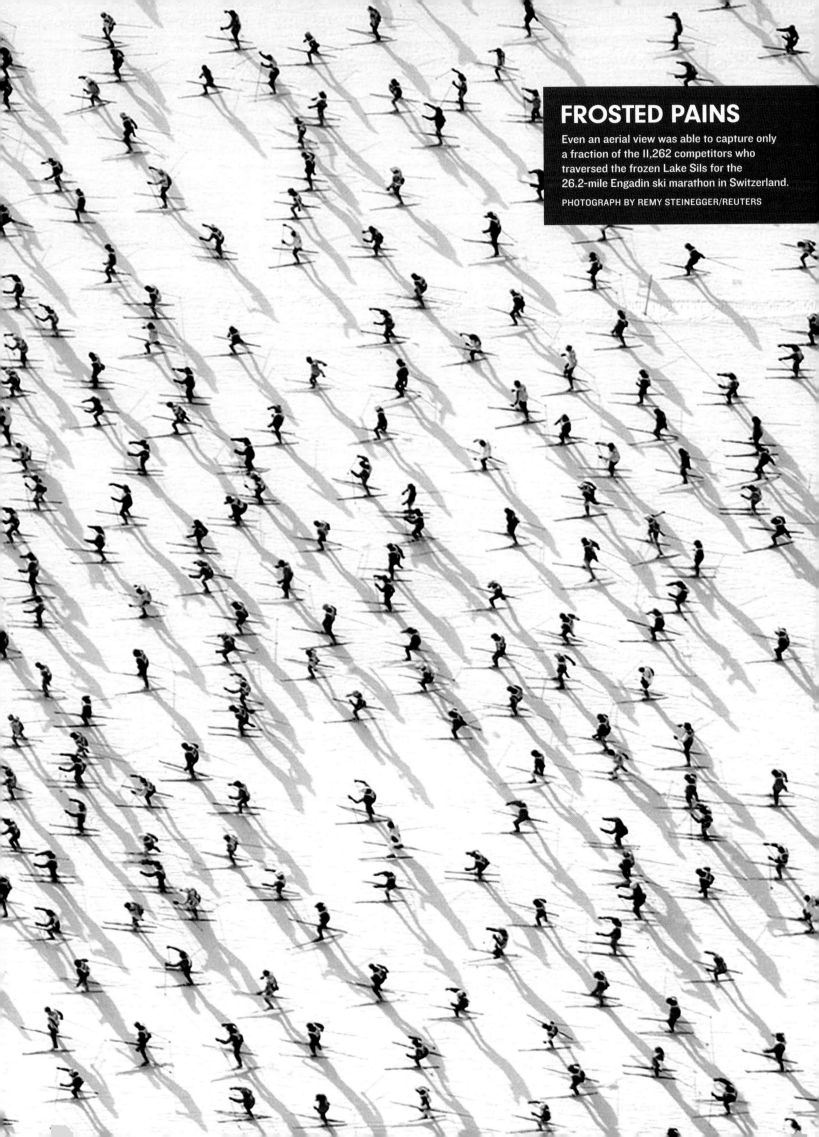

FROSTED PAINS

Even an aerial view was able to capture only a fraction of the 11,262 competitors who traversed the frozen Lake Sils for the 26.2-mile Engadin ski marathon in Switzerland.

PHOTOGRAPH BY REMY STEINEGGER/REUTERS

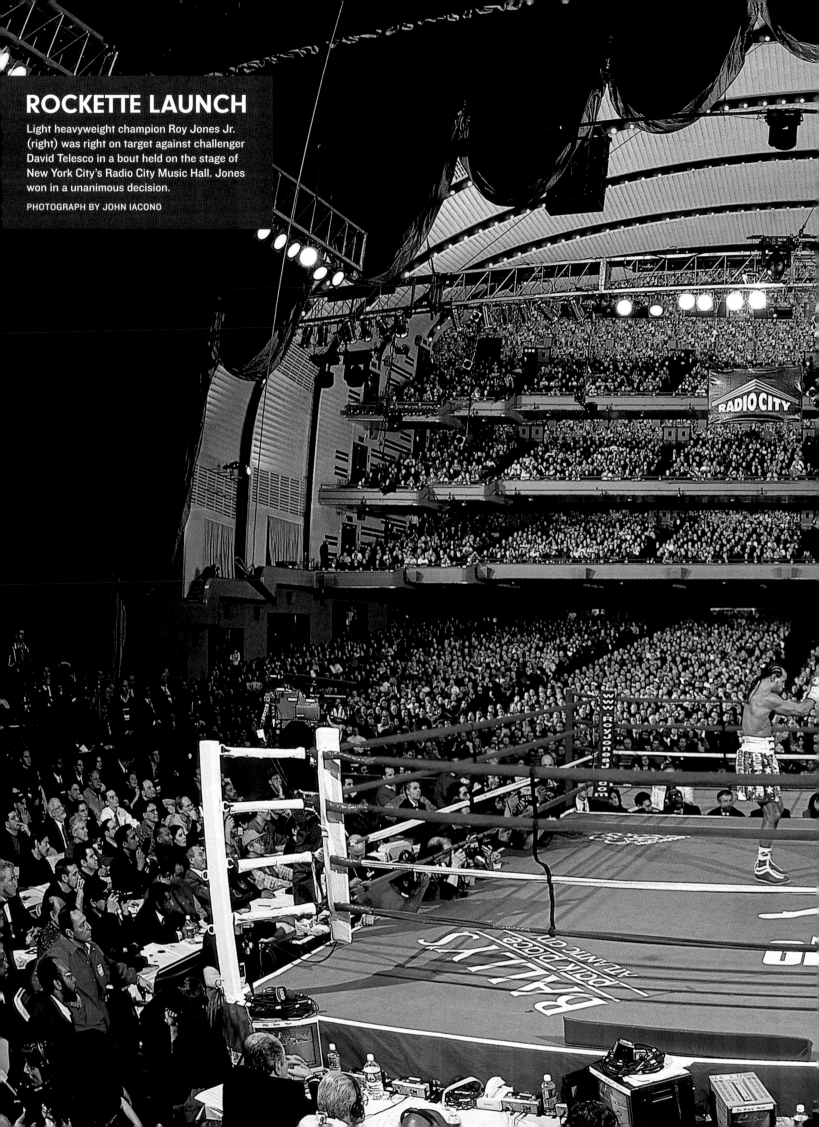

ROCKETTE LAUNCH

Light heavyweight champion Roy Jones Jr. (right) was right on target against challenger David Telesco in a bout held on the stage of New York City's Radio City Music Hall. Jones won in a unanimous decision.

PHOTOGRAPH BY JOHN IACONO

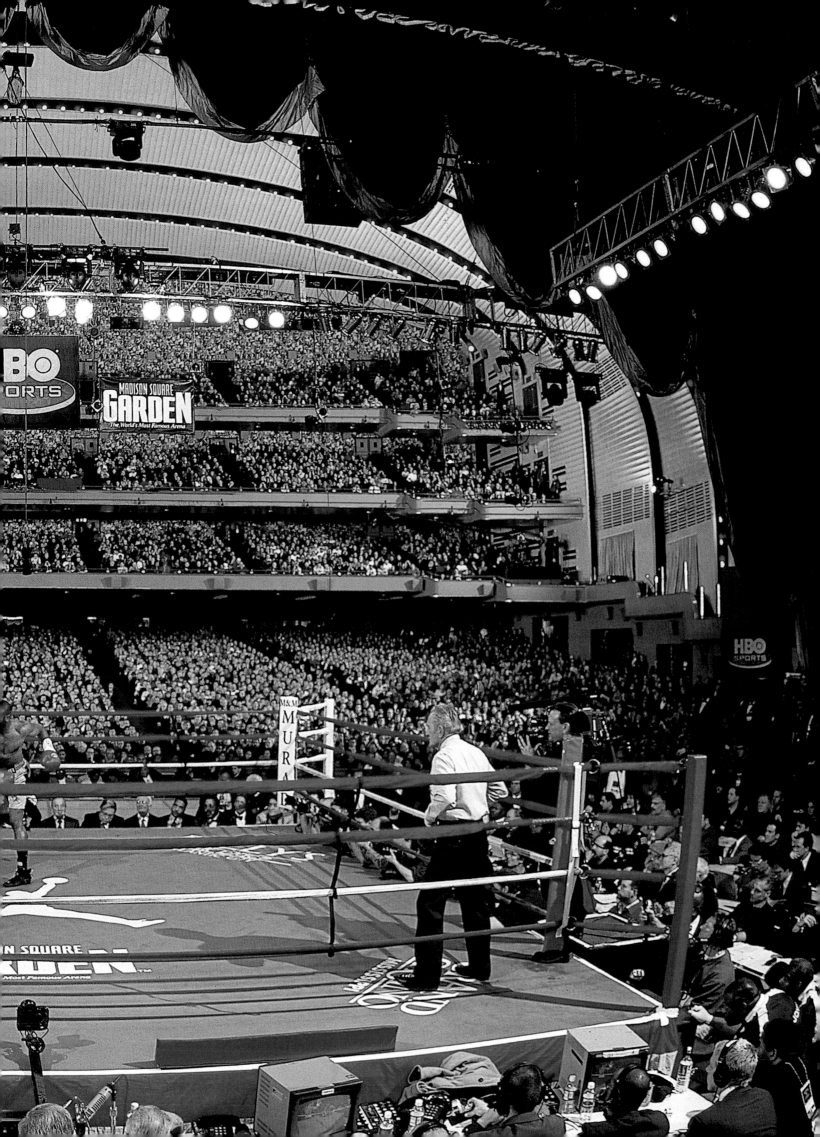

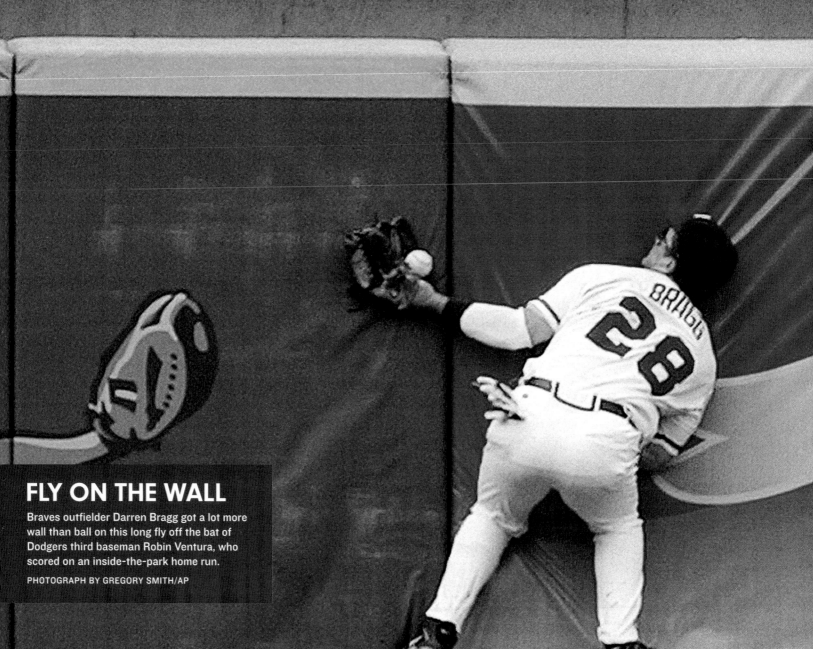

FLY ON THE WALL

Braves outfielder Darren Bragg got a lot more wall than ball on this long fly off the bat of Dodgers third baseman Robin Ventura, who scored on an inside-the-park home run.

PHOTOGRAPH BY GREGORY SMITH/AP

—BY E.M. SWIFT *Sports Illustrated 3/4/02*

GOING INTO THE FINAL PROGRAM, Sarah Hughes was fourth in the standings. In her eyes was a spark of fire, maybe anger. This was no timid ice princess. She wasn't thinking about medals, she was thinking: I'll show them. She was angry, all right. . . . She landed her first double Axel and began feeding off the crowd's roars. She landed her triple Salchow–triple loop combination, the most difficult jump any woman did that night. She was gaining momentum, but she still hadn't done enough. To move from fourth to first, you must make history. Midway through her program, Hughes did precisely that when she landed her second triple triple. The rest of her program was a blur of giddiness and joy. Hughes was screaming from her heart, "I love skating!" Flowers and toys and thunderous applause rained down seconds after she ended her final spin, and she exchanged an eye-popping look of disbelief with her coach. "What did I just do?" she seemed to ask. . . .

Sarah Hughes flies toward her gold medal in the 2002 Winter Olympics. PHOTOGRAPH BY SIMON BRUTY

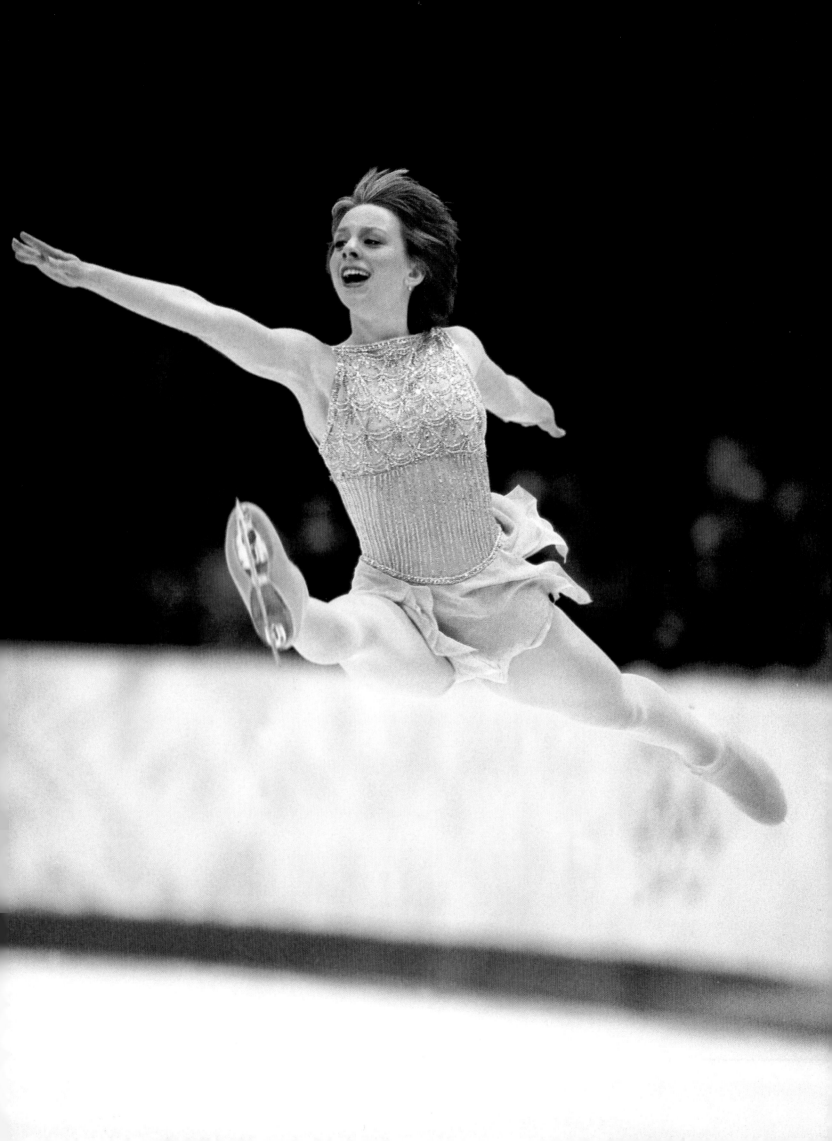

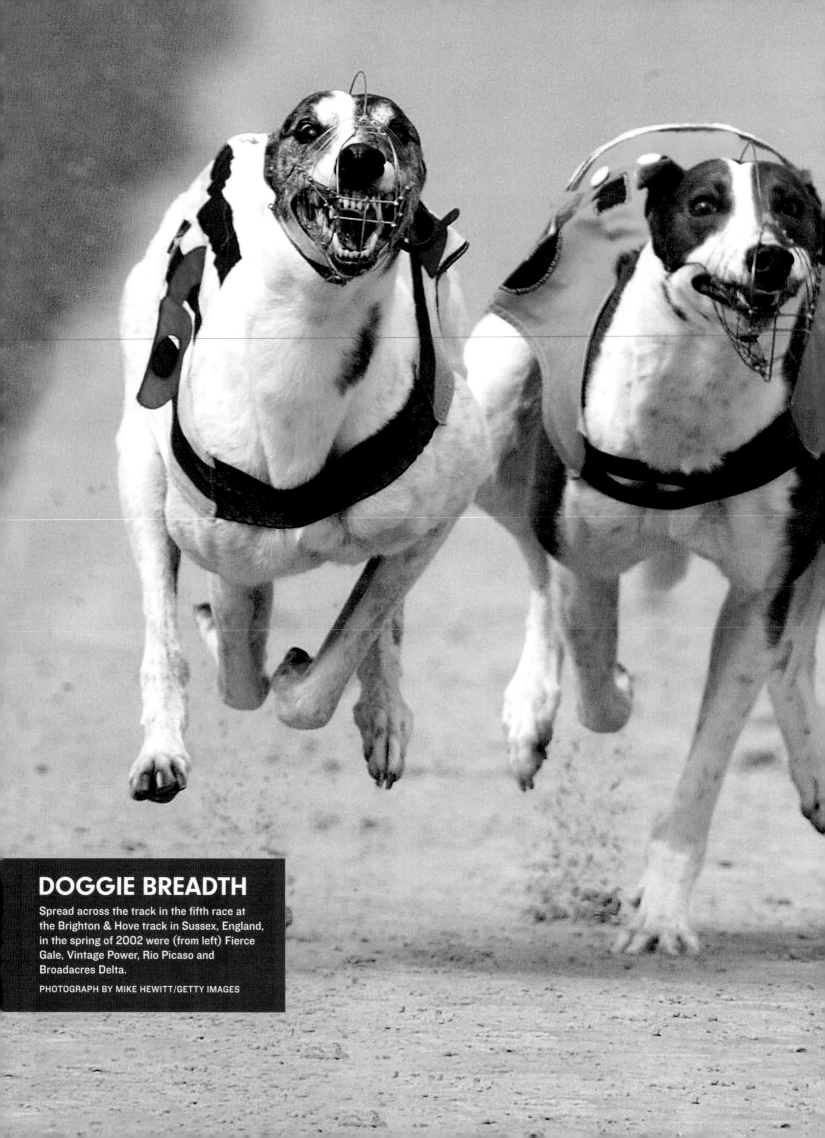

DOGGIE BREADTH

Spread across the track in the fifth race at the Brighton & Hove track in Sussex, England, in the spring of 2002 were (from left) Fierce Gale, Vintage Power, Rio Picaso and Broadacres Delta.

PHOTOGRAPH BY MIKE HEWITT/GETTY IMAGES

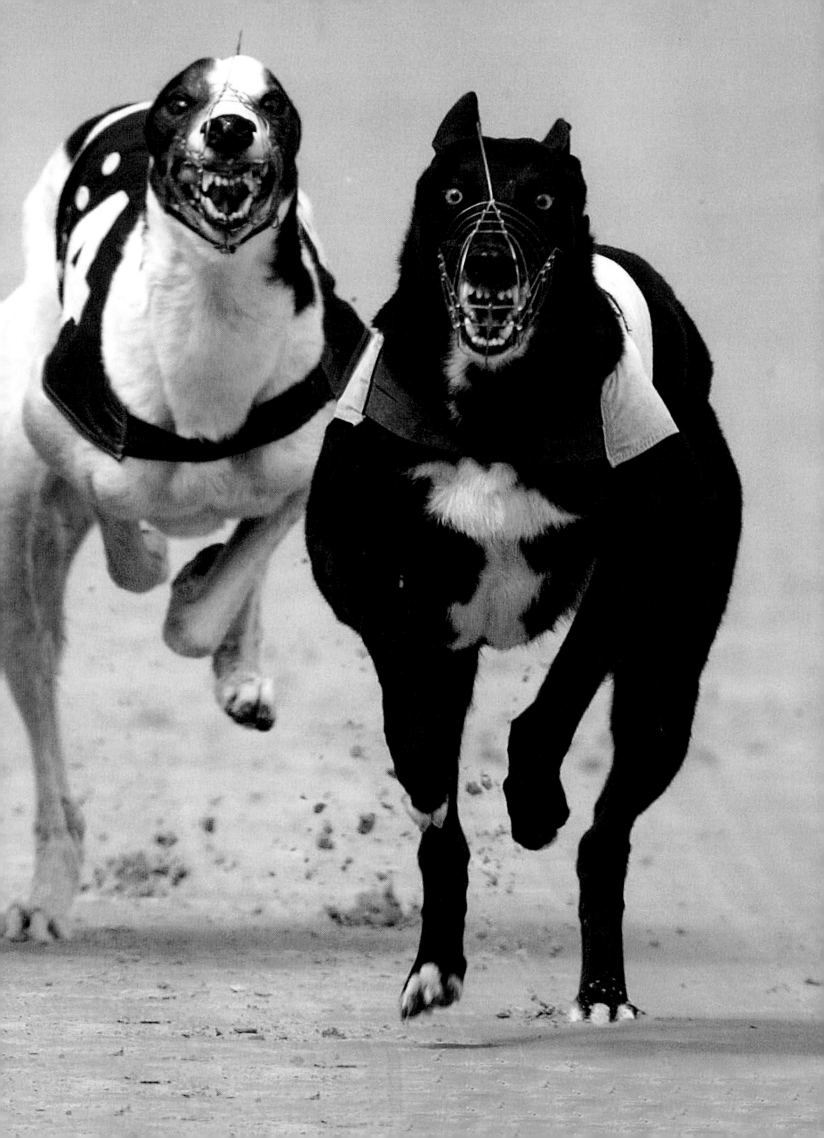

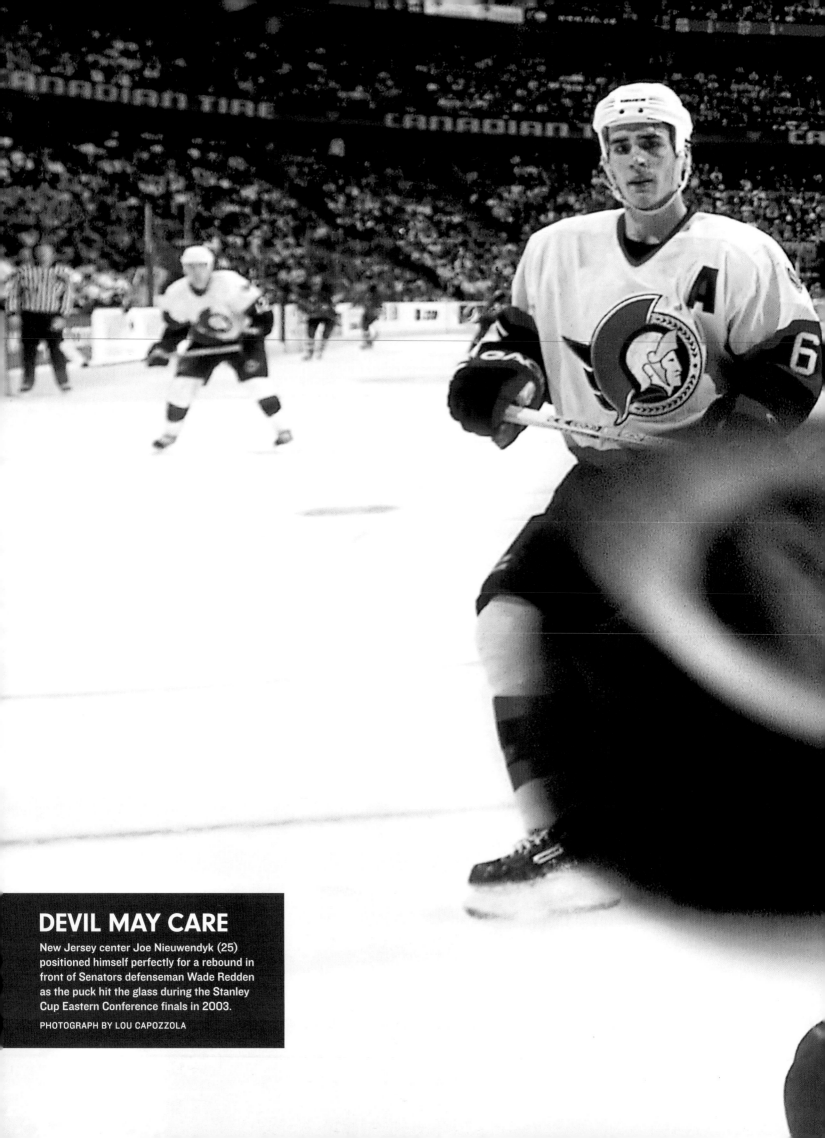

DEVIL MAY CARE

New Jersey center Joe Nieuwendyk (25) positioned himself perfectly for a rebound in front of Senators defenseman Wade Redden as the puck hit the glass during the Stanley Cup Eastern Conference finals in 2003.

PHOTOGRAPH BY LOU CAPOZZOLA

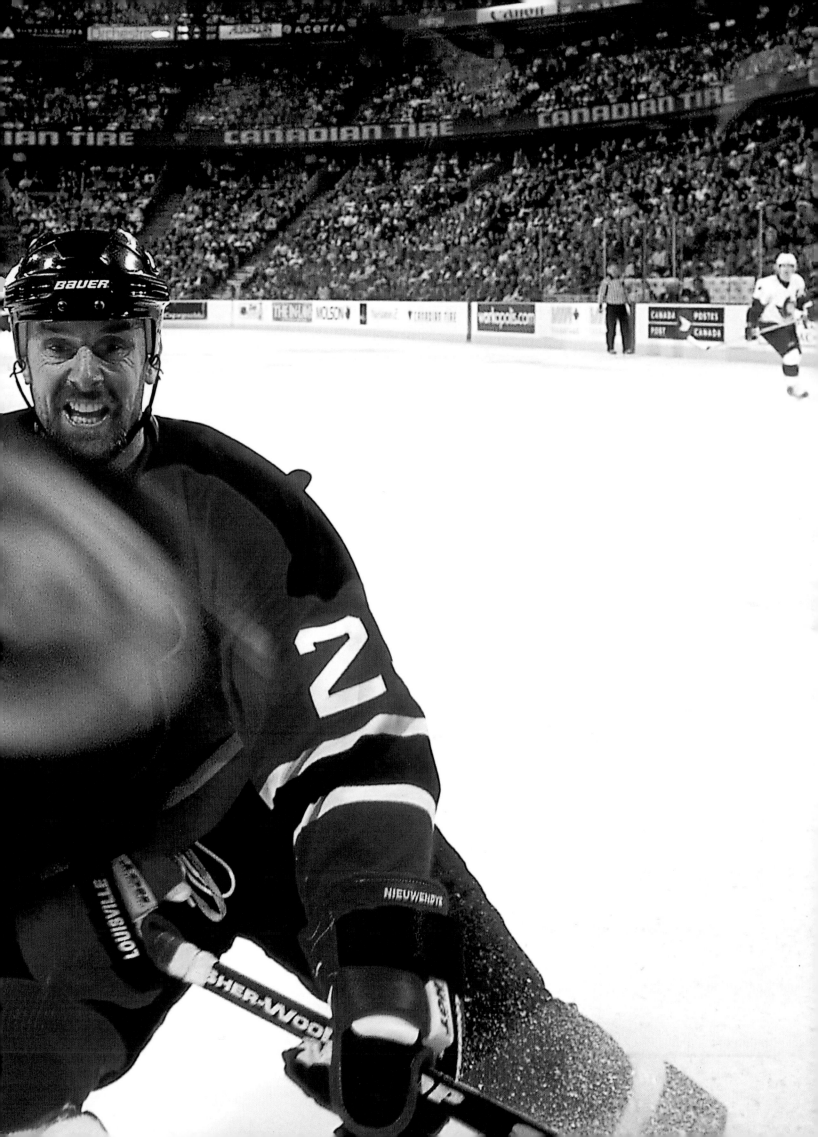

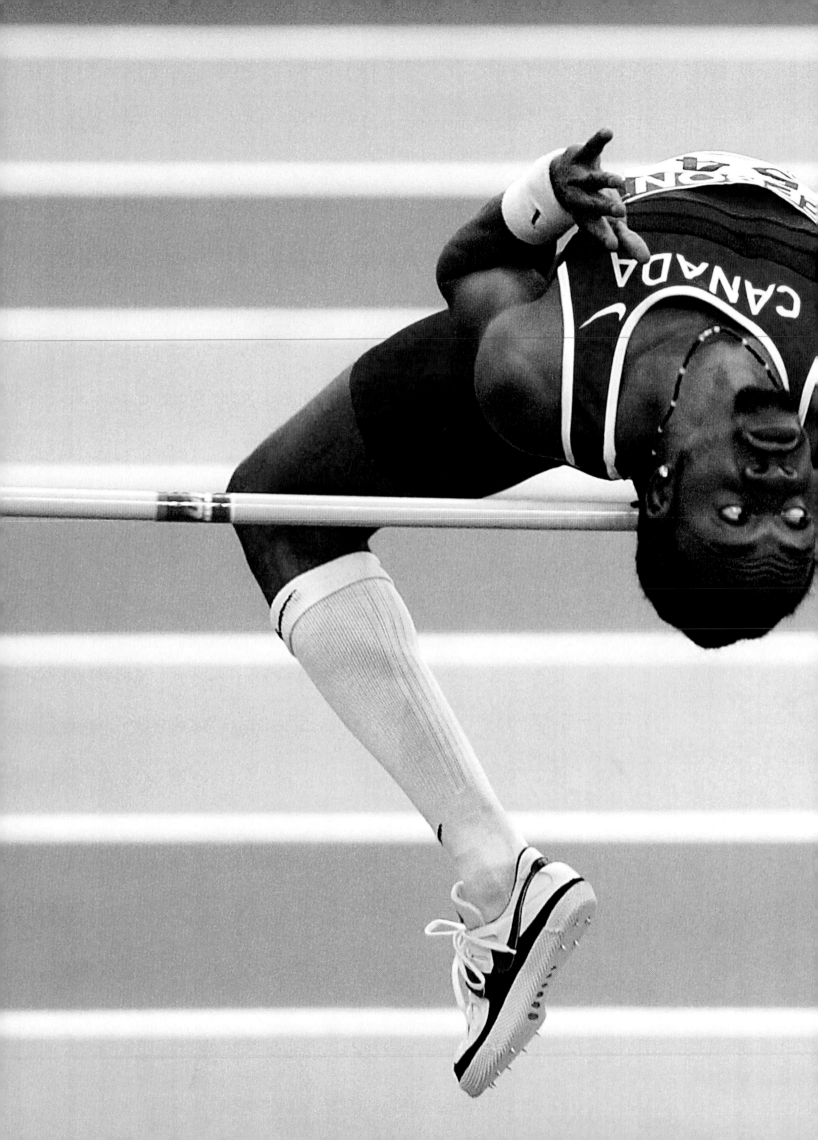

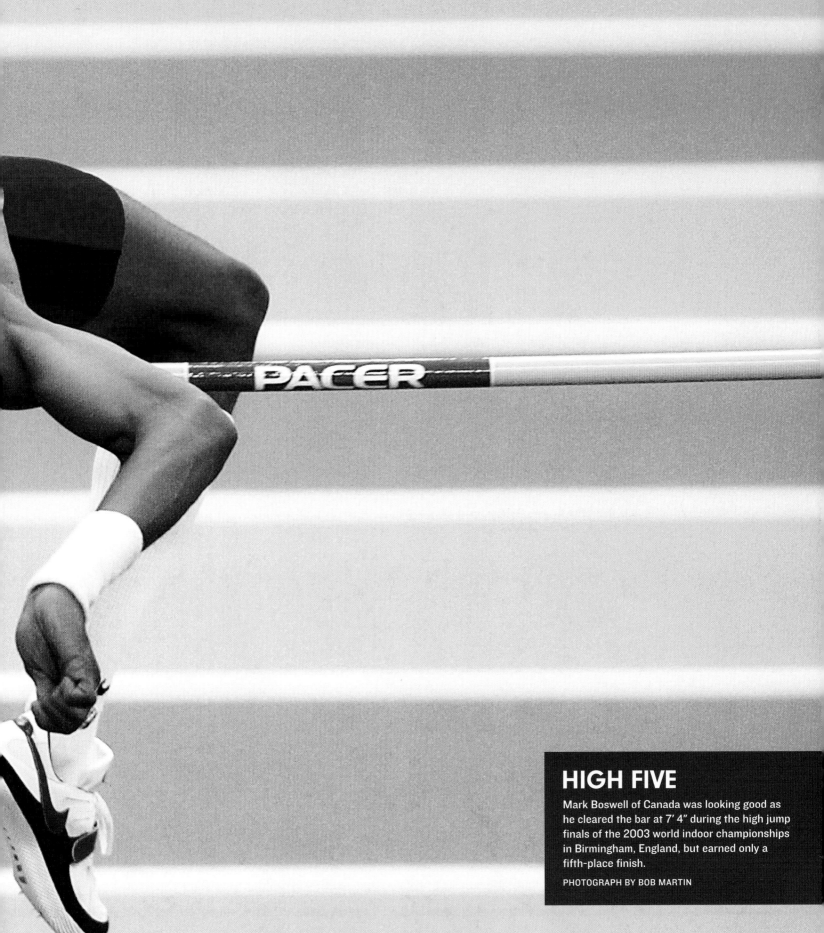

HIGH FIVE

Mark Boswell of Canada was looking good as he cleared the bar at 7′ 4″ during the high jump finals of the 2003 world indoor championships in Birmingham, England, but earned only a fifth-place finish.

PHOTOGRAPH BY BOB MARTIN

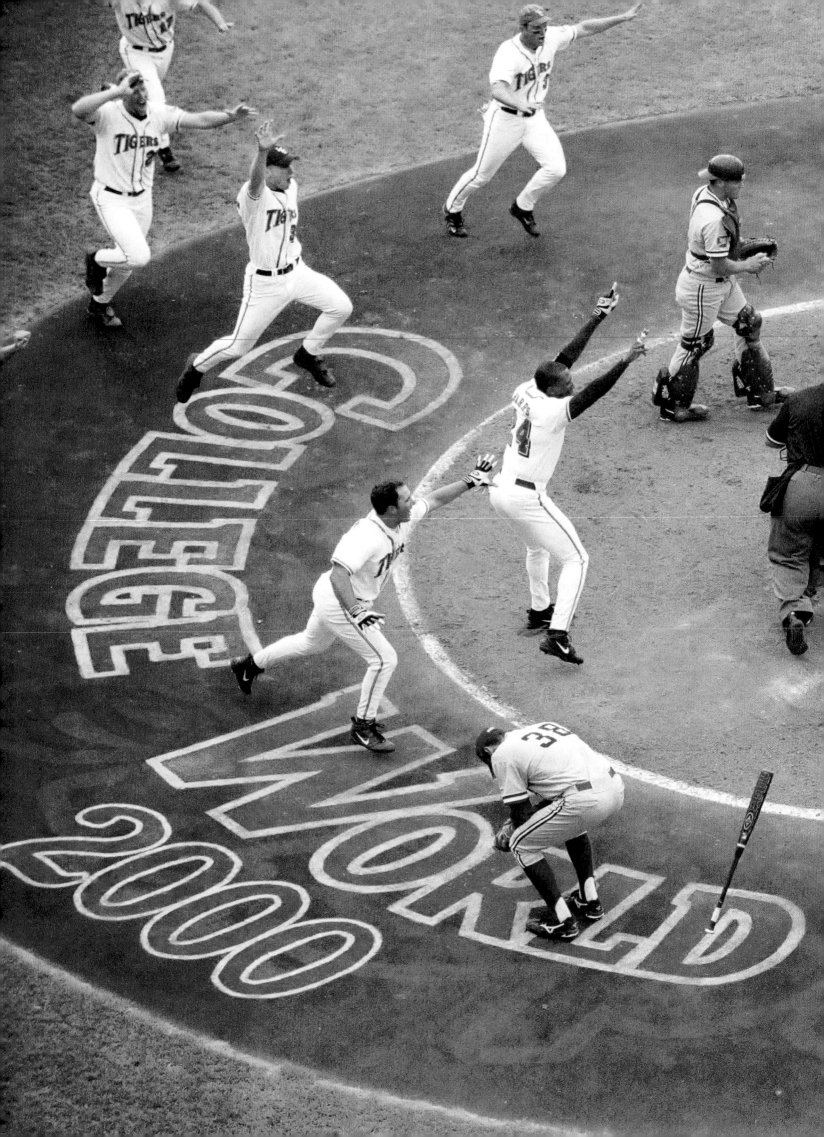

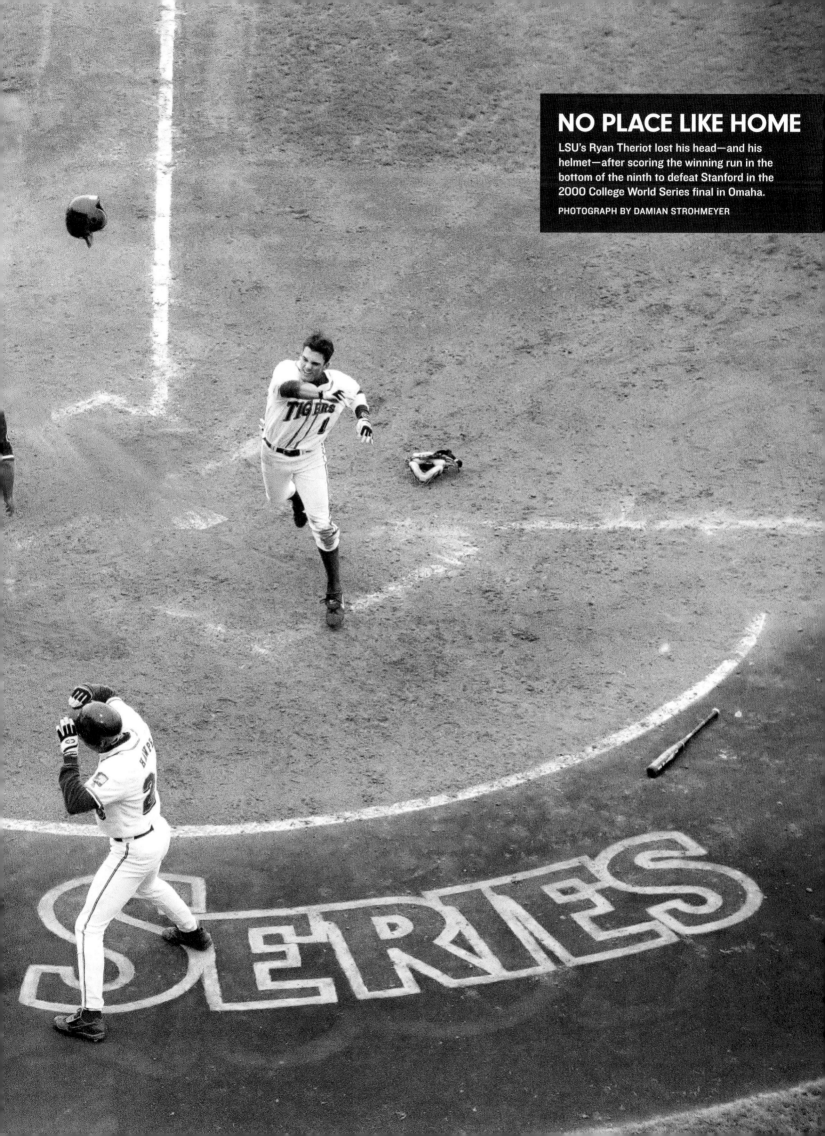

NO PLACE LIKE HOME

LSU's Ryan Theriot lost his head—and his helmet—after scoring the winning run in the bottom of the ninth to defeat Stanford in the 2000 College World Series final in Omaha.

PHOTOGRAPH BY DAMIAN STROHMEYER

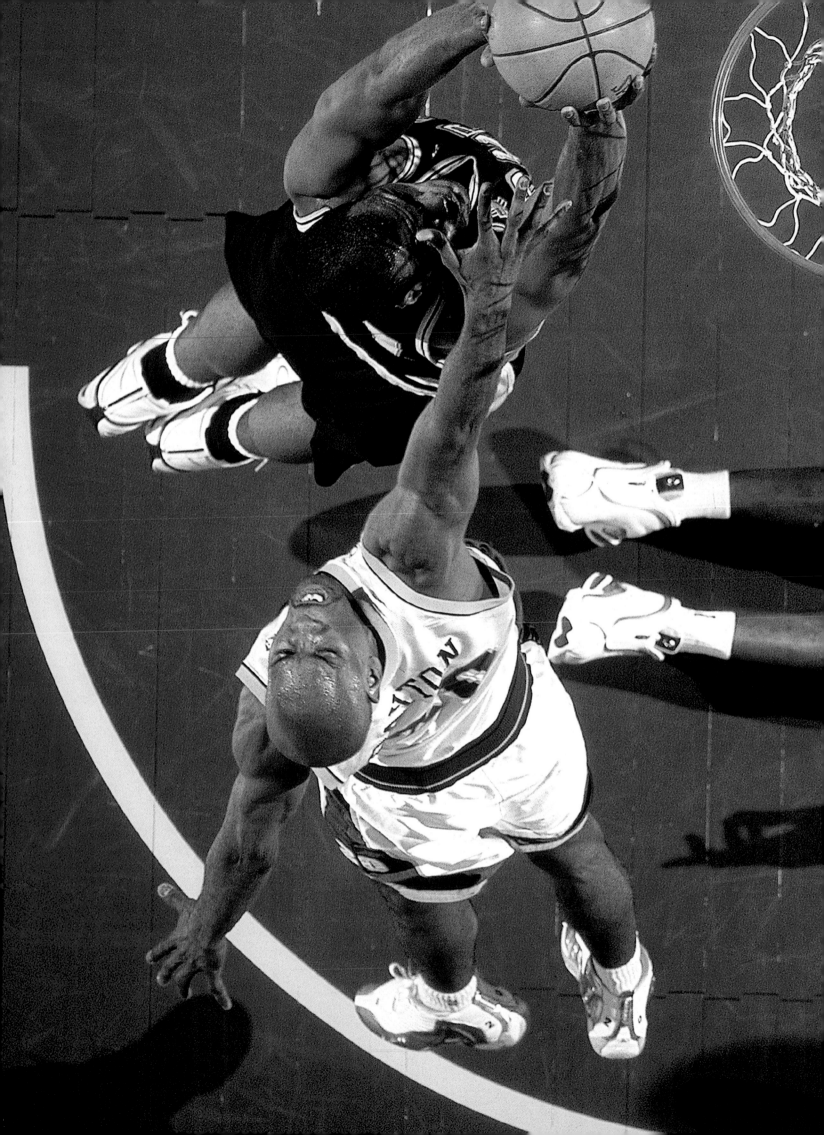

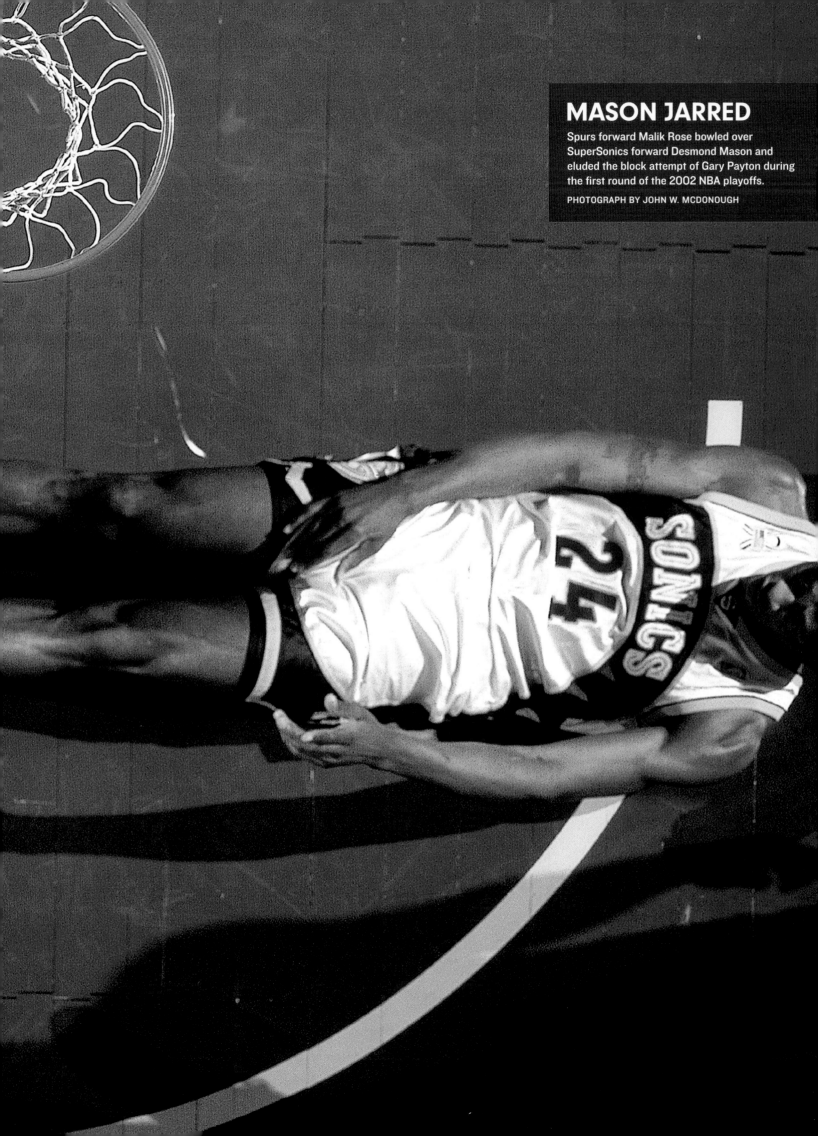

MASON JARRED

Spurs forward Malik Rose bowled over SuperSonics forward Desmond Mason and eluded the block attempt of Gary Payton during the first round of the 2002 NBA playoffs.

PHOTOGRAPH BY JOHN W. MCDONOUGH

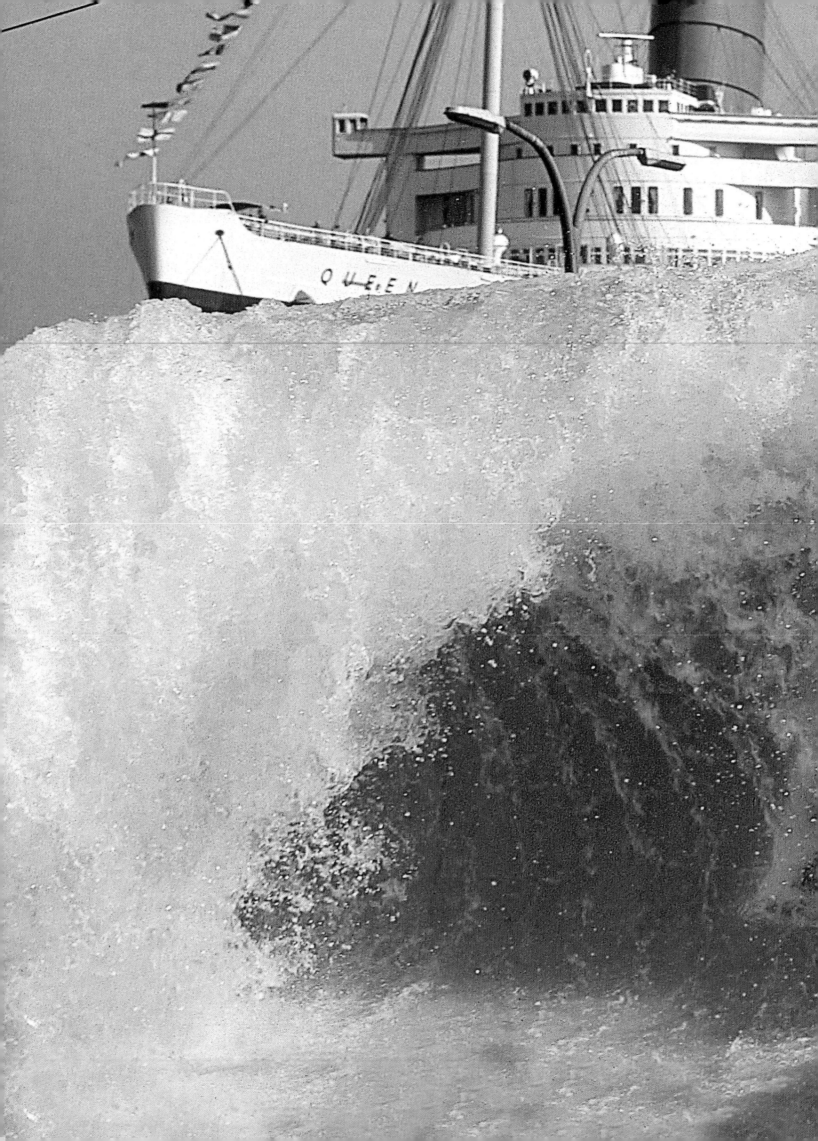

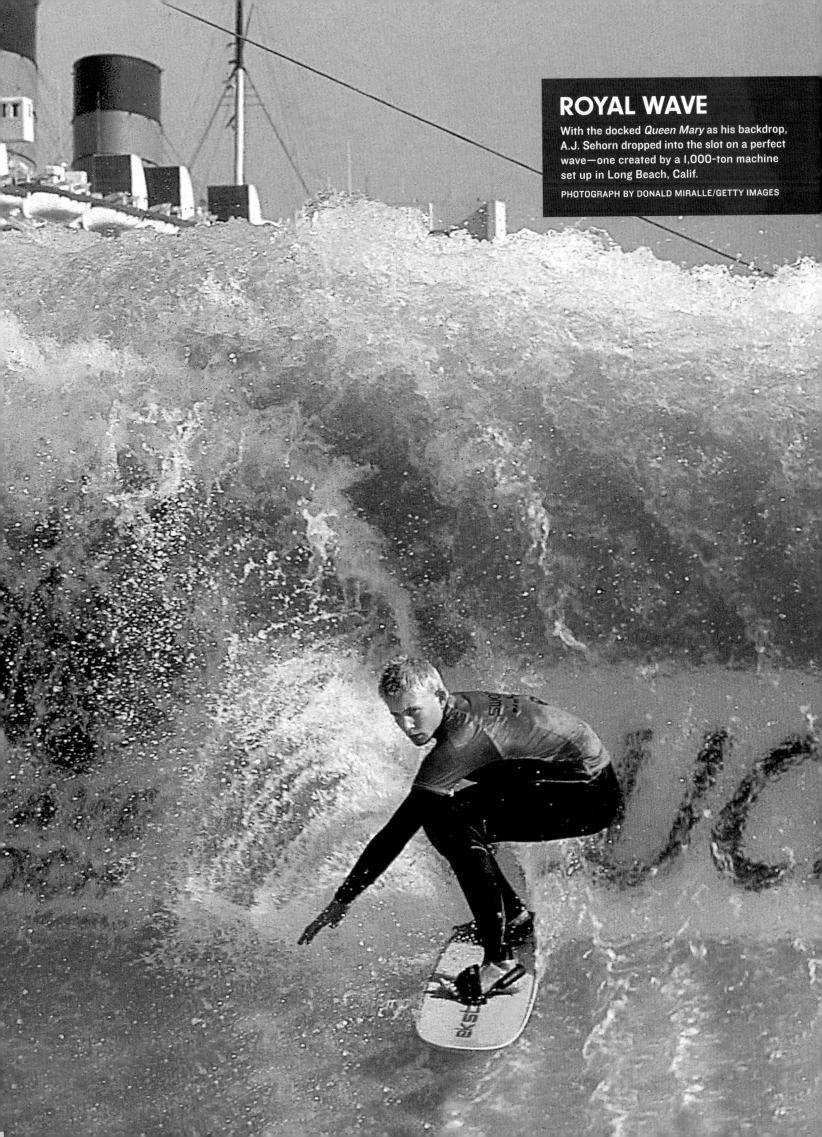

ROYAL WAVE

With the docked *Queen Mary* as his backdrop, A.J. Sehorn dropped into the slot on a perfect wave—one created by a 1,000-ton machine set up in Long Beach, Calif.

PHOTOGRAPH BY DONALD MIRALLE/GETTY IMAGES

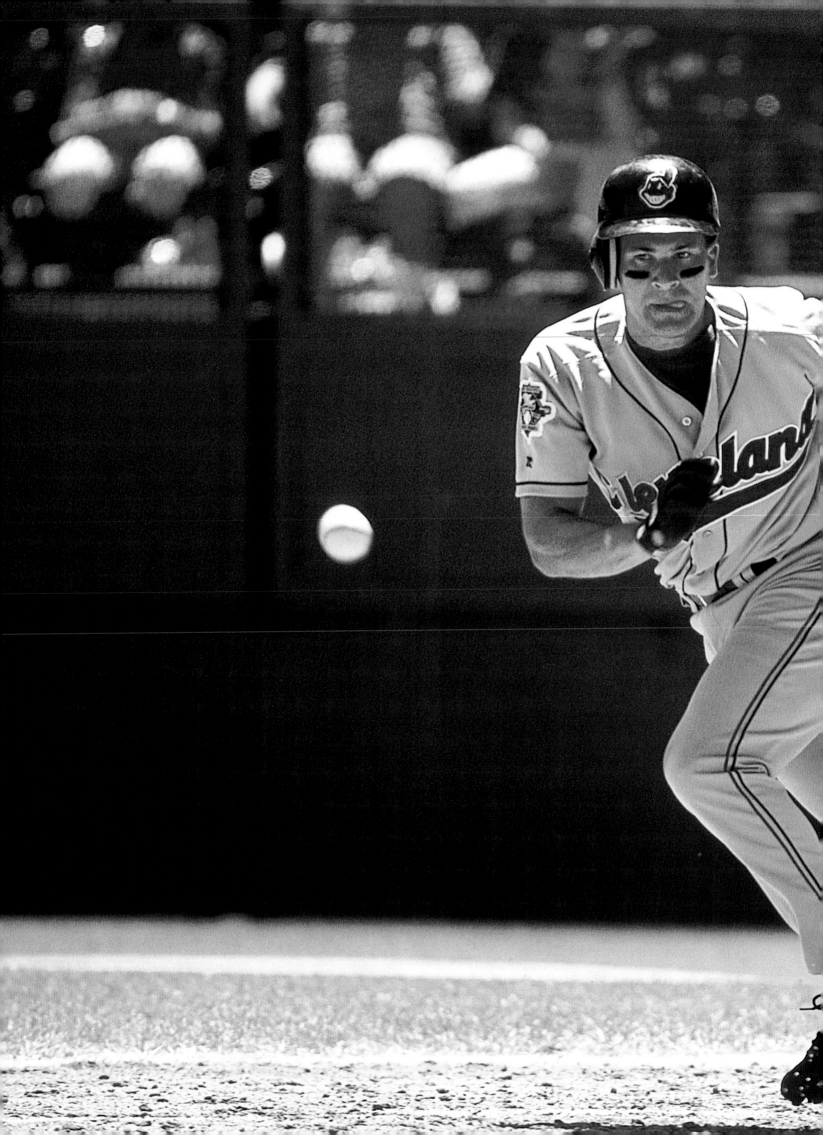

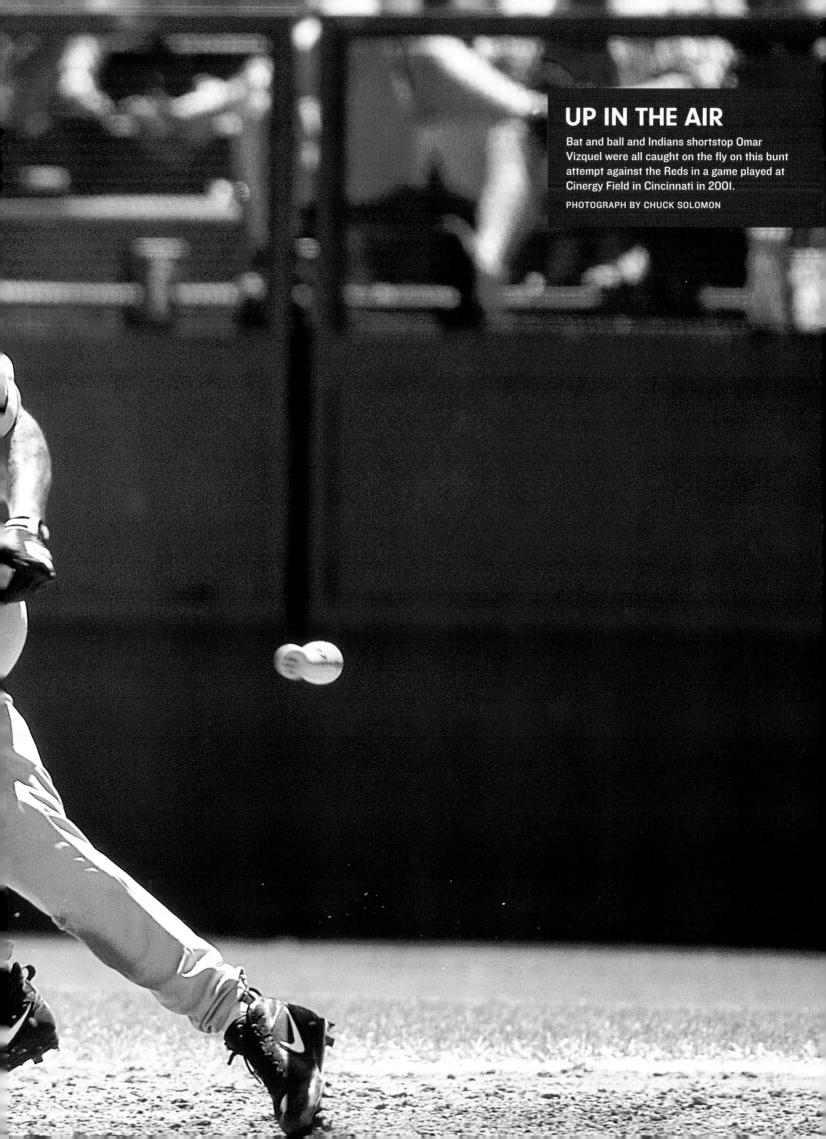

UP IN THE AIR

Bat and ball and Indians shortstop Omar Vizquel were all caught on the fly on this bunt attempt against the Reds in a game played at Cinergy Field in Cincinnati in 2001.

PHOTOGRAPH BY CHUCK SOLOMON

—BY S.L. PRICE *Sports Illustrated 9/16/02*

FOR SO LONG HE HADN'T NEEDED ANY of it: not the support of the fans, not the presence of family, not the on-court histrionics. Pete Sampras did not scream, "That's what I'm talking about!" after winning a set in his prime, half a decade ago, and he didn't take motivation from words lovingly scribbled on a piece of paper. His was a cool and lonely march to greatness and if his body sometimes betrayed him with a strange fragility, his talent carried him time and again. He had his hair and his nerve then. Losing it all, bit by humiliating bit, didn't seem possible. At 7:38 on Sunday, Sampras glanced across the court at his oldest rival, lifted his left arm and tossed a tennis ball up into the cooling New York night. Two points away from a victory no one had predicted, about to hit a second serve against the greatest returner in the game, Sampras felt the wind at his back. His stomach began to churn. His mind raced: What if I miss? But this time, unlike so many times in the past two years, he didn't falter. He held nothing back. . . .

Pete Sampras wins his fifth U.S. Open. PHOTOGRAPH BY HEINZ KLUETMEIER

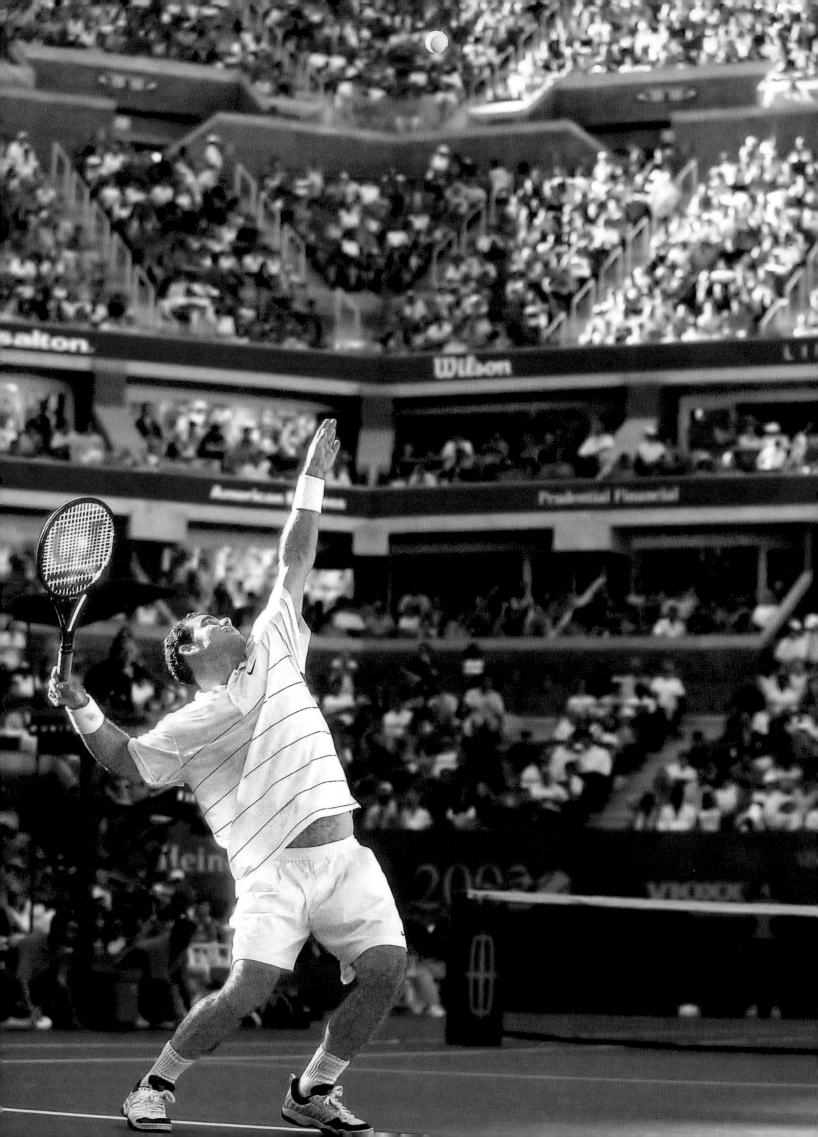

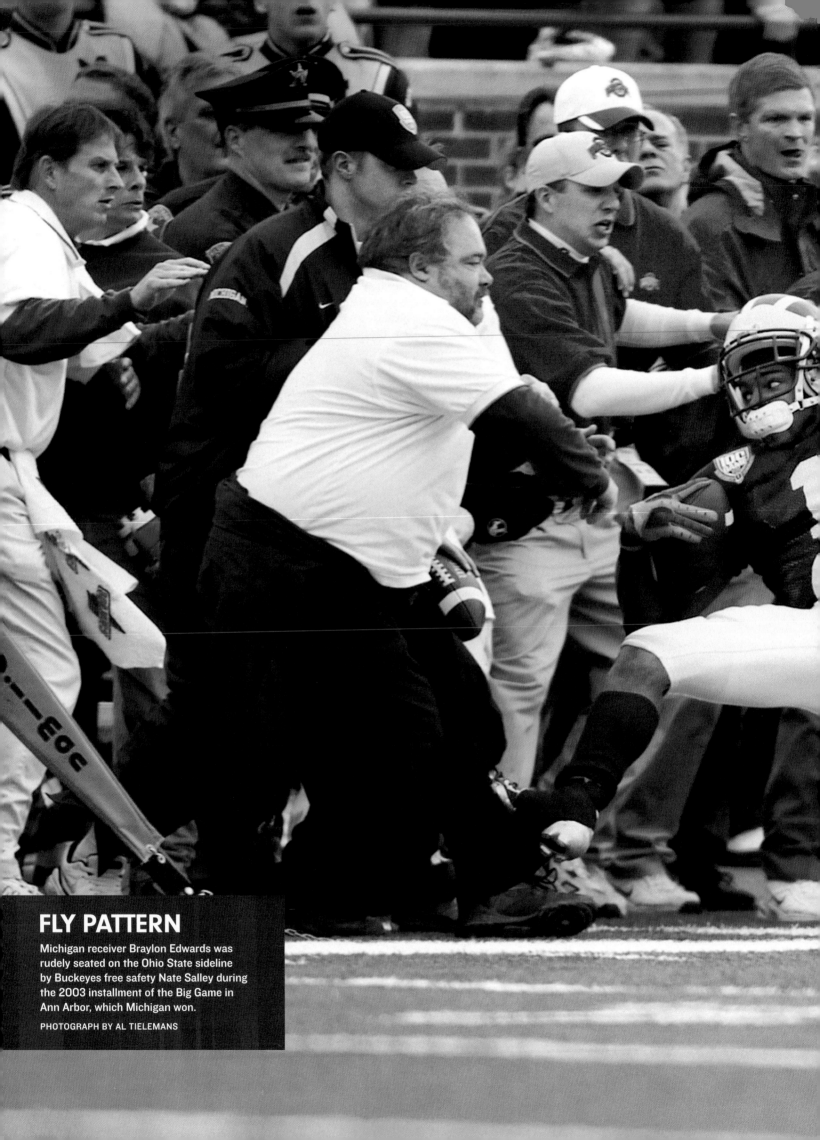

FLY PATTERN

Michigan receiver Braylon Edwards was rudely seated on the Ohio State sideline by Buckeyes free safety Nate Salley during the 2003 installment of the Big Game in Ann Arbor, which Michigan won.

PHOTOGRAPH BY AL TIELEMANS

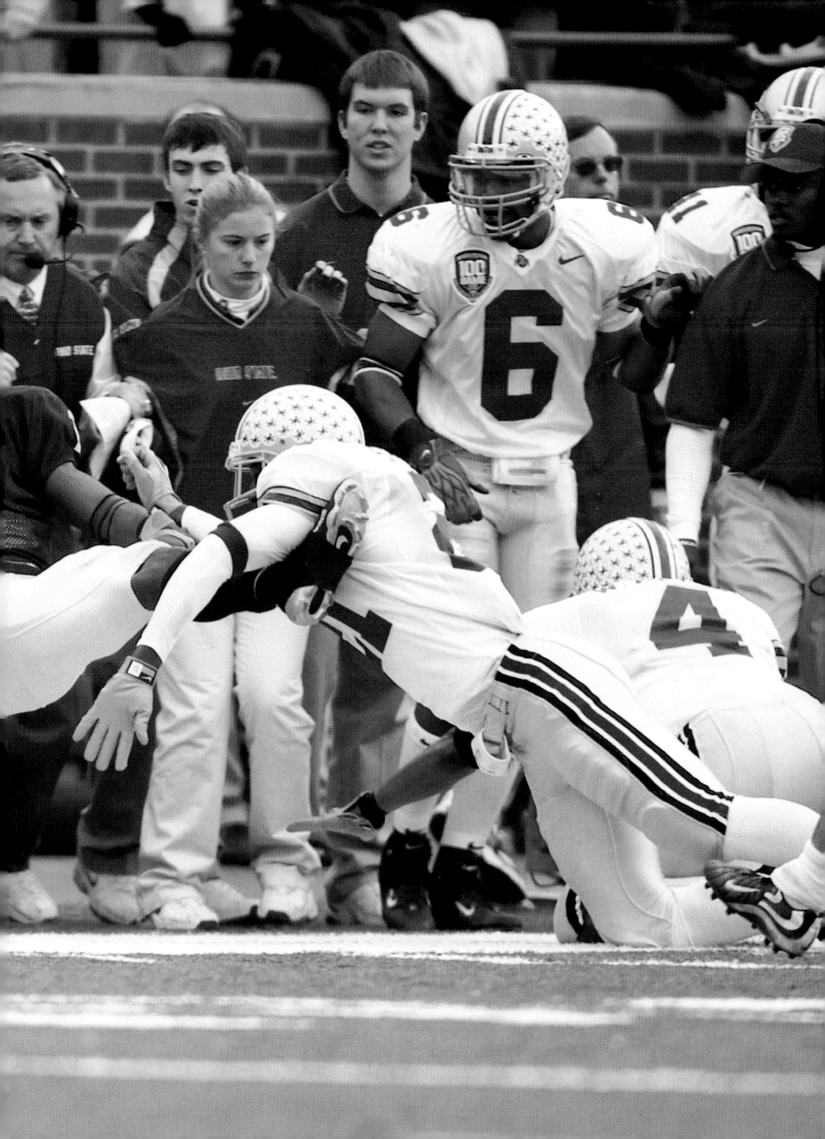

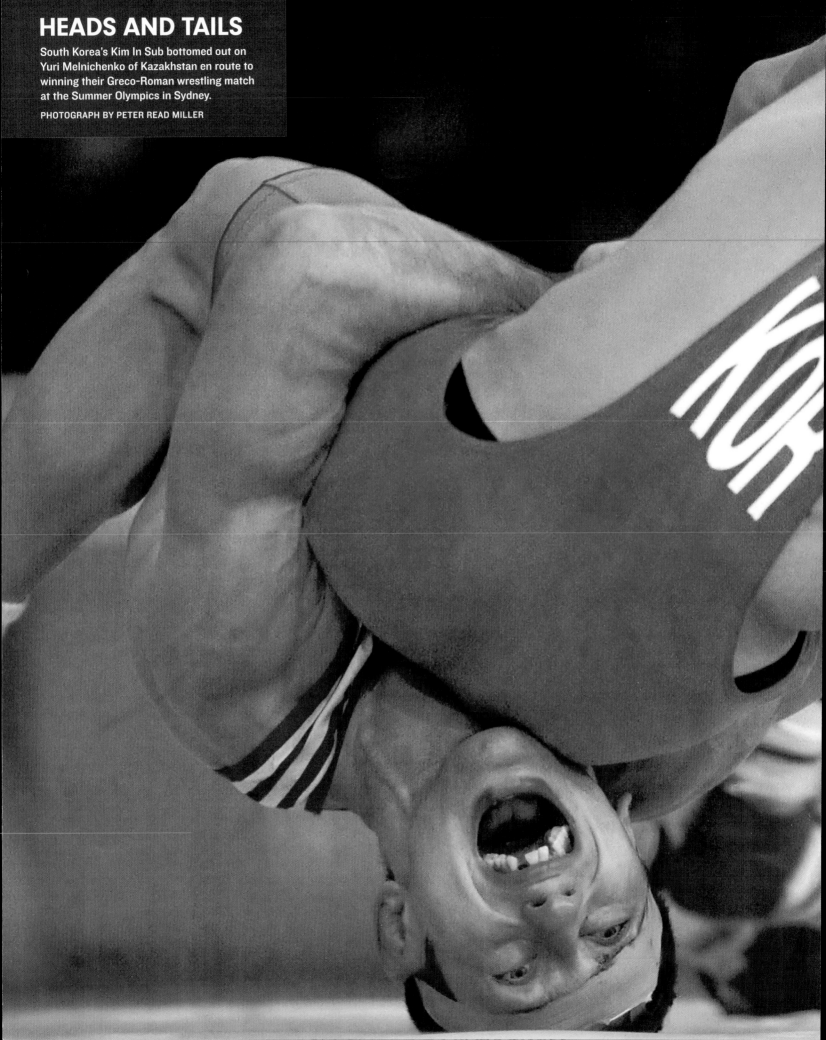

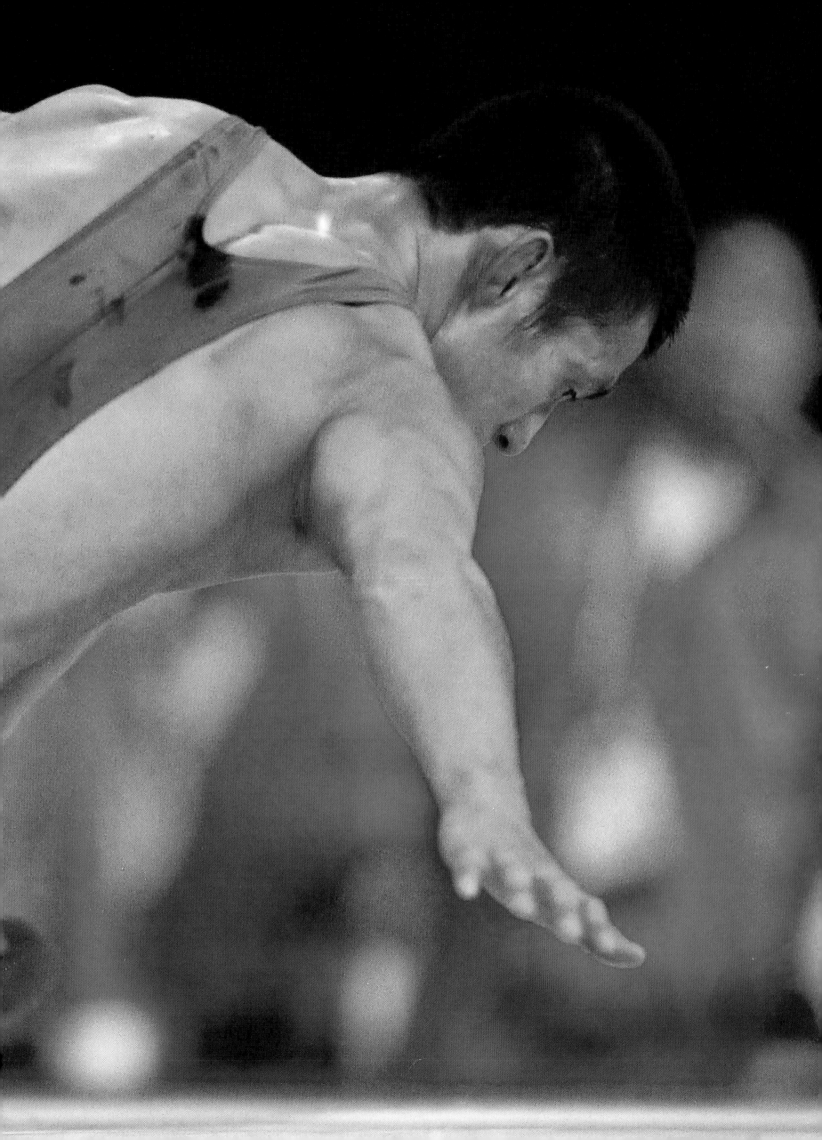

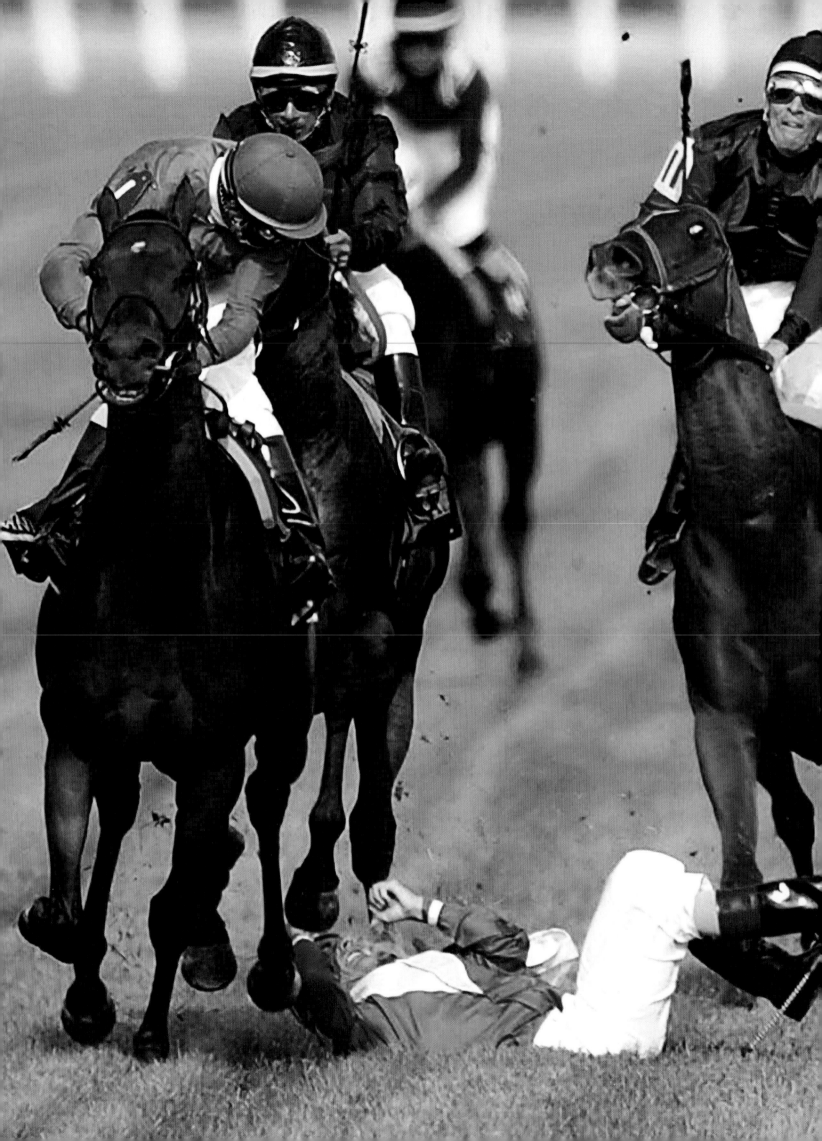

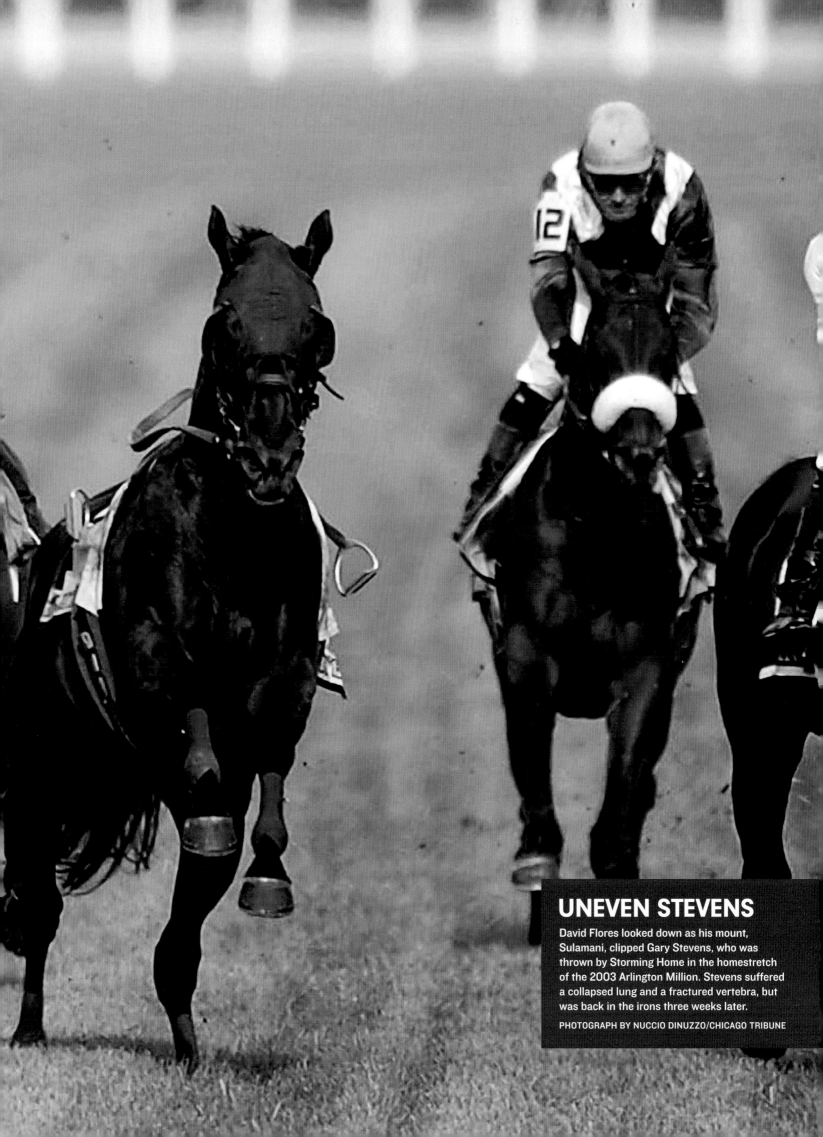

UNEVEN STEVENS

David Flores looked down as his mount, Sulamani, clipped Gary Stevens, who was thrown by Storming Home in the homestretch of the 2003 Arlington Million. Stevens suffered a collapsed lung and a fractured vertebra, but was back in the irons three weeks later.

PHOTOGRAPH BY NUCCIO DINUZZO/CHICAGO TRIBUNE

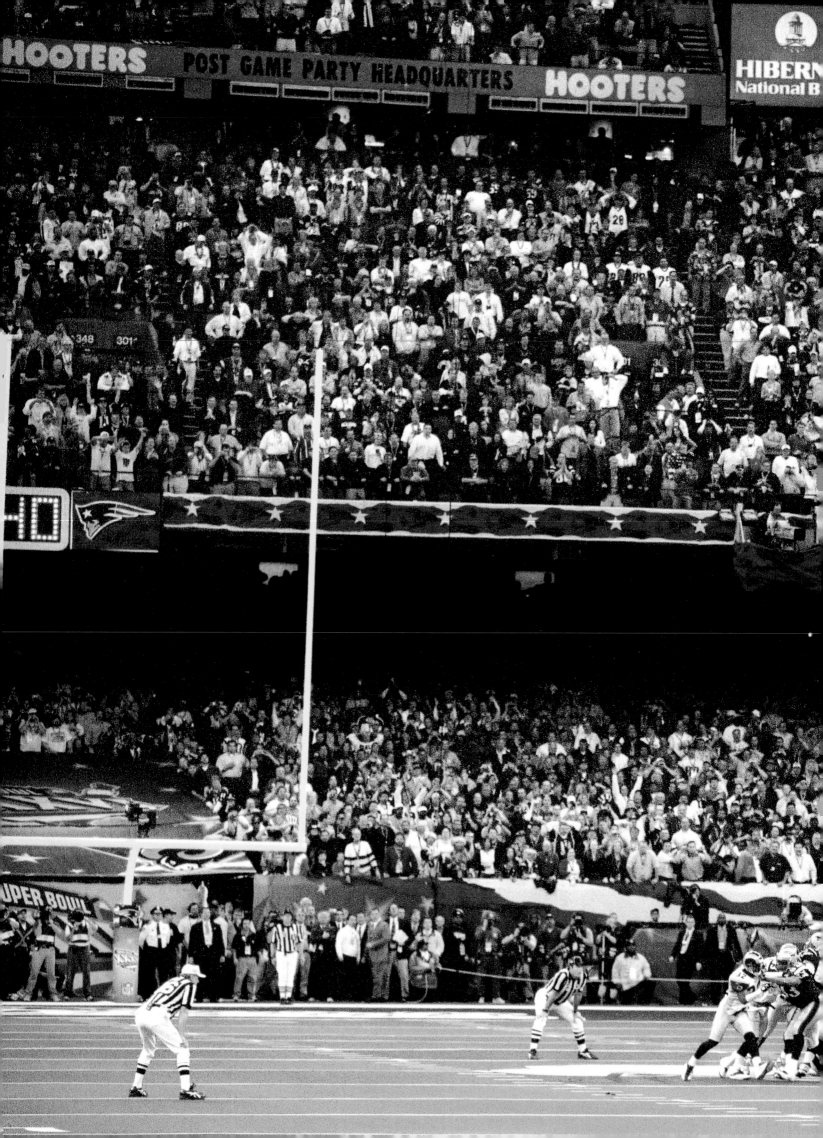

RAMS 17 0 BALL 50 0:06
PATRIOTS 17 0 DOWN 3
T.O.L. TO GO 4 QTR 4

veri on wireless **Budweiser** Patriots
04 A. Vinatieri

PATRIOT MISSILE

New England kicker Adam Vinatieri hit this game-winning 48-yard field goal as time was running out to beat the Rams in Super Bowl XXXVI in New Orleans.

PHOTOGRAPH BY JOHN W. MCDONOUGH

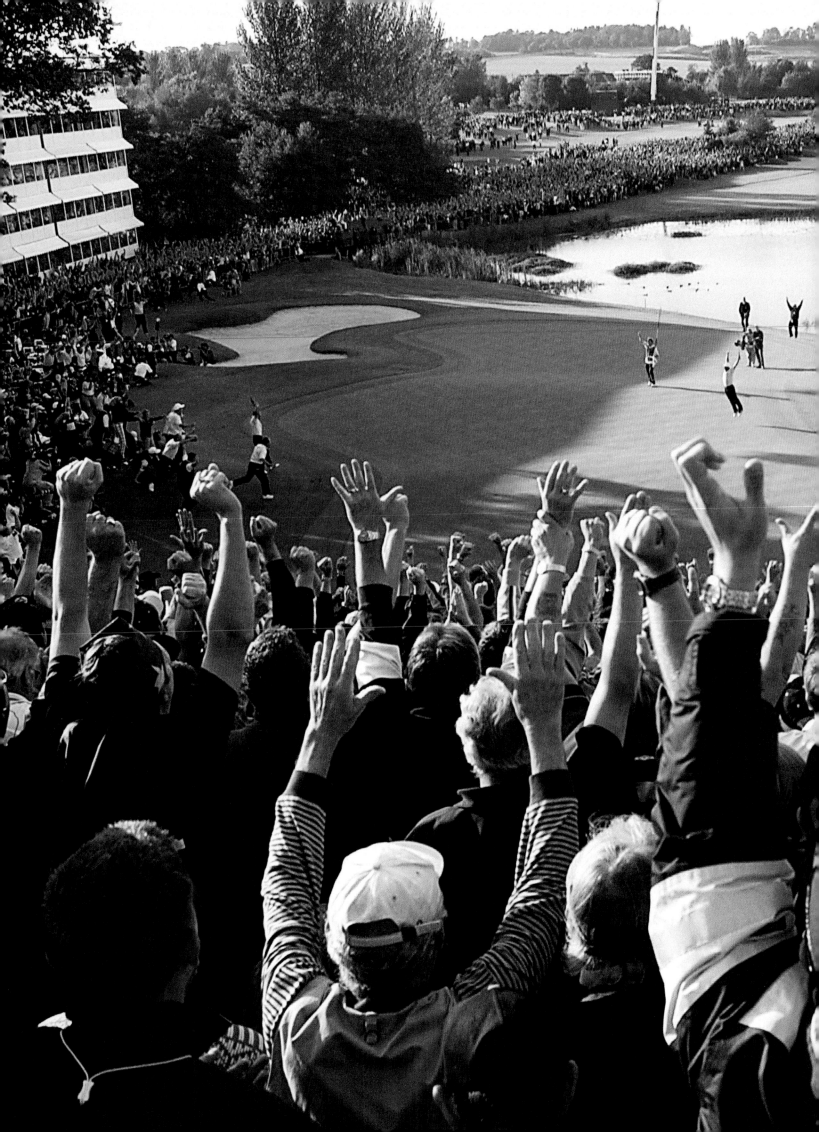

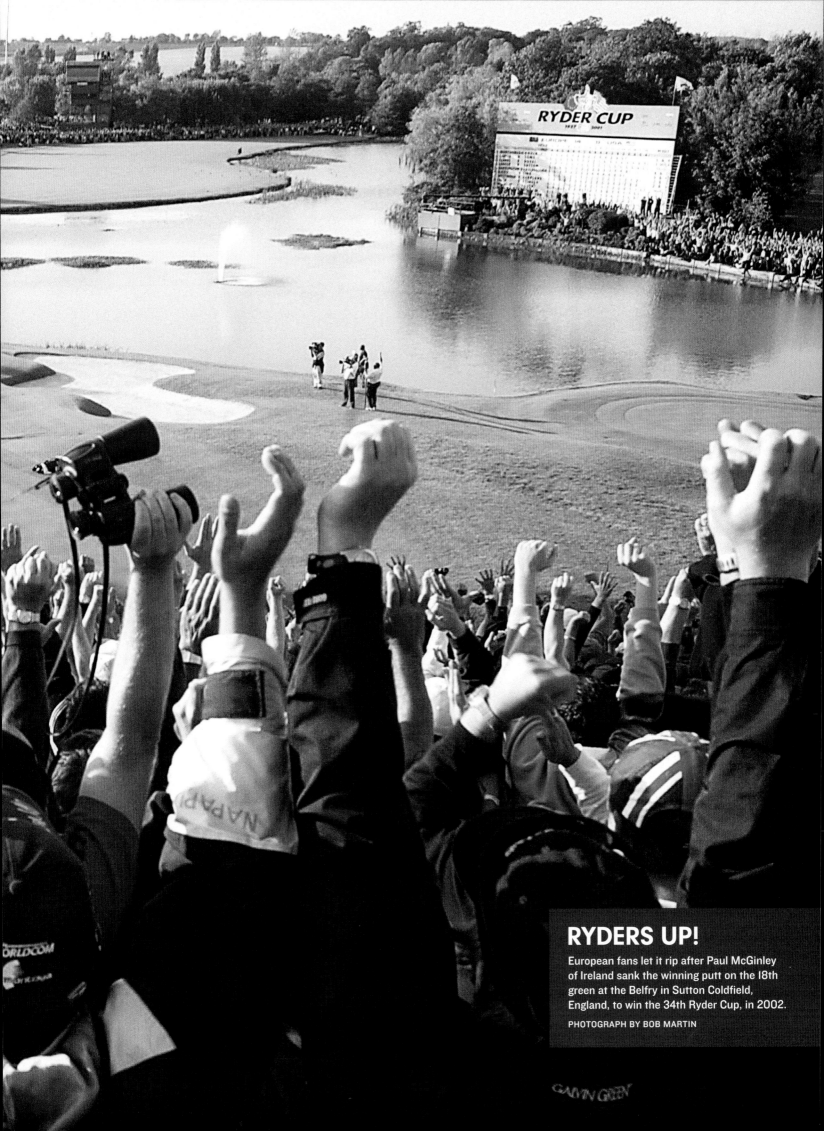

RYDERS UP!

European fans let it rip after Paul McGinley of Ireland sank the winning putt on the 18th green at the Belfry in Sutton Coldfield, England, to win the 34th Ryder Cup, in 2002.

PHOTOGRAPH BY BOB MARTIN

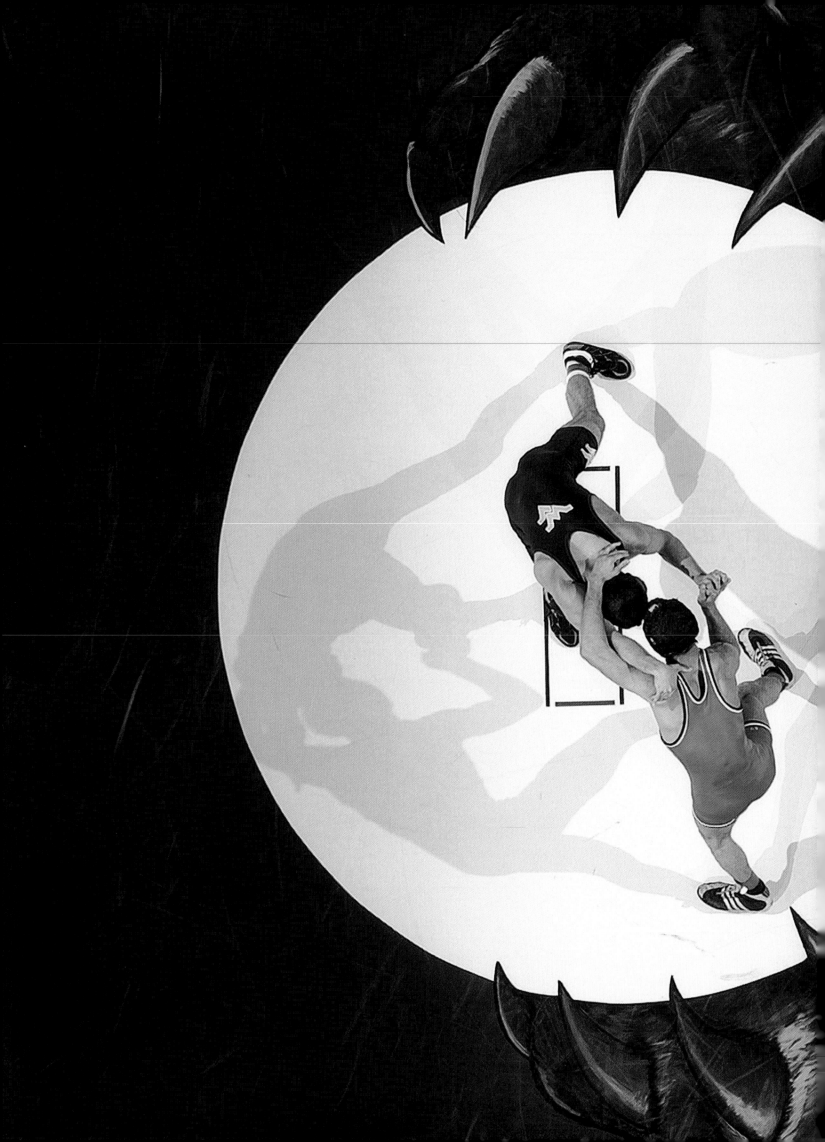

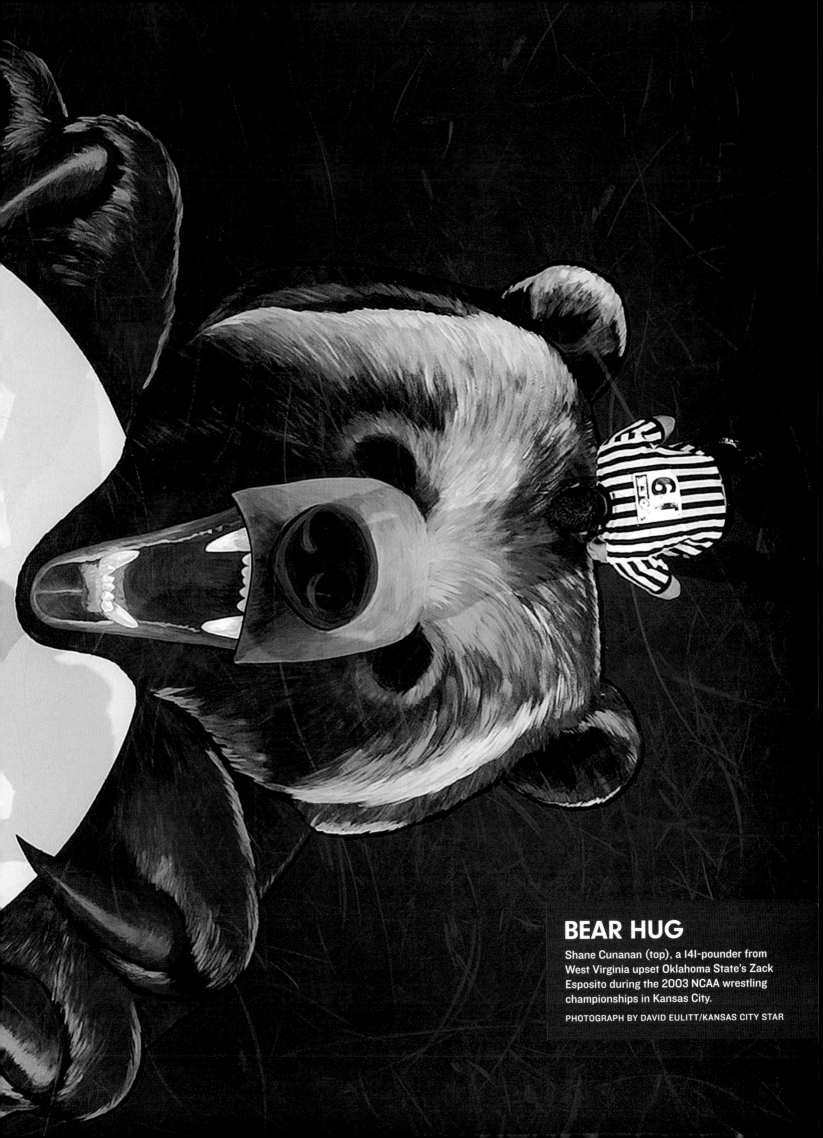

BEAR HUG

Shane Cunanan (top), a 141-pounder from West Virginia upset Oklahoma State's Zack Esposito during the 2003 NCAA wrestling championships in Kansas City.

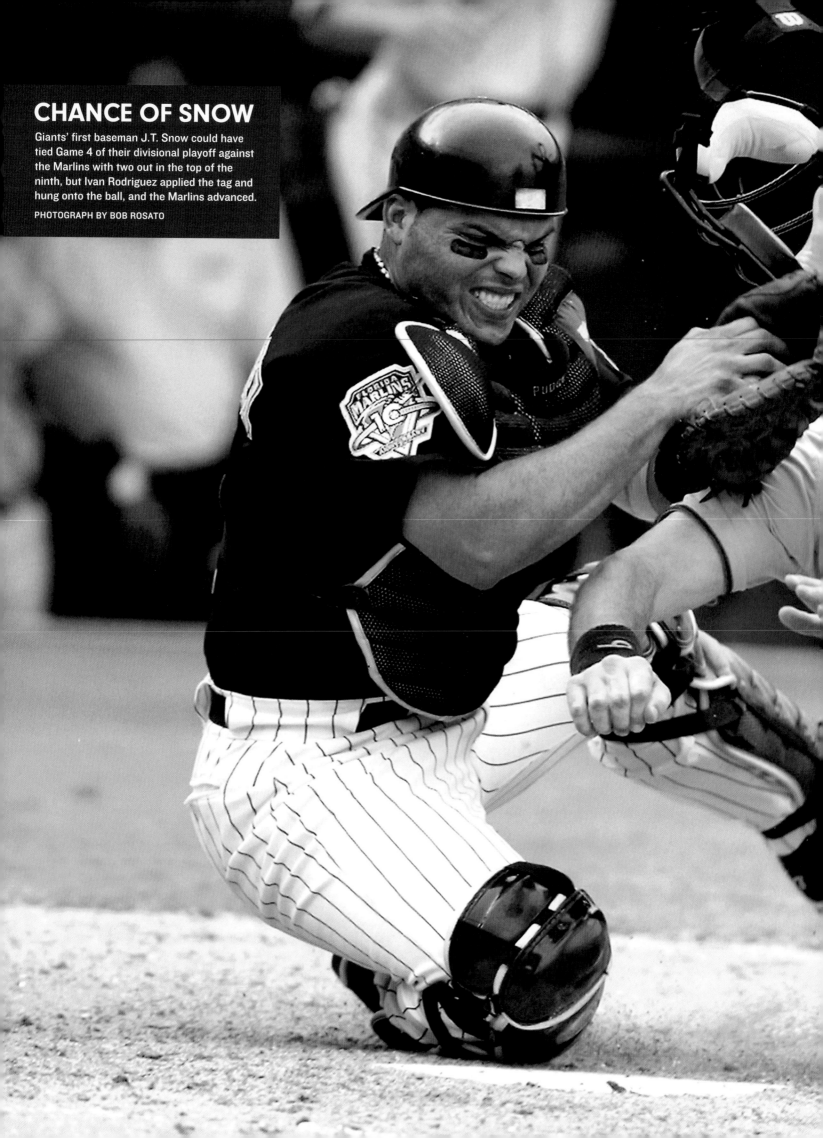

CHANCE OF SNOW

Giants' first baseman J.T. Snow could have tied Game 4 of their divisional playoff against the Marlins with two out in the top of the ninth, but Ivan Rodriguez applied the tag and hung onto the ball, and the Marlins advanced.

PHOTOGRAPH BY BOB ROSATO

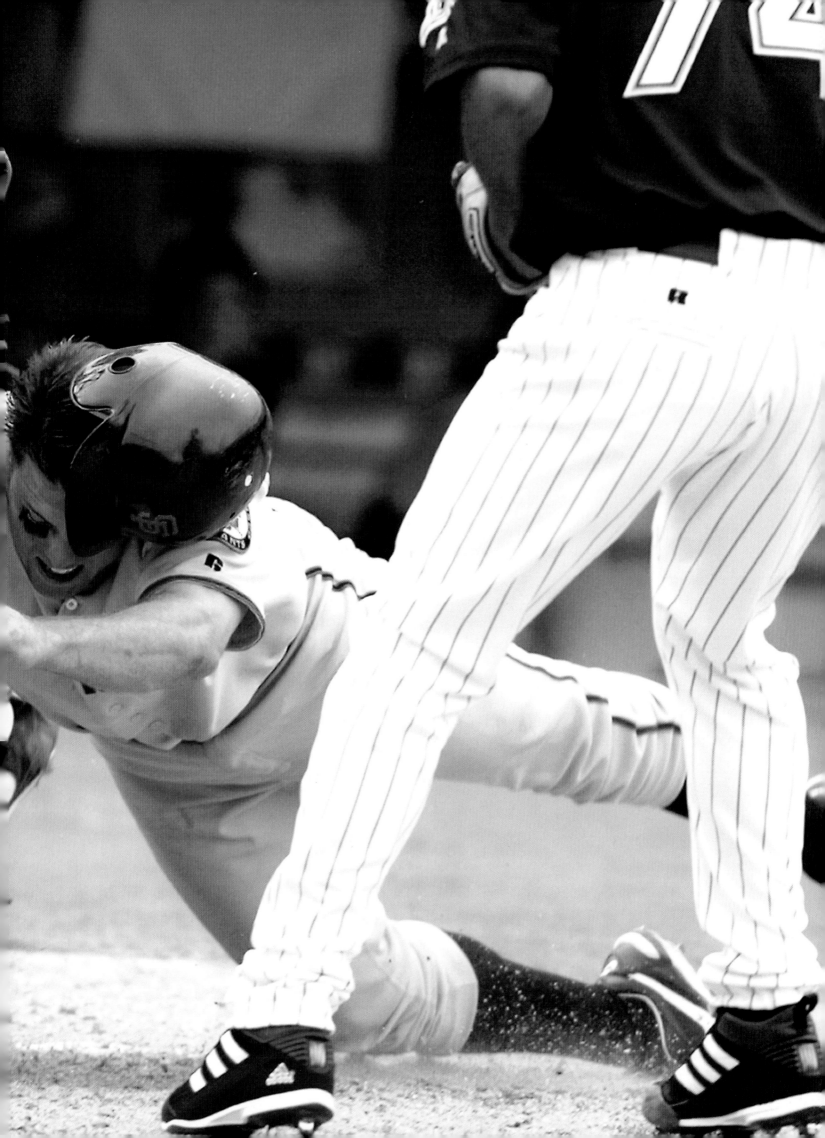

—BY IAN THOMSEN *Sports Illustrated 10/28/02*

T 7' 5" AND 296 POUNDS, YAO MING could have scored his 32.4 points per game last season in the Chinese league the easy way, dropping them into the bucket like an apple picker on a ladder. So why did he often hoist jumpers from 18 feet? "First of all, I'm not buff," he says through his interpreter. "I got pushed away from the basket. And even when I didn't, I couldn't get anyone to throw me a pass." (Which leads to the next question: What's Mandarin for "buff"?) Frustrated by coaches and teammates who didn't have the first idea about how to exploit his size, skill and agility, the 22-year-old Yao, the first pick in the NBA draft this year, is eager to join the Houston Rockets, and the NBA is even more eager to have him. No doubt, Yao won't be ready to push Shaq off the low block for some time—the best guess here is that he will spend the next couple of years learning from the league's diversified big men, then spend the rest of his career taking them to school. . . .

Shaq and Yao get acquainted on a first-name basis. PHOTOGRAPH BY JOHN W. MCDONOUGH

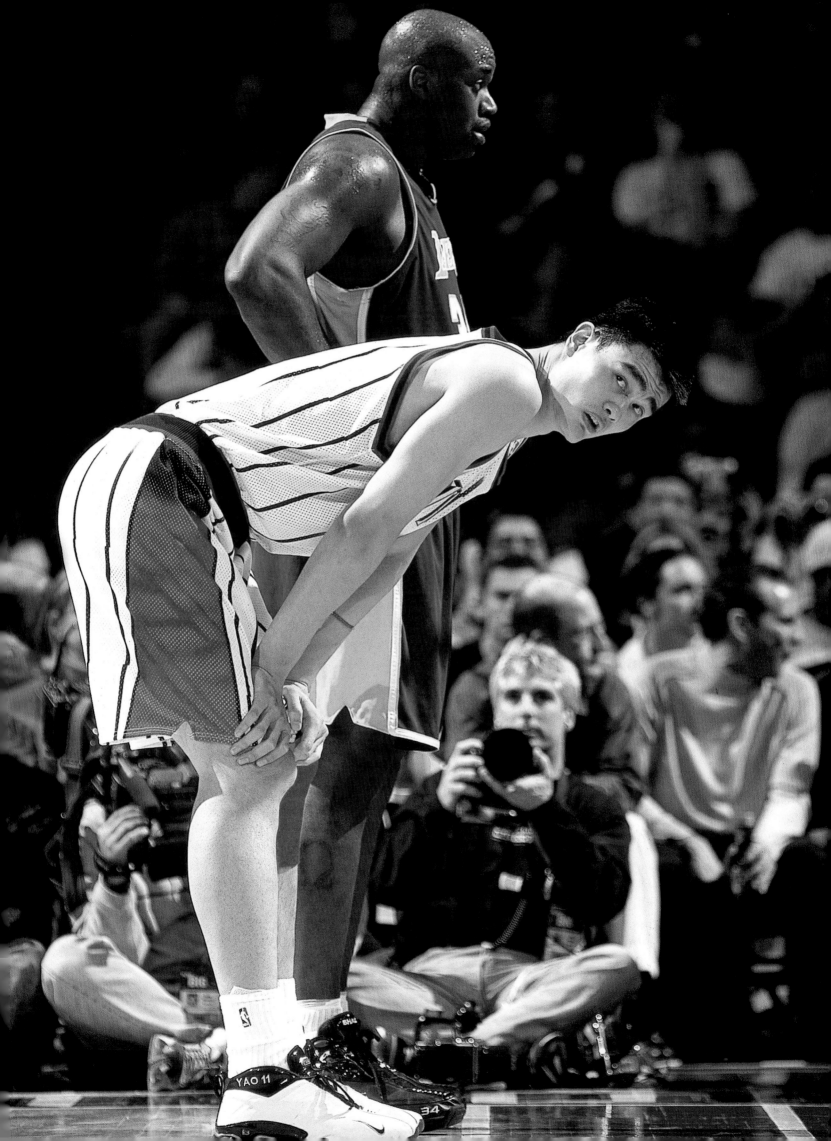

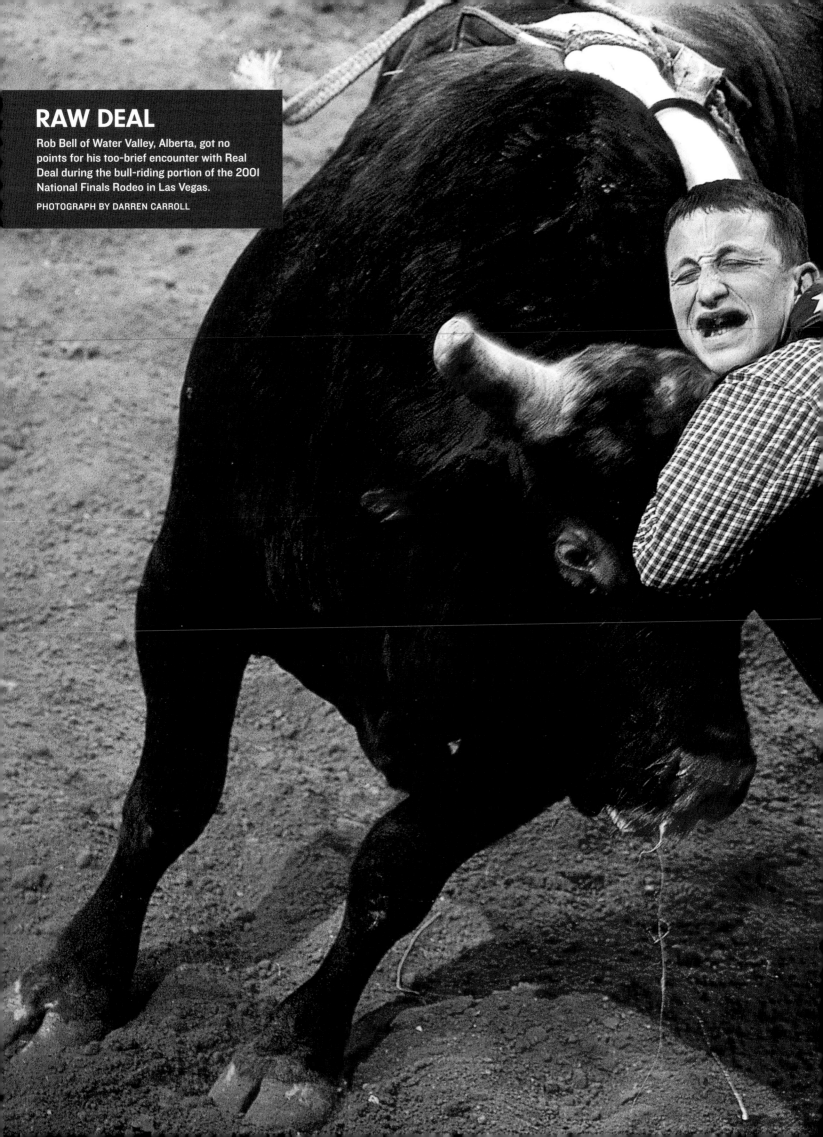

RAW DEAL

Rob Bell of Water Valley, Alberta, got no points for his too-brief encounter with Real Deal during the bull-riding portion of the 2001 National Finals Rodeo in Las Vegas.

PHOTOGRAPH BY DARREN CARROLL

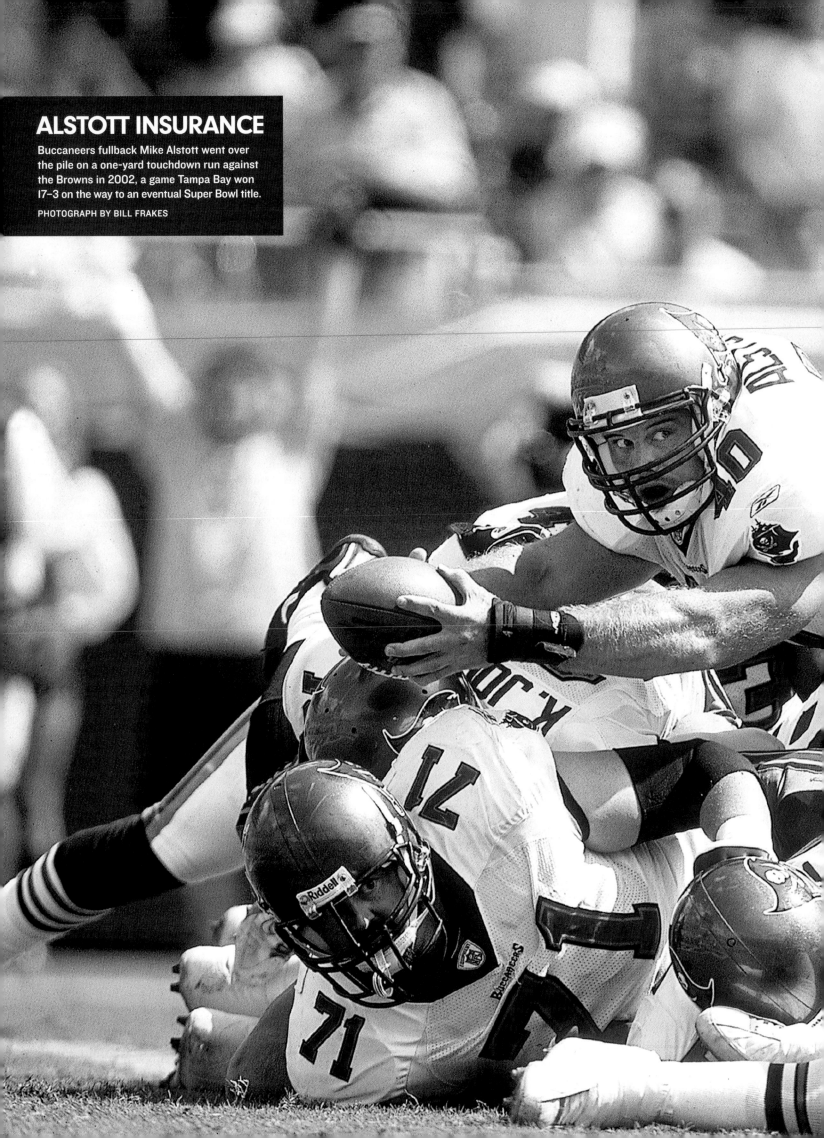

ALSTOTT INSURANCE

Buccaneers fullback Mike Alstott went over the pile on a one-yard touchdown run against the Browns in 2002, a game Tampa Bay won 17–3 on the way to an eventual Super Bowl title.

PHOTOGRAPH BY BILL FRAKES

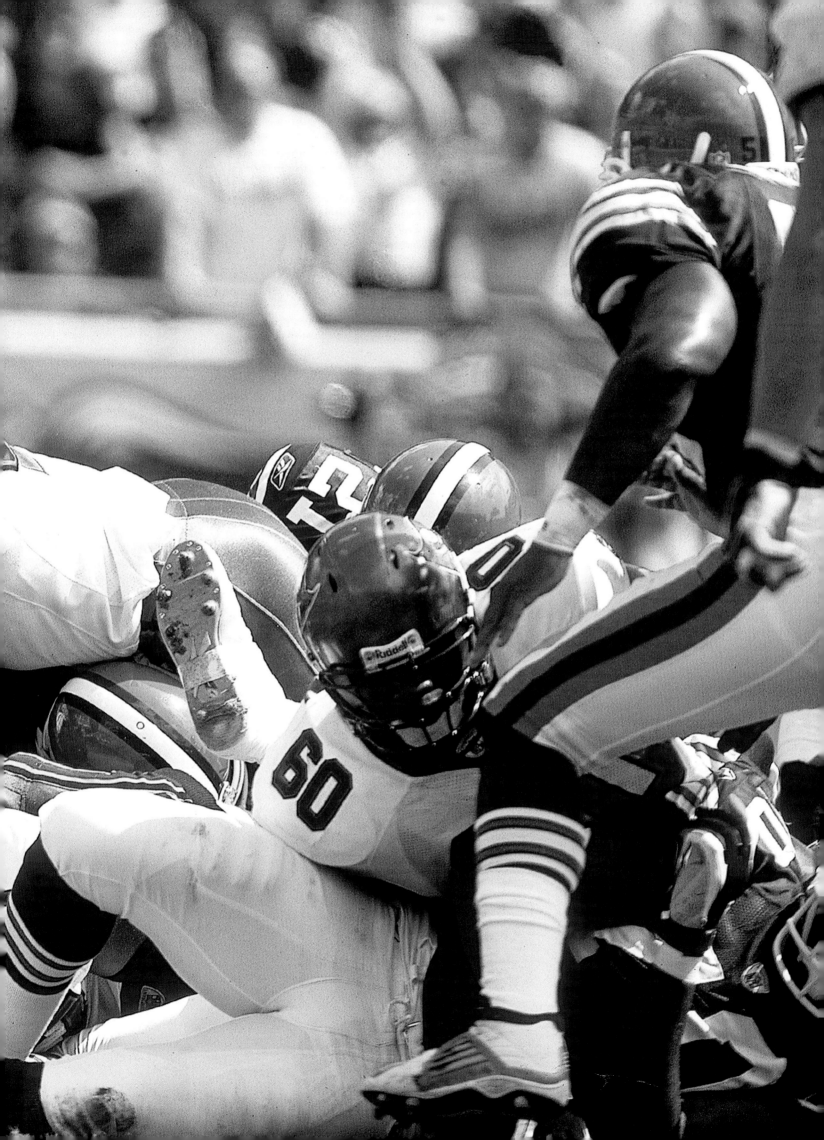

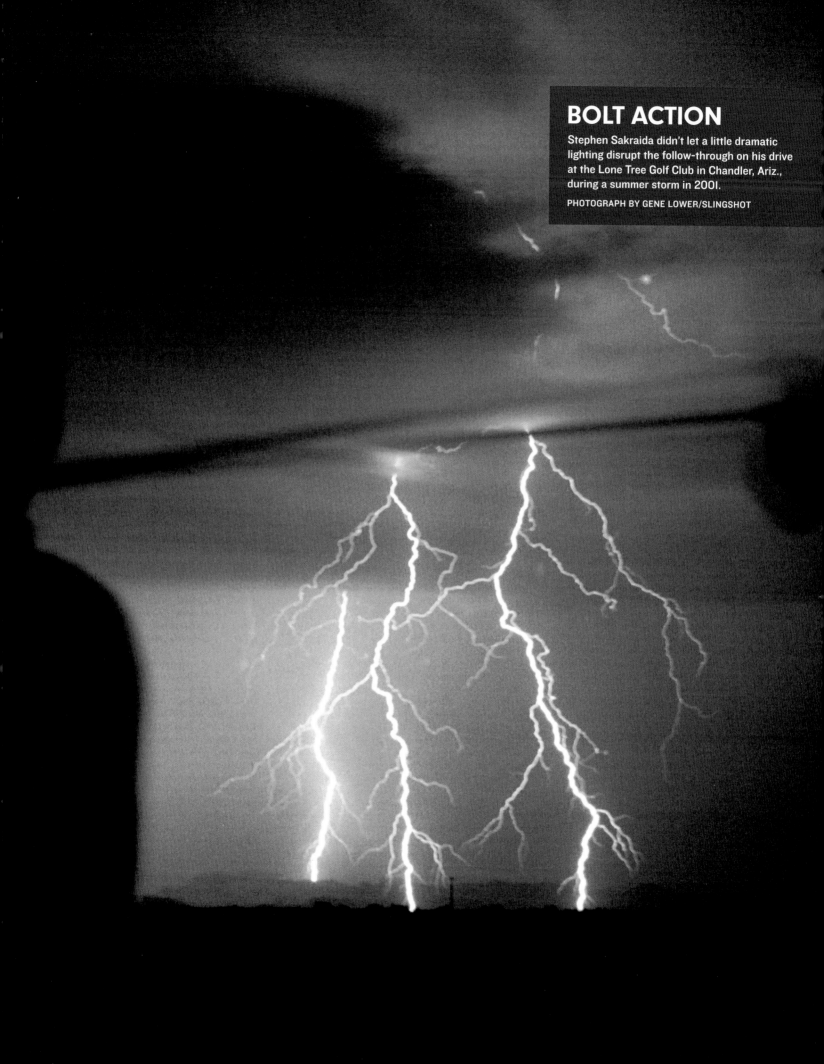

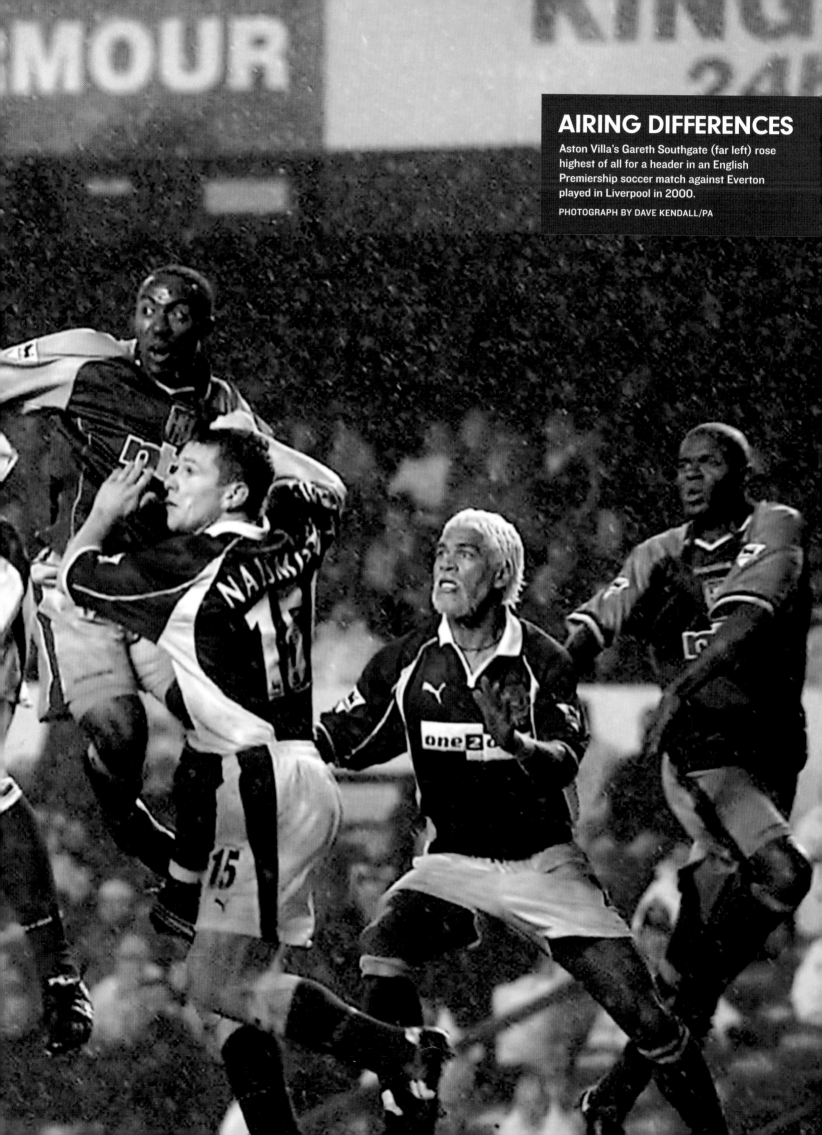

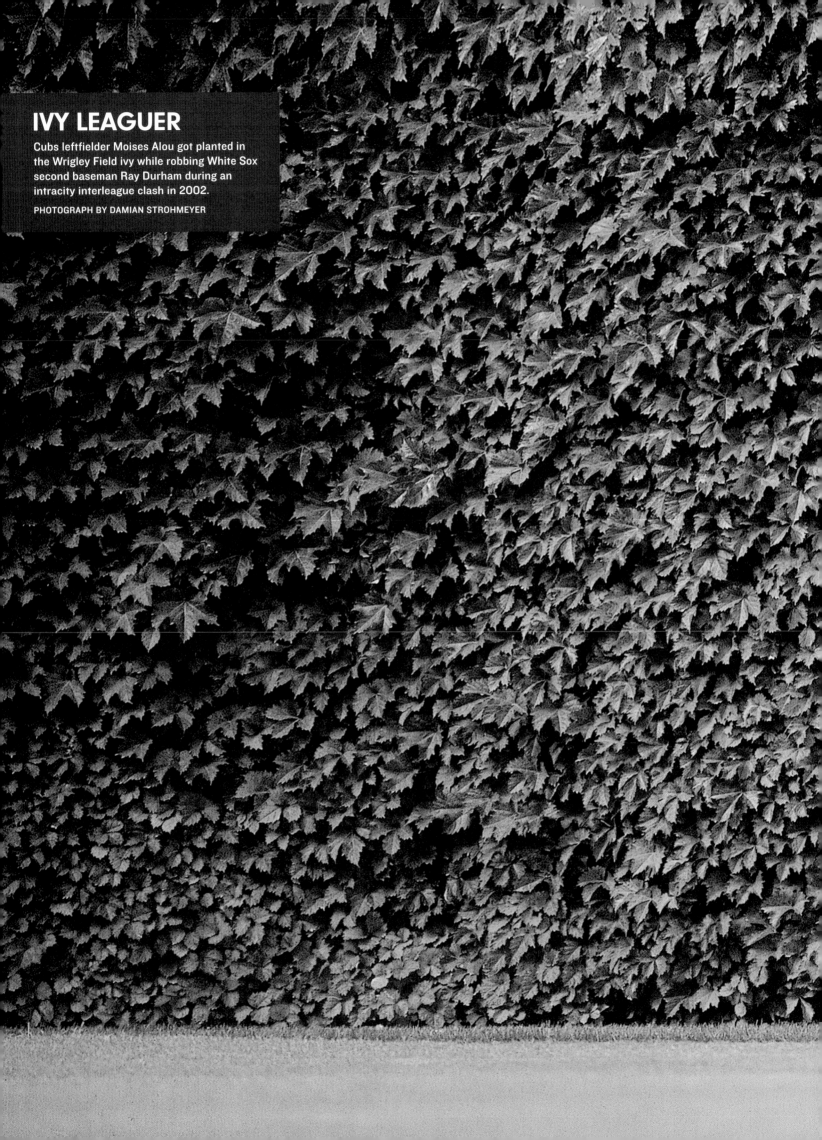

IVY LEAGUER

Cubs leftfielder Moises Alou got planted in the Wrigley Field ivy while robbing White Sox second baseman Ray Durham during an intracity interleague clash in 2002.

PHOTOGRAPH BY DAMIAN STROHMEYER

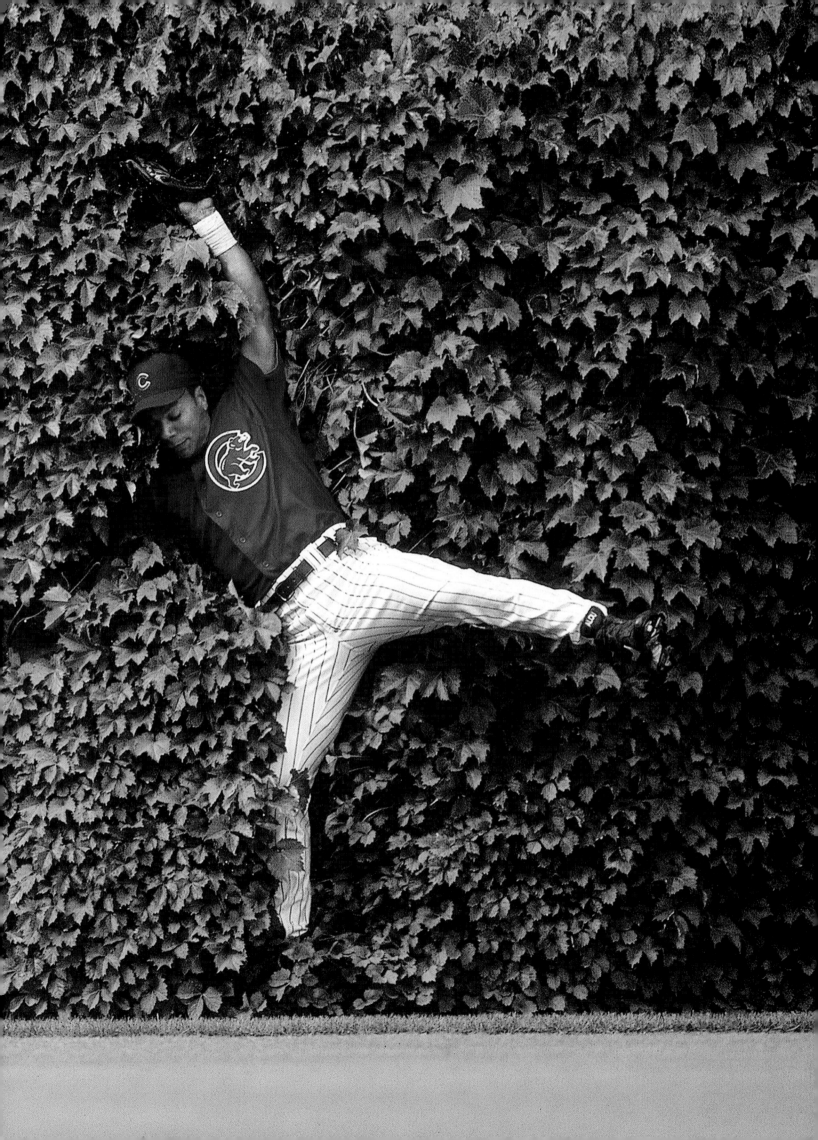

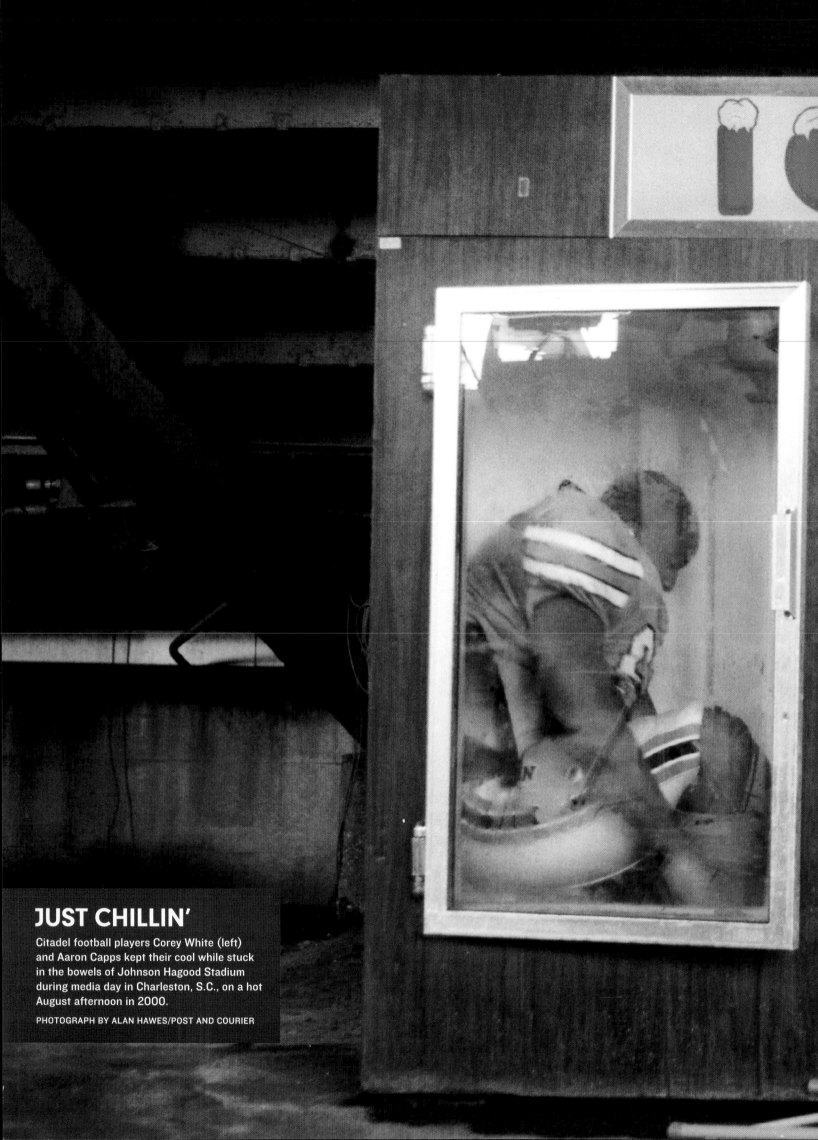

JUST CHILLIN'

Citadel football players Corey White (left) and Aaron Capps kept their cool while stuck in the bowels of Johnson Hagood Stadium during media day in Charleston, S.C., on a hot August afternoon in 2000.

PHOTOGRAPH BY ALAN HAWES/POST AND COURIER

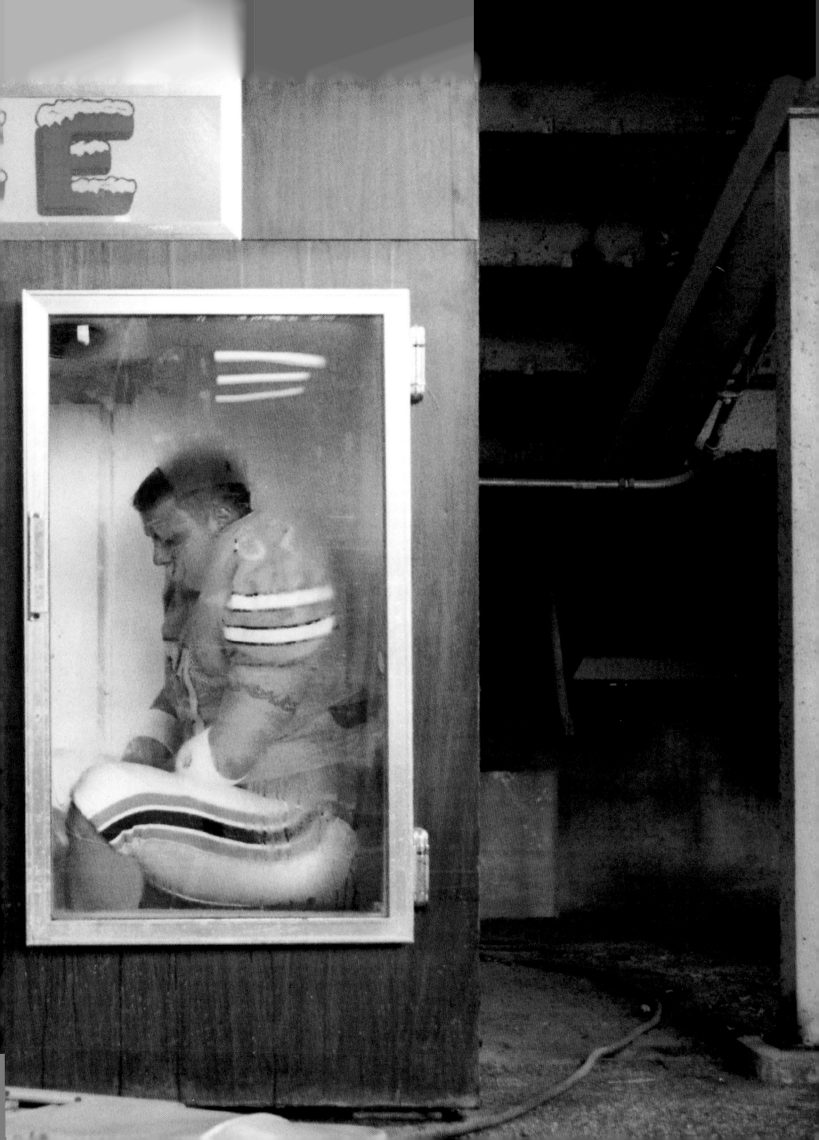

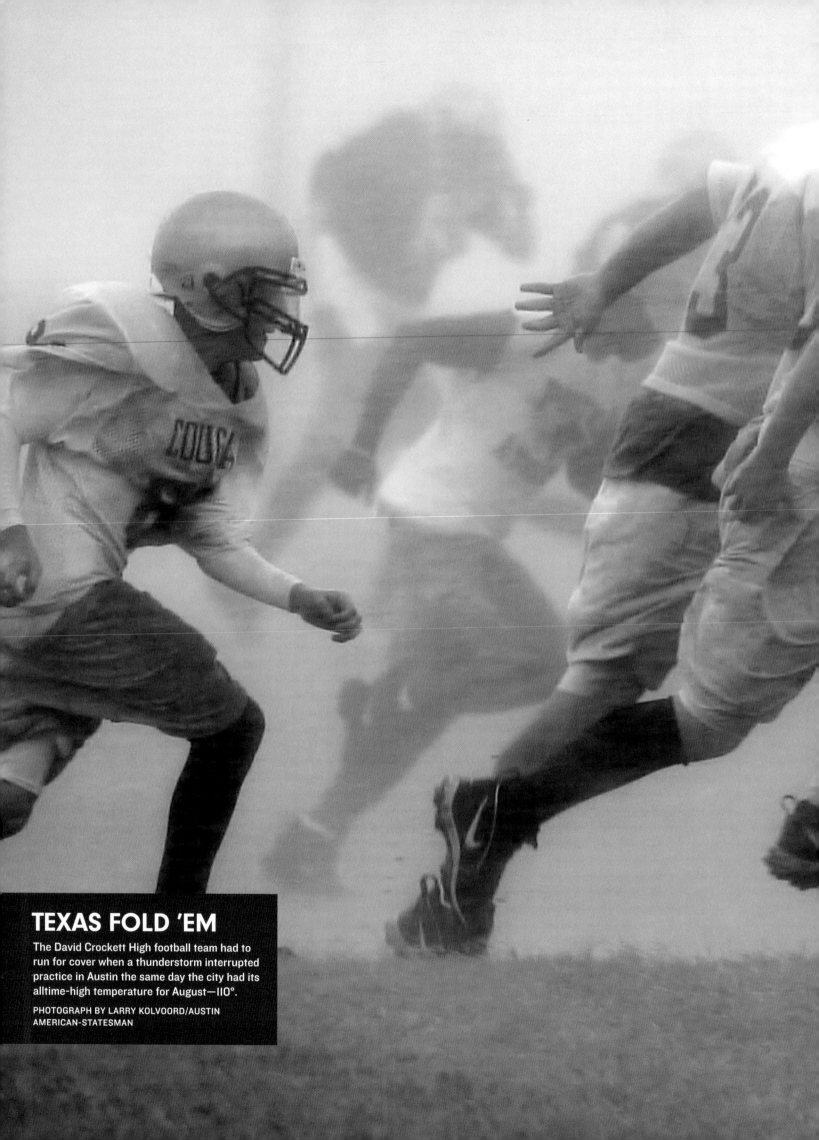

TEXAS FOLD 'EM

The David Crockett High football team had to run for cover when a thunderstorm interrupted practice in Austin the same day the city had its alltime-high temperature for August—110°.

PHOTOGRAPH BY LARRY KOLVOORD/AUSTIN AMERICAN-STATESMAN

—BY RICK REILLY *Sports Illustrated 8/4/03*

THEY SHOULD'VE BURIED LANCE Armstrong this time. They had him laid out like a yard sale on a Pyrenees road. Had him sick, white-mouthed and dizzy.... Had him scabbed and swollen, out of water and luck and hope. But they didn't bury him. Couldn't ... Armstrong and his son play a little game. Lance asks Luke, "What does Daddy do?" And Luke always answers, "Daddy makes them suffer." But this Tour was all about Armstrong's suffering. Diarrhea to start. Hideous road rash ... [and] ripped flesh that made even the doctors' faces go chalky. Killer hip tendinitis. A pileup during stage 1 that produced ... an 18-inch tire track across his back. It got worse: In the brick-oven heat of stage 12, Armstrong miscalculated how much water he would need and became so dehydrated he could barely keep the bike upright. He was dizzy, face beet-red and swollen, eyes bulging, a pasty white ring around his mouth. "That's as close as I've come to just getting off the bike and quitting...."

Lance Armstrong wins his fifth straight Tour de France. PHOTOGRAPH BY ROBERT LABERGE/GETTY IMAGES

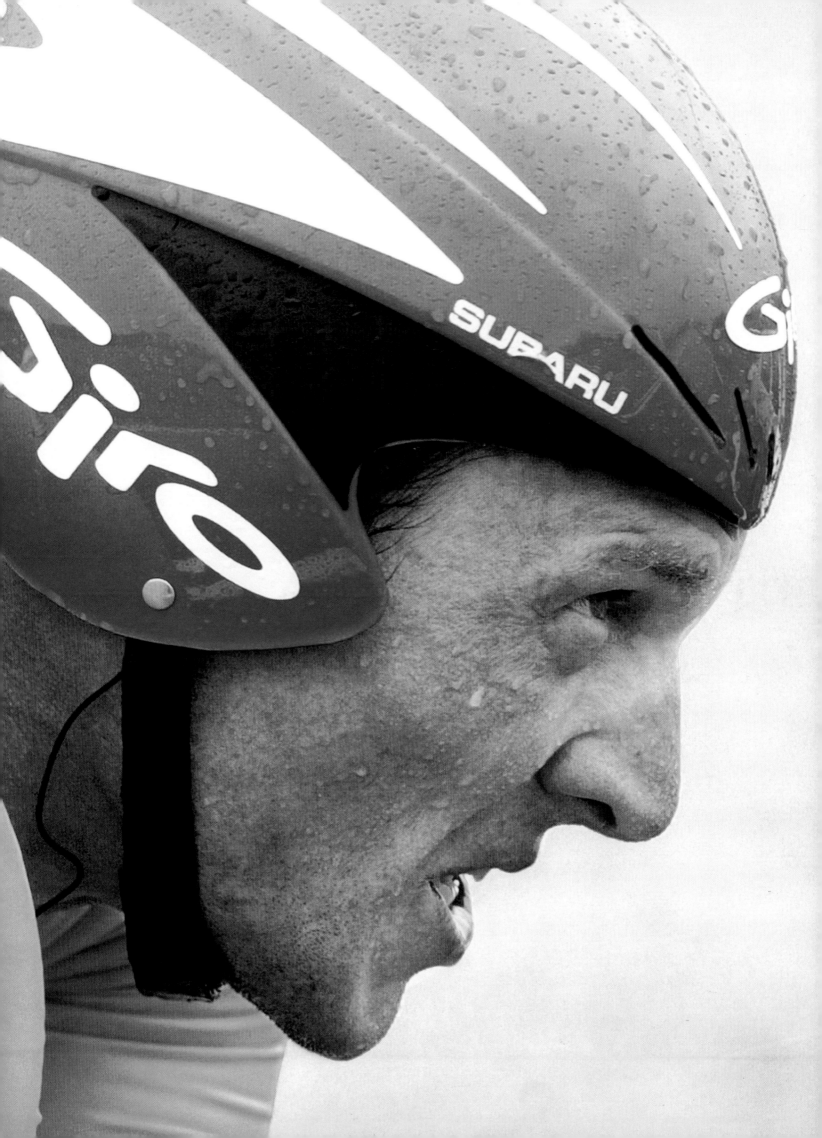

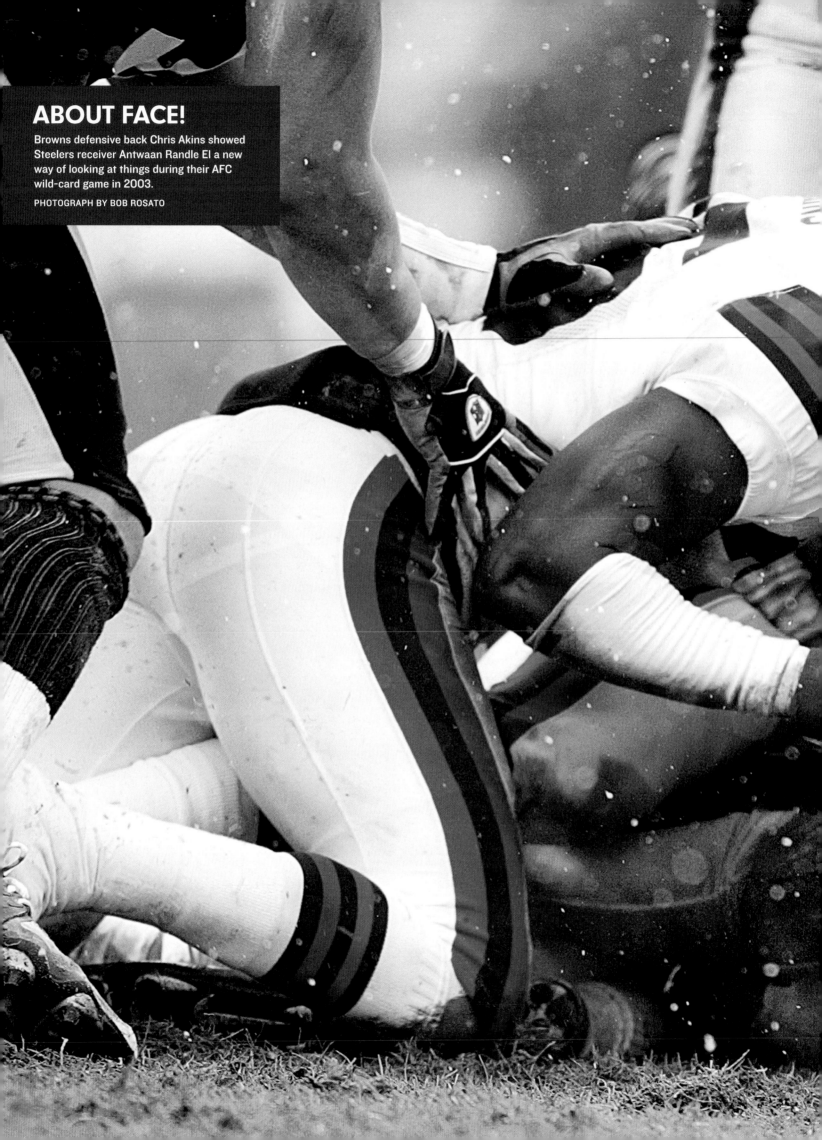

ABOUT FACE!

Browns defensive back Chris Akins showed Steelers receiver Antwaan Randle El a new way of looking at things during their AFC wild-card game in 2003.

PHOTOGRAPH BY BOB ROSATO

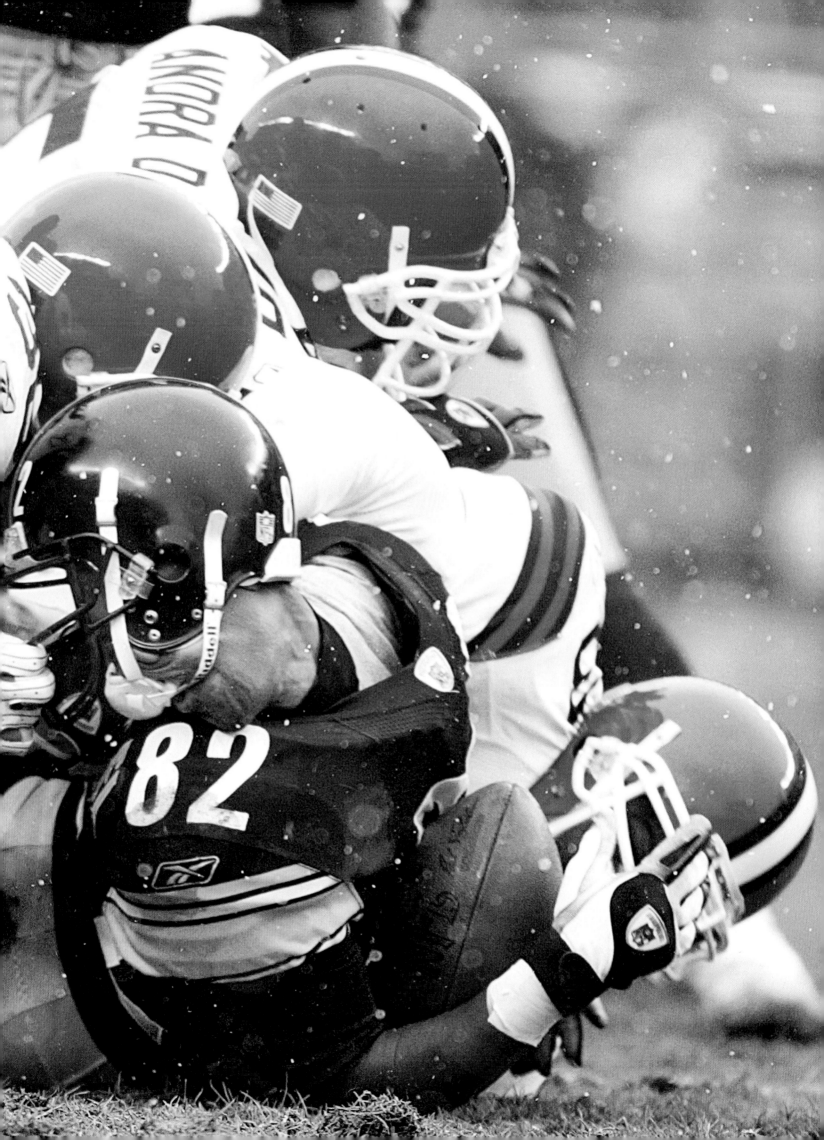

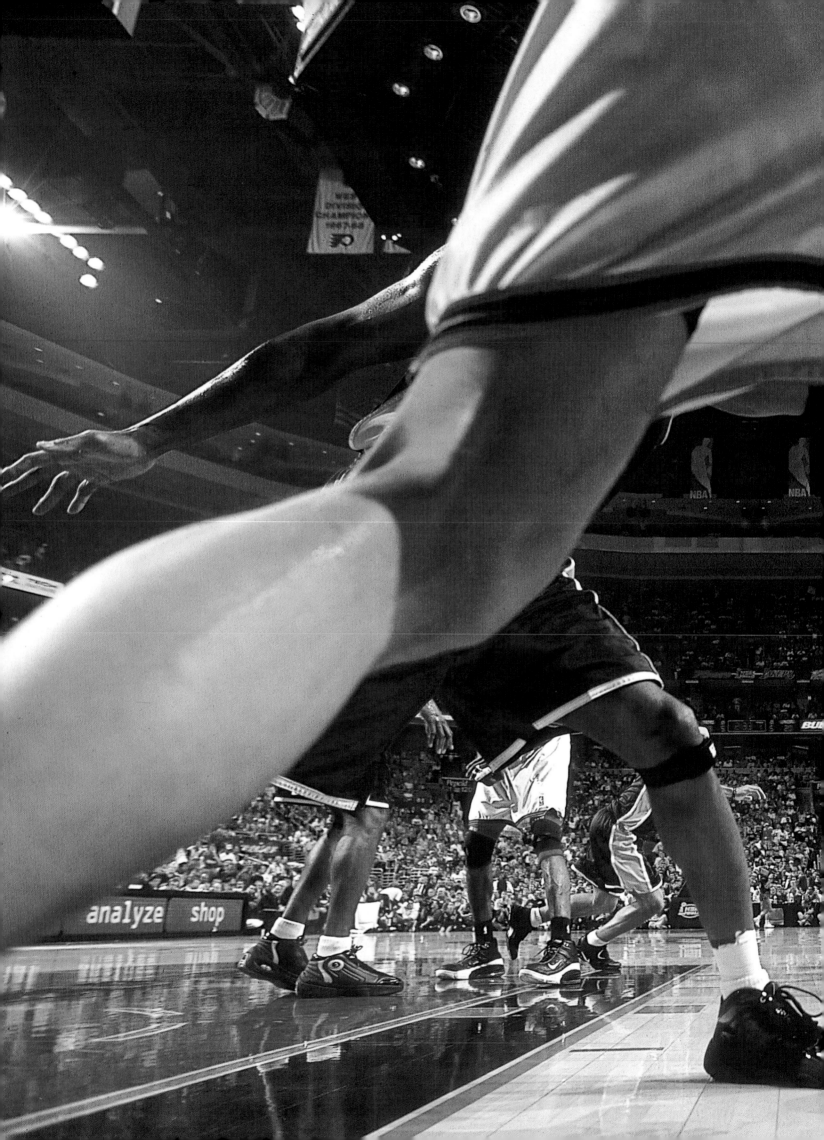

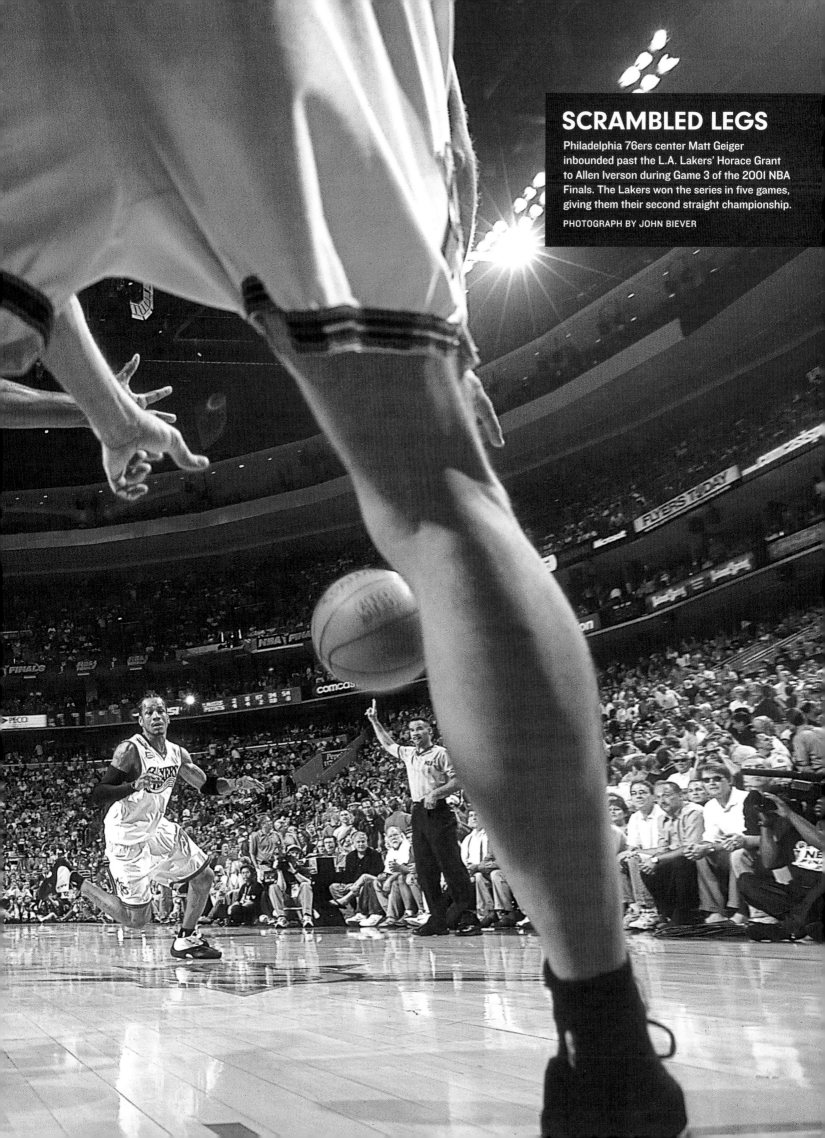

SCRAMBLED LEGS

Philadelphia 76ers center Matt Geiger inbounded past the L.A. Lakers' Horace Grant to Allen Iverson during Game 3 of the 2001 NBA Finals. The Lakers won the series in five games, giving them their second straight championship.

PHOTOGRAPH BY JOHN BIEVER

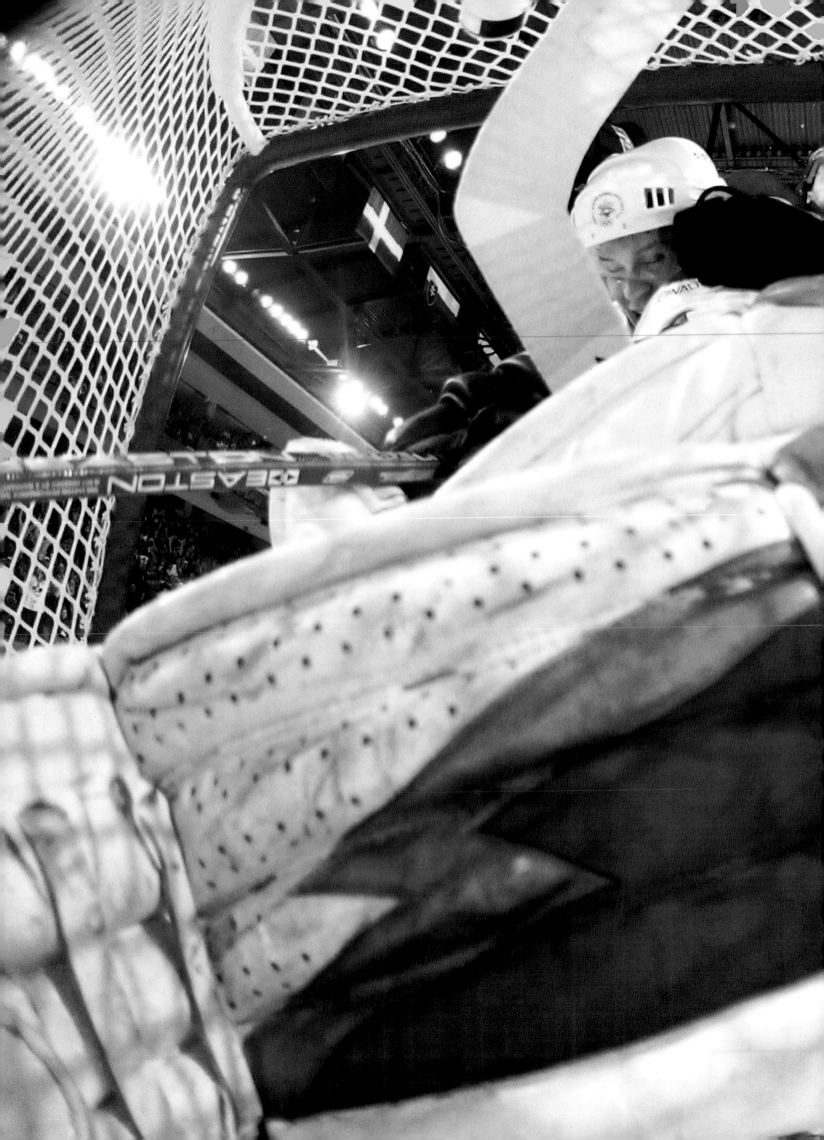

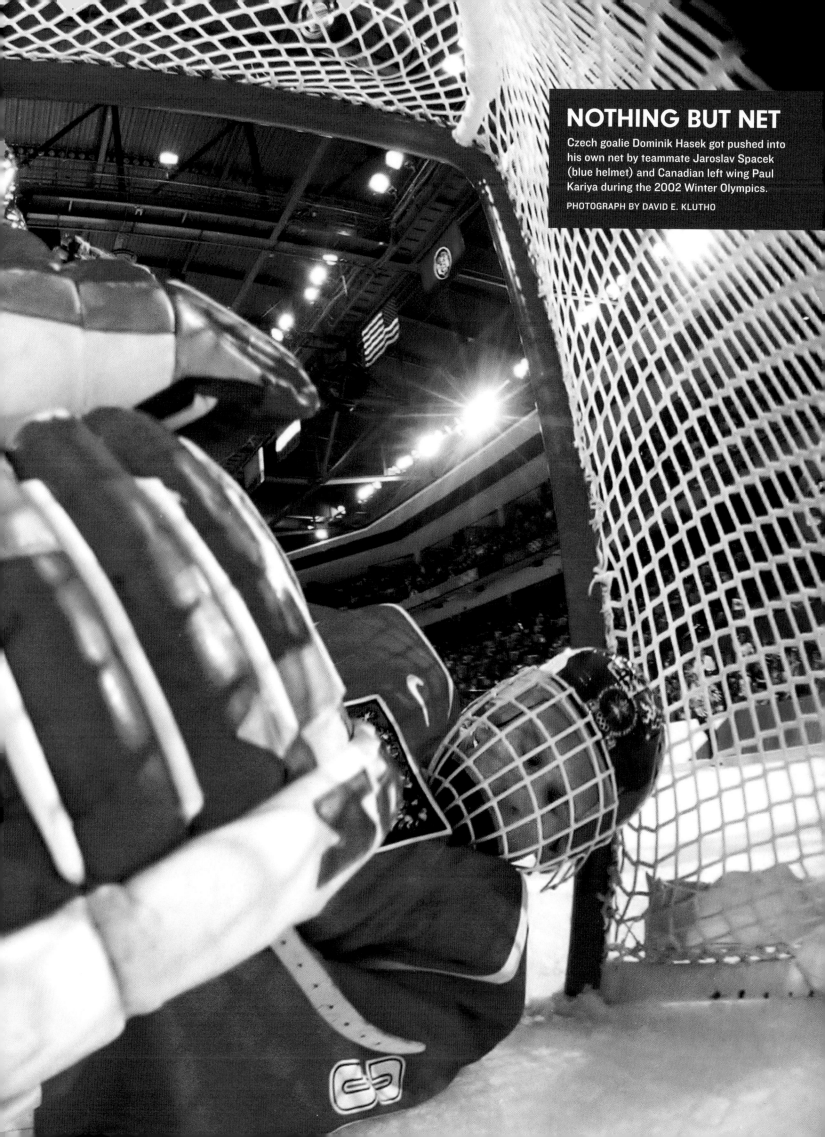

NOTHING BUT NET

Czech goalie Dominik Hasek got pushed into his own net by teammate Jaroslav Spacek (blue helmet) and Canadian left wing Paul Kariya during the 2002 Winter Olympics.

PHOTOGRAPH BY DAVID E. KLUTHO

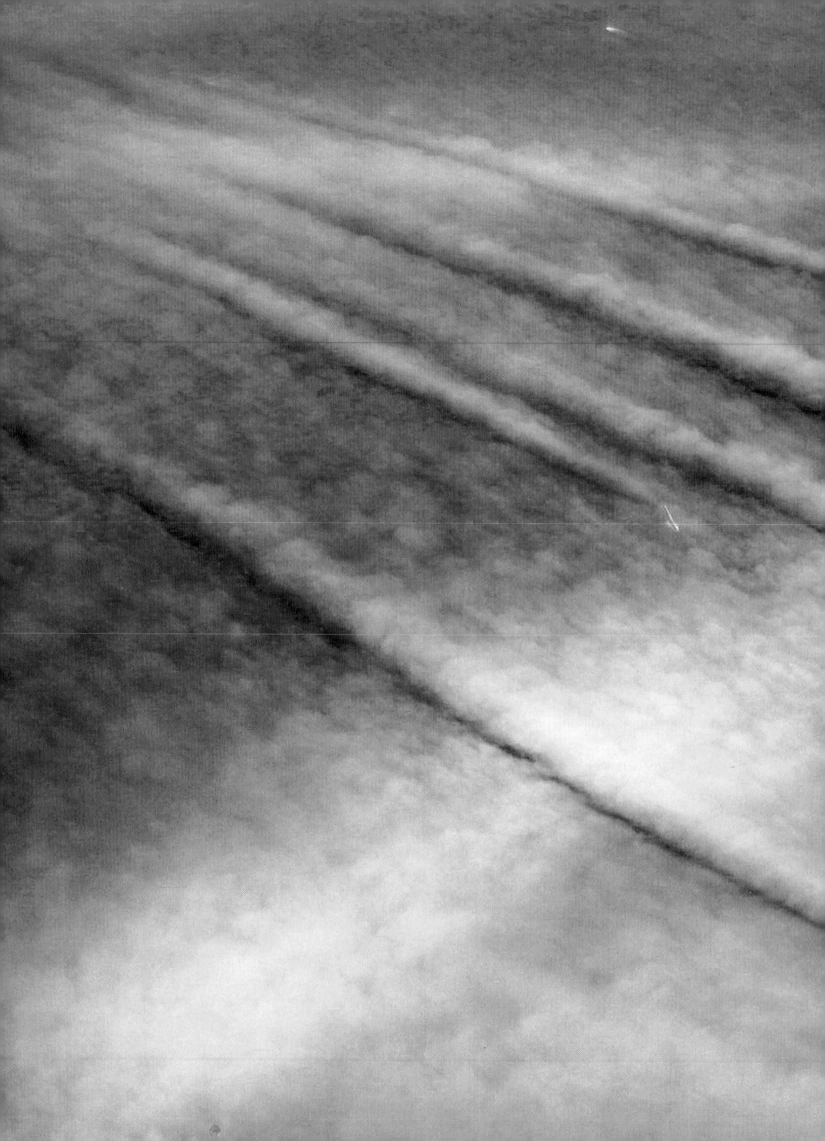

VAPOR TRAILS

The masts of sailboats in the Volvo Ocean
Race Round the World cut through low-lying
fog as they departed from Cape Town, South
Africa, on the second leg of their 32,700
nautical-mile circumnavigation.

PHOTOGRAPH BY DANIEL FOSTER/DPPI

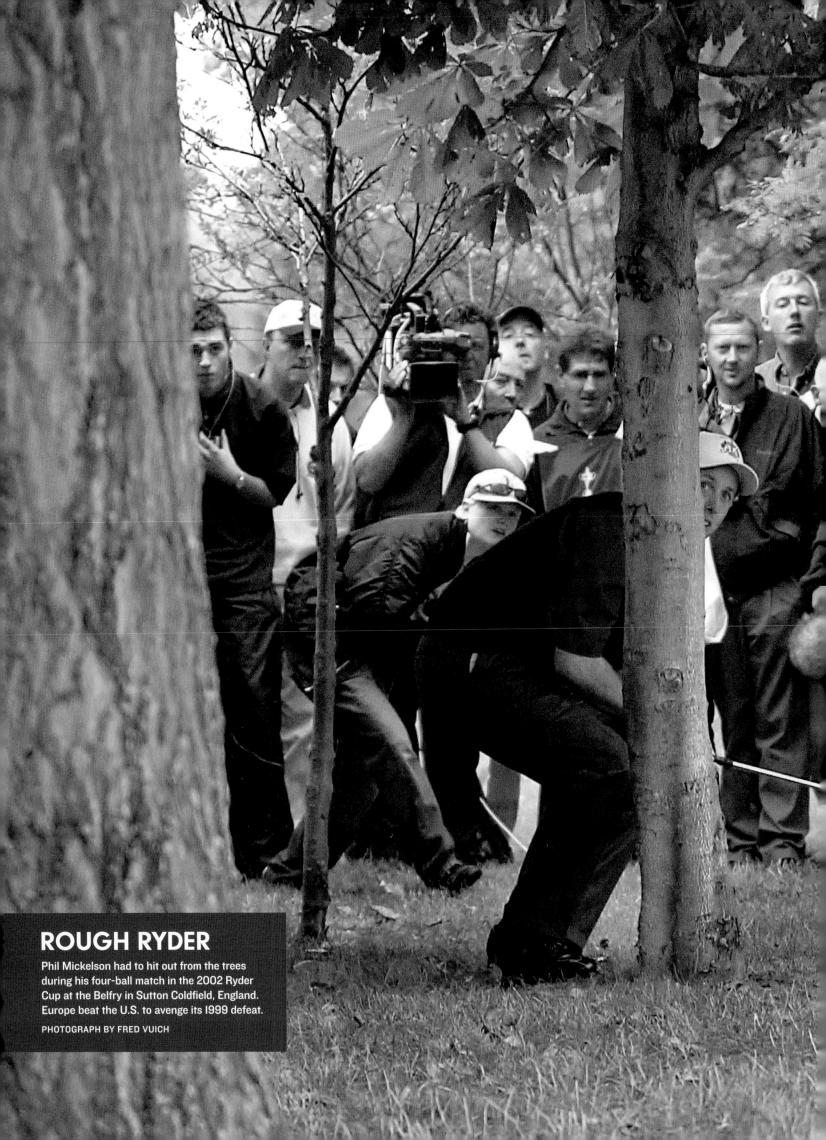

ROUGH RYDER

Phil Mickelson had to hit out from the trees during his four-ball match in the 2002 Ryder Cup at the Belfry in Sutton Coldfield, England. Europe beat the U.S. to avenge its 1999 defeat.

PHOTOGRAPH BY FRED VUICH

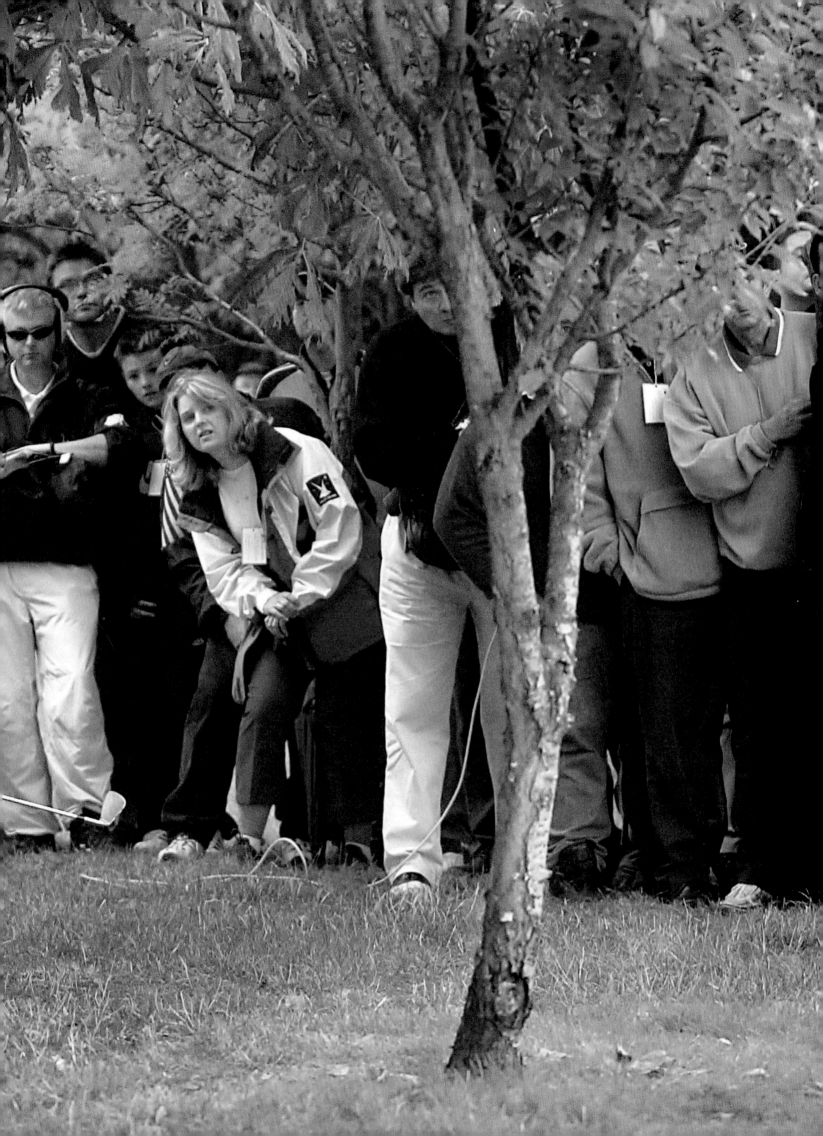

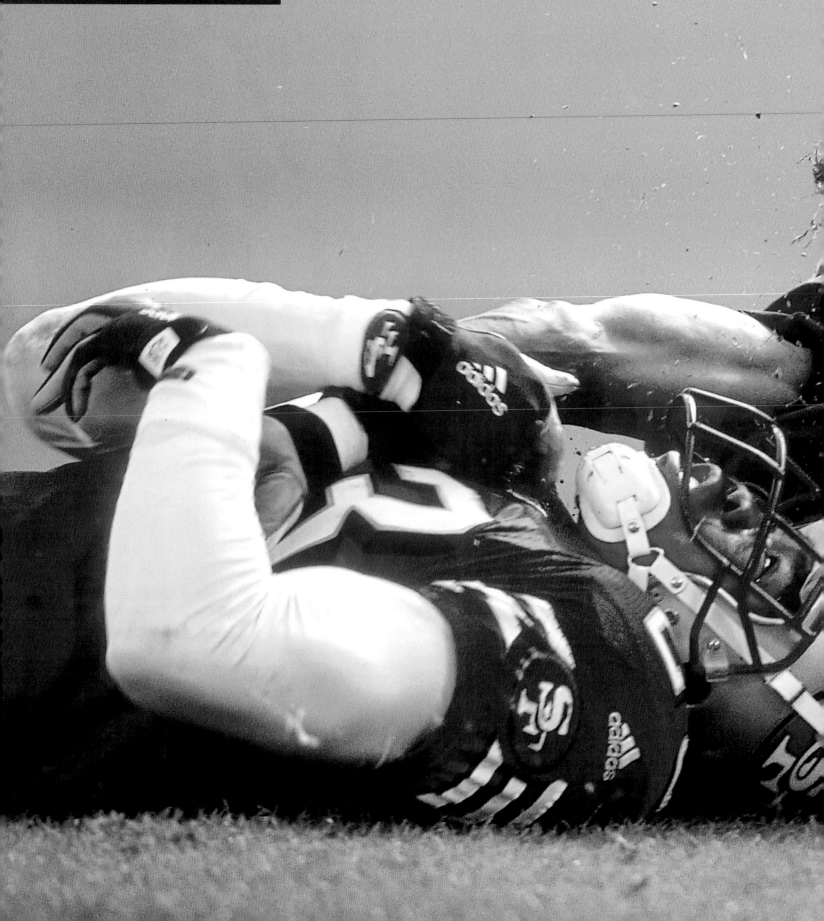

ARM TACKLE

St. Louis Rams receiver Isaac Bruce hung onto the ball despite getting bent, folded and mutilated by 49ers safety Pierson Prioleau during a game at 3Com Park in San Francisco.

PHOTOGRAPH BY JOHN W. MCDONOUGH

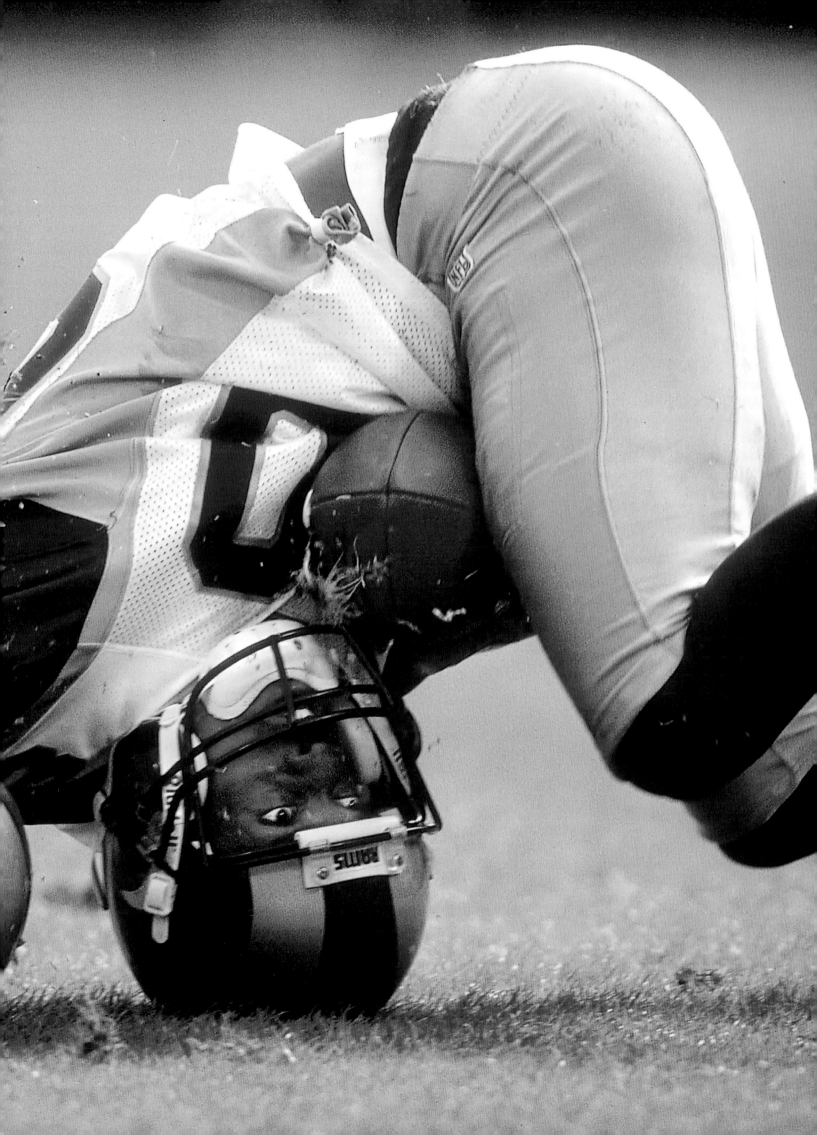

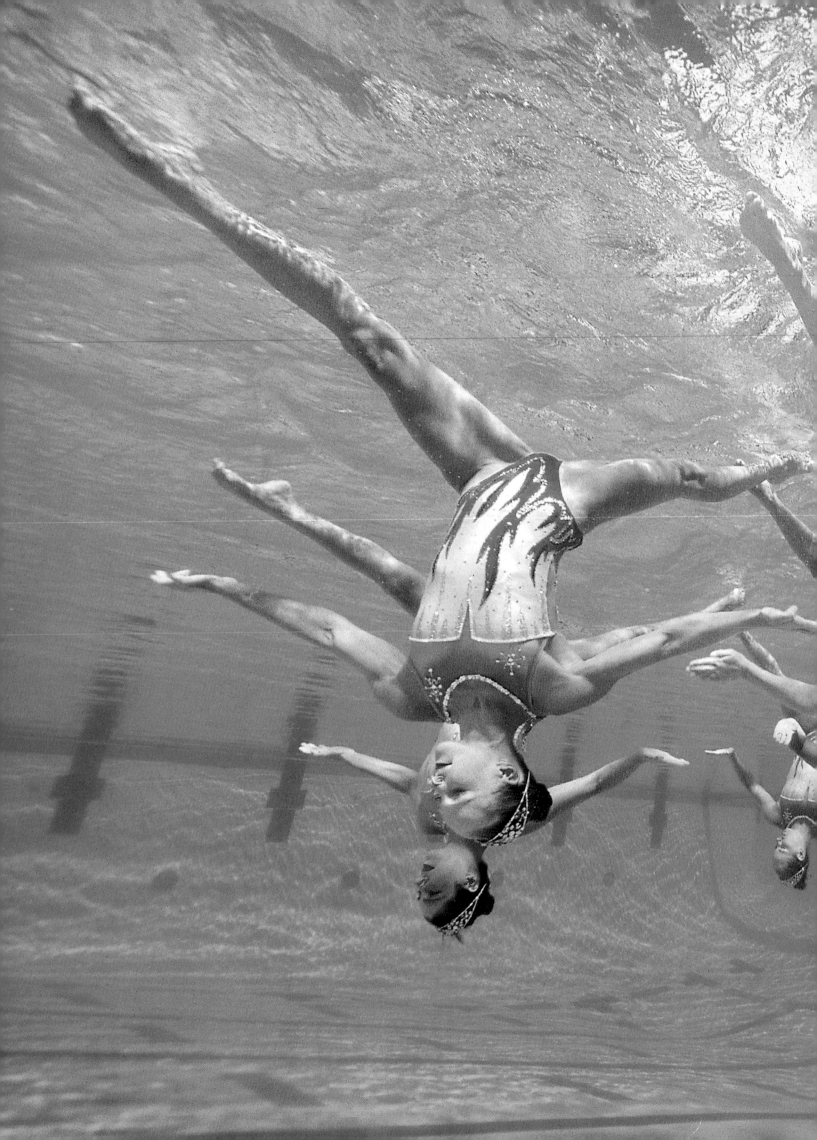

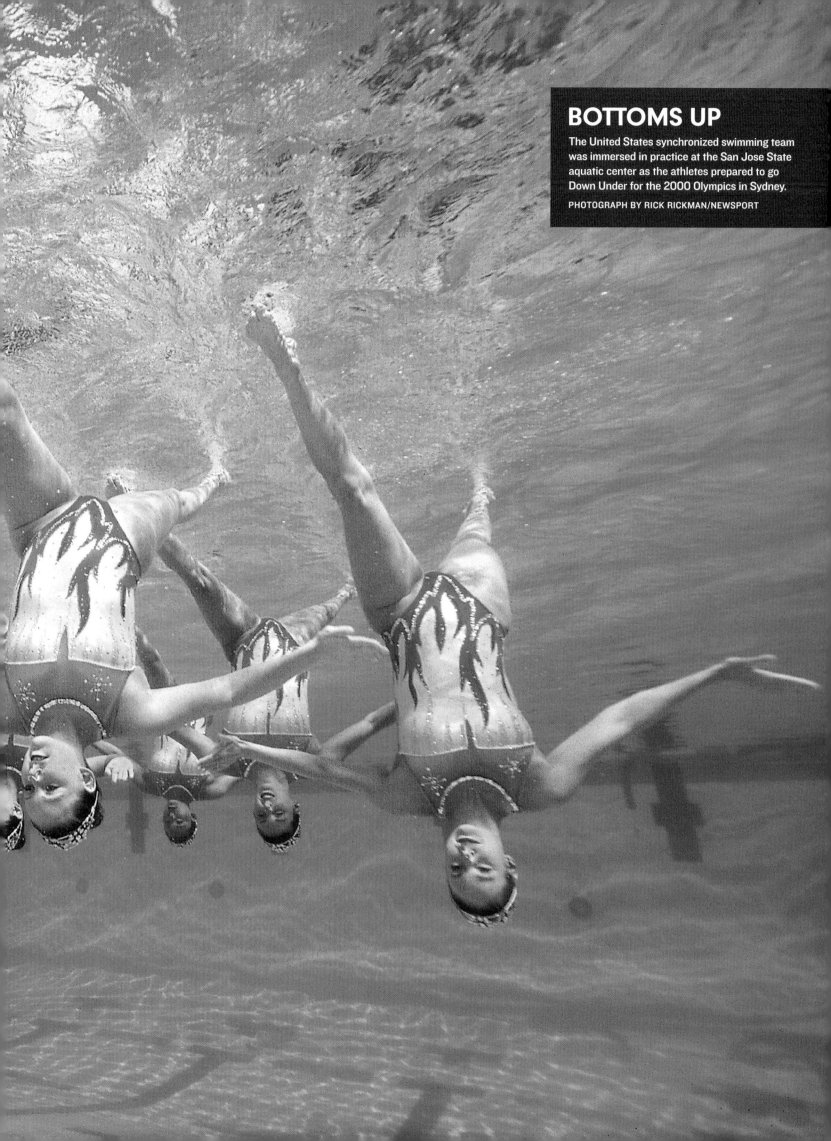

BOTTOMS UP

The United States synchronized swimming team was immersed in practice at the San Jose State aquatic center as the athletes prepared to go Down Under for the 2000 Olympics in Sydney.

PHOTOGRAPH BY RICK RICKMAN/NEWSPORT

—BY MICHAEL SILVER *Sports Illustrated 2/3/03*

MAMA TOLD JON GRUDEN THERE'D be days like these—days when his dreams would play out with chilling clarity, his incessant intensity would be rewarded and nothing could wipe the blissful smirk from his freckled face. As a six-year-old in Dayton, little Jonny watched the Kansas City Chiefs upset the Minnesota Vikings in Super Bowl IV; then, he says, "I went out in the backyard and made diving catches in the mud, pretending I was Otis Taylor." Thirty-three years later, Gruden's dream became reality. The first-year coach of the Tampa Bay Buccaneers prodded and cajoled his team to a 48–21 weed-whacking of the Oakland Raiders in Super Bowl XXXVII. It was a story line only a hokey screenwriter would pitch, with an ending only a mother could love. And so, late on Sunday at the Bucs' team hotel, Kathy Gruden entered Room 2086 and started crying as she locked her son in a long embrace and whispered, "I'm so proud of you. . . . "

Joe Jurevicius fends off Raiders CB Tory James in Super Bowl XXXVII. PHOTOGRAPH BY JOHN BIEVER

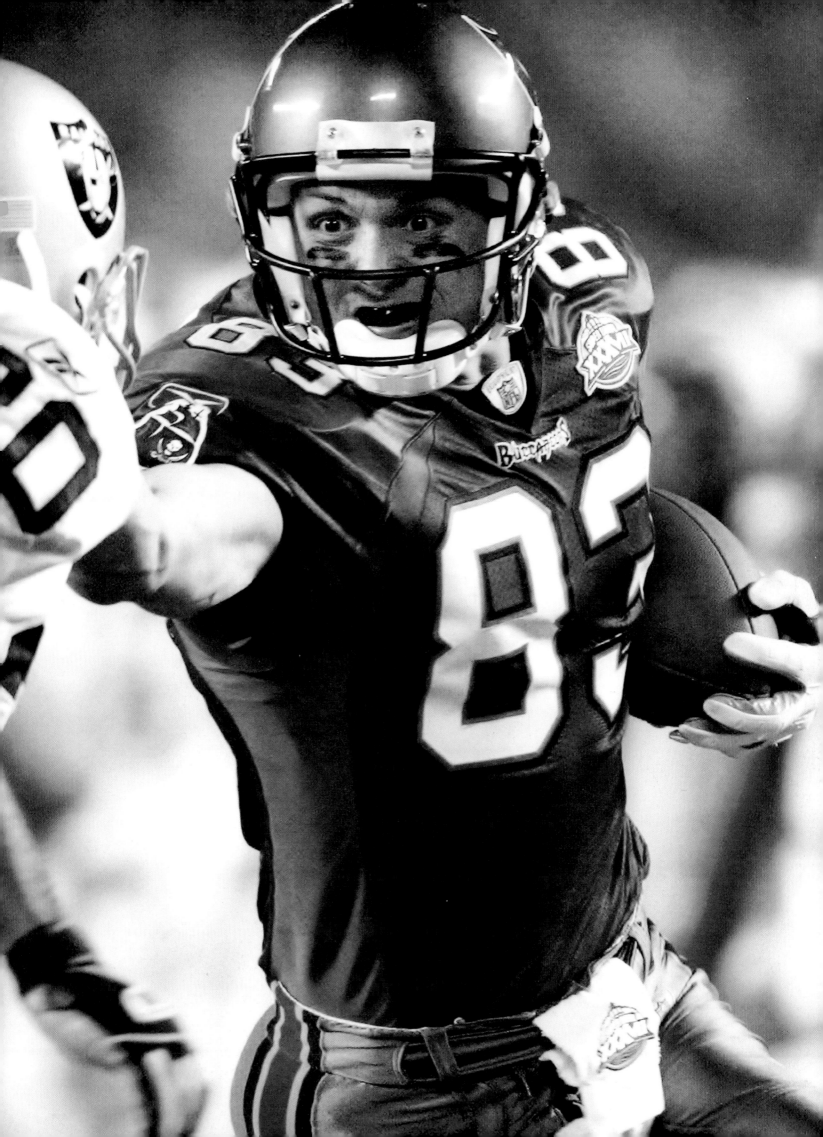

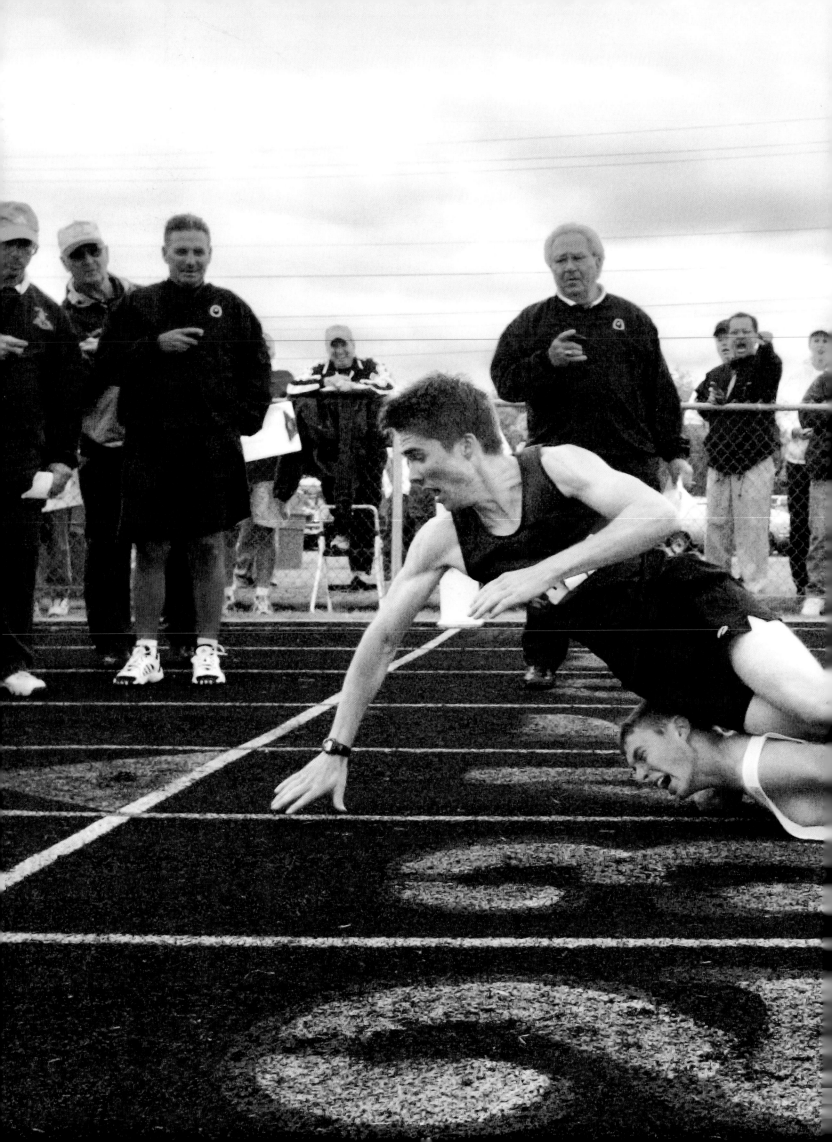

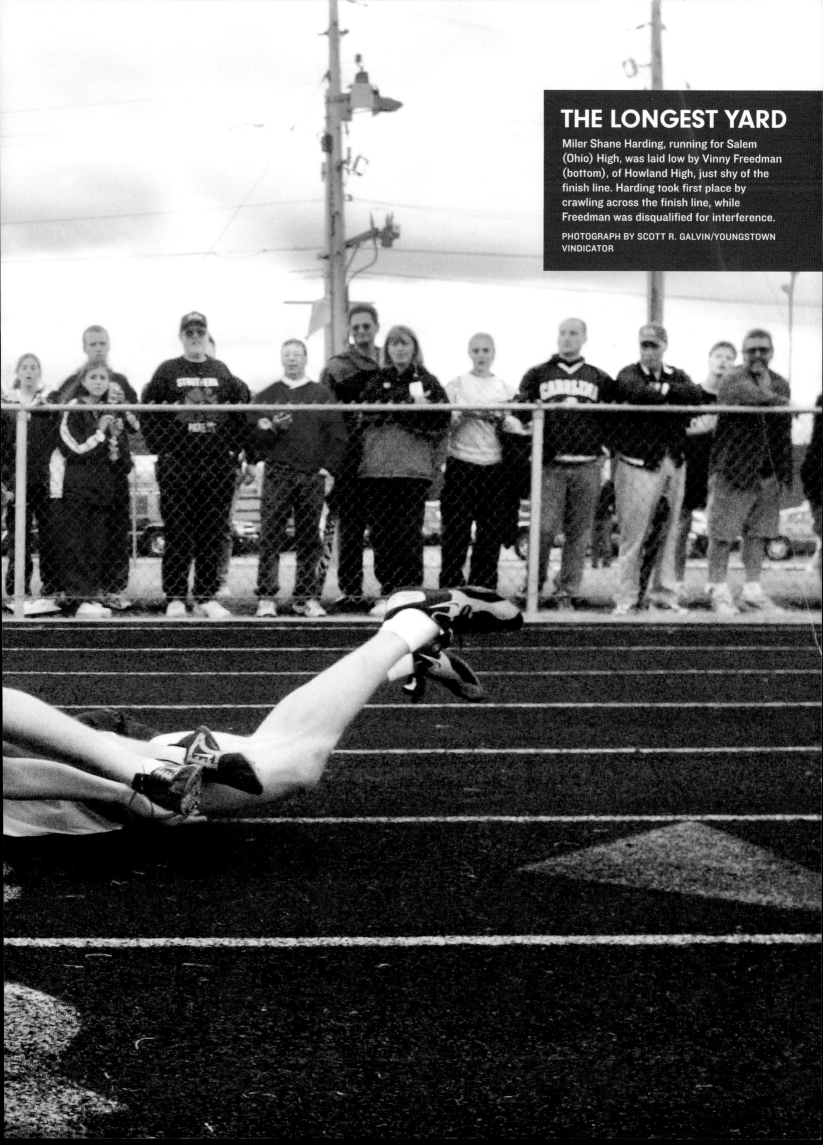

THE LONGEST YARD

Miler Shane Harding, running for Salem (Ohio) High, was laid low by Vinny Freedman (bottom), of Howland High, just shy of the finish line. Harding took first place by crawling across the finish line, while Freedman was disqualified for interference.

PHOTOGRAPH BY SCOTT R. GALVIN/YOUNGSTOWN VINDICATOR

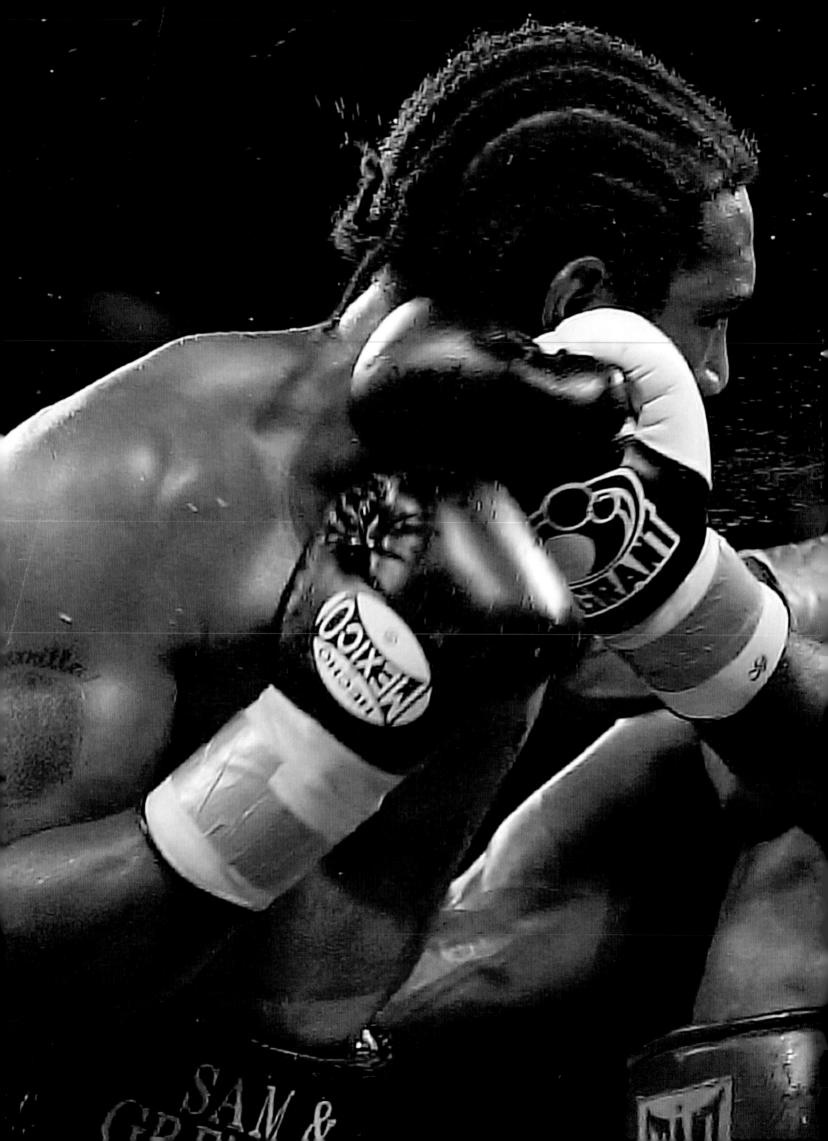

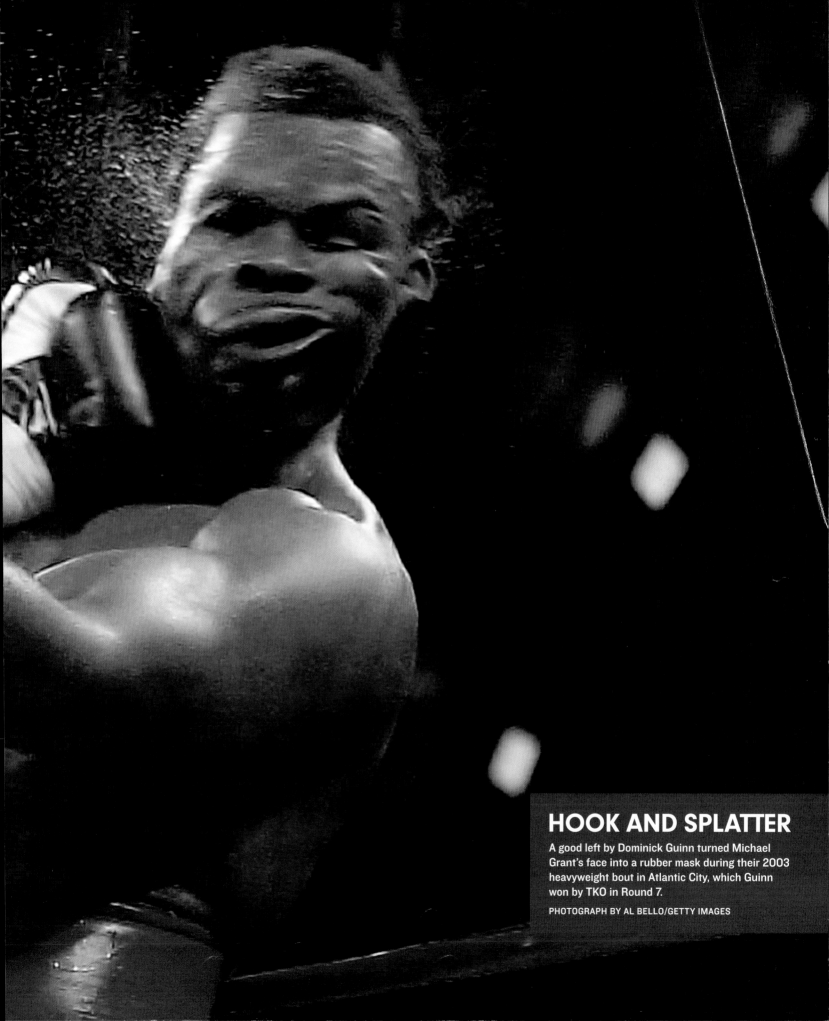

HOOK AND SPLATTER

A good left by Dominick Guinn turned Michael Grant's face into a rubber mask during their 2003 heavyweight bout in Atlantic City, which Guinn won by TKO in Round 7.

PHOTOGRAPH BY AL BELLO/GETTY IMAGES

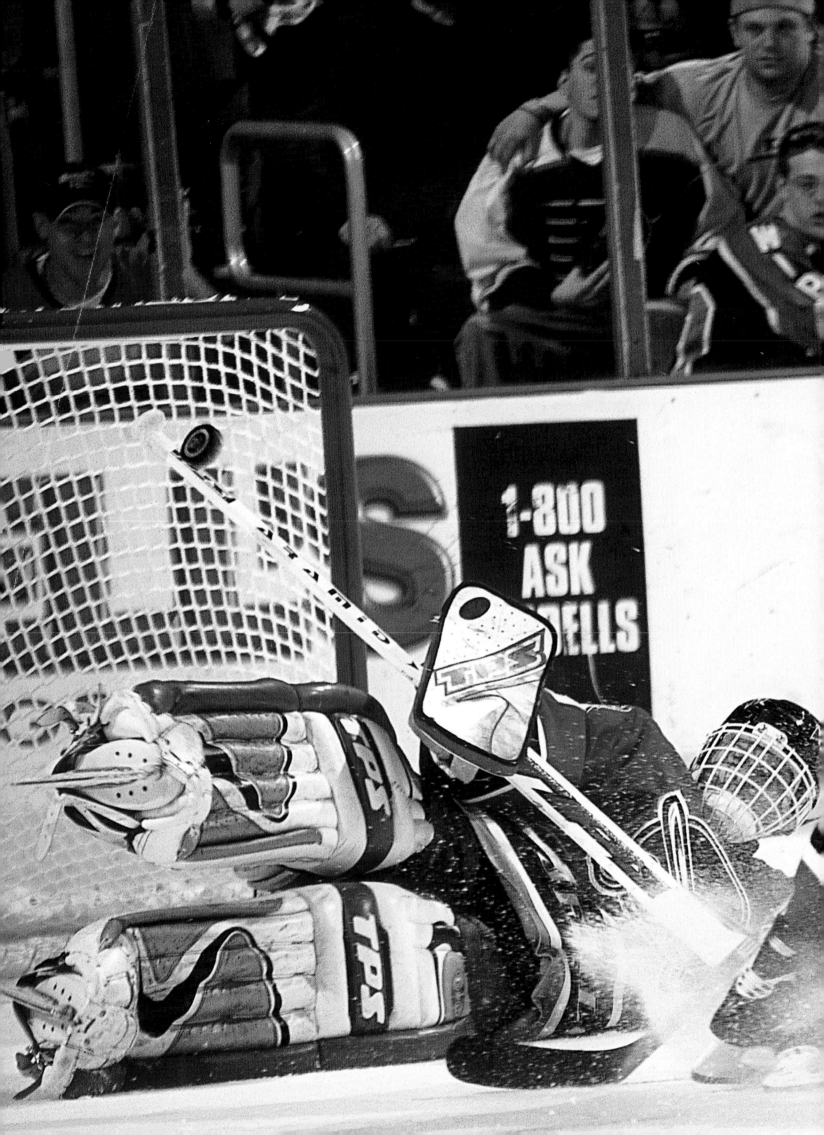

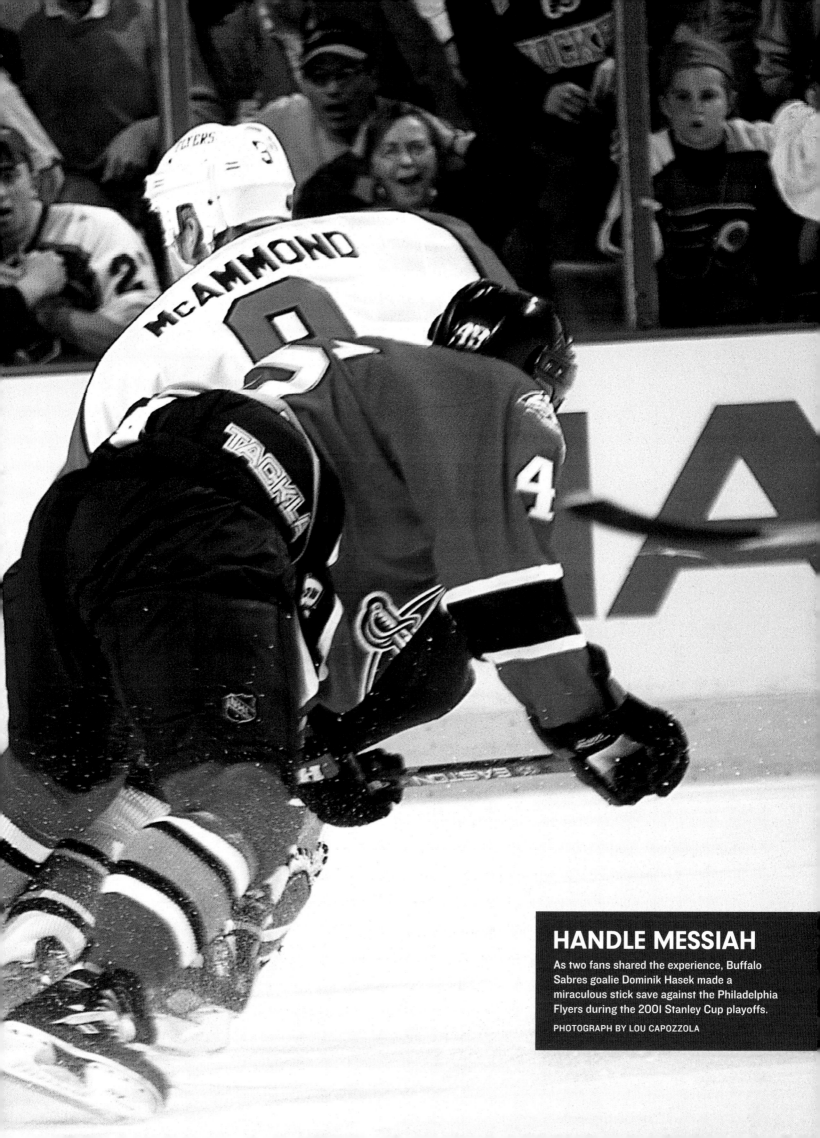

HANDLE MESSIAH

As two fans shared the experience, Buffalo Sabres goalie Dominik Hasek made a miraculous stick save against the Philadelphia Flyers during the 2001 Stanley Cup playoffs.

PHOTOGRAPH BY LOU CAPOZZOLA

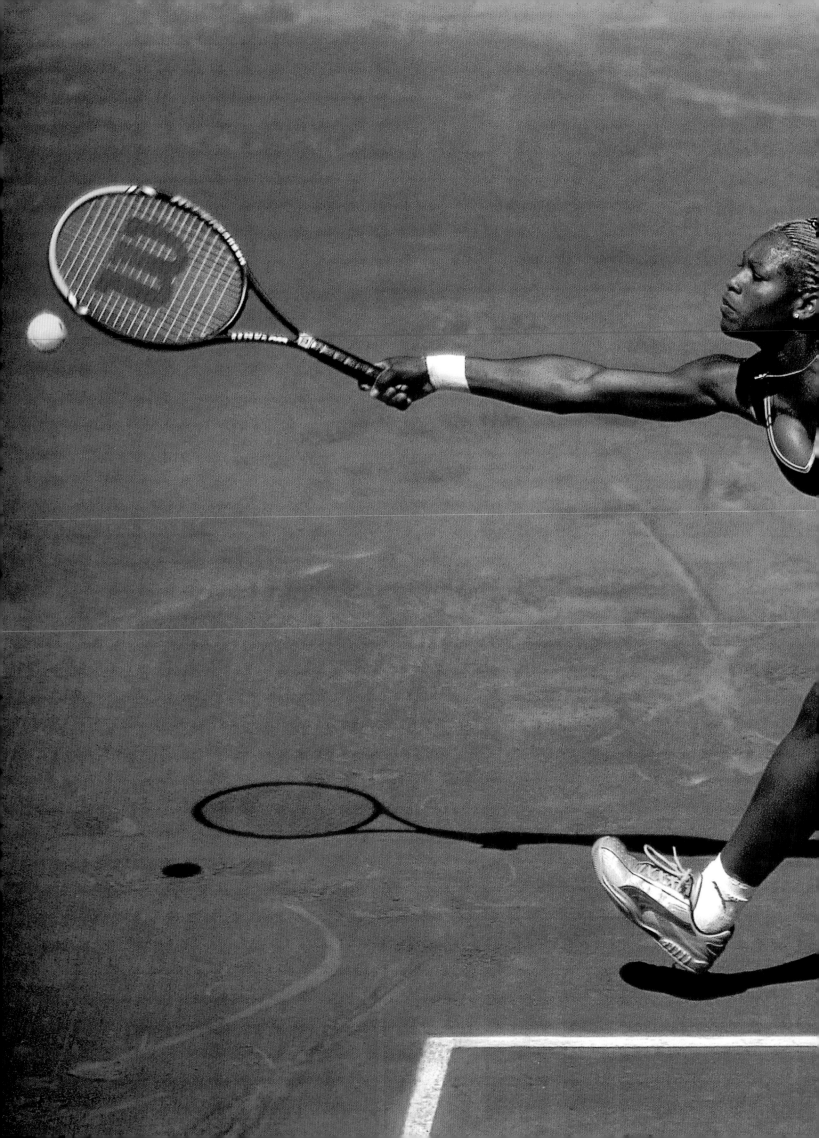

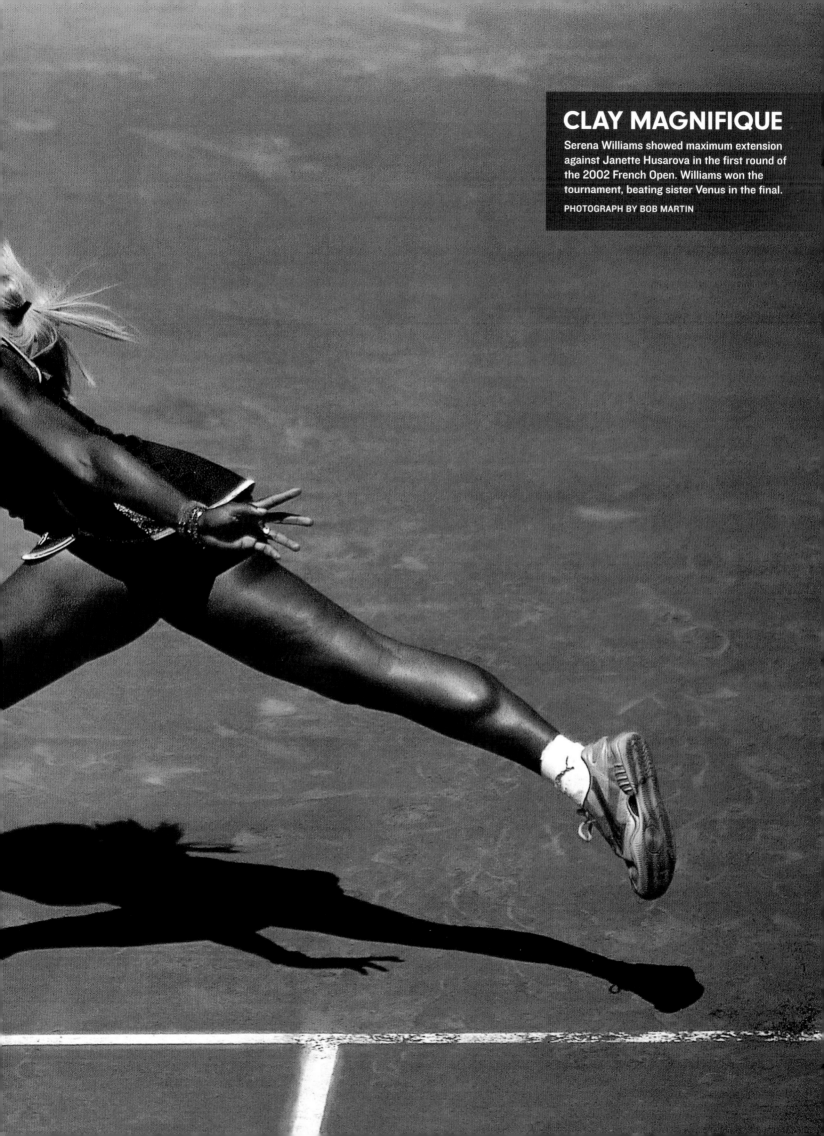

CLAY MAGNIFIQUE

Serena Williams showed maximum extension against Janette Husarova in the first round of the 2002 French Open. Williams won the tournament, beating sister Venus in the final.

PHOTOGRAPH BY BOB MARTIN

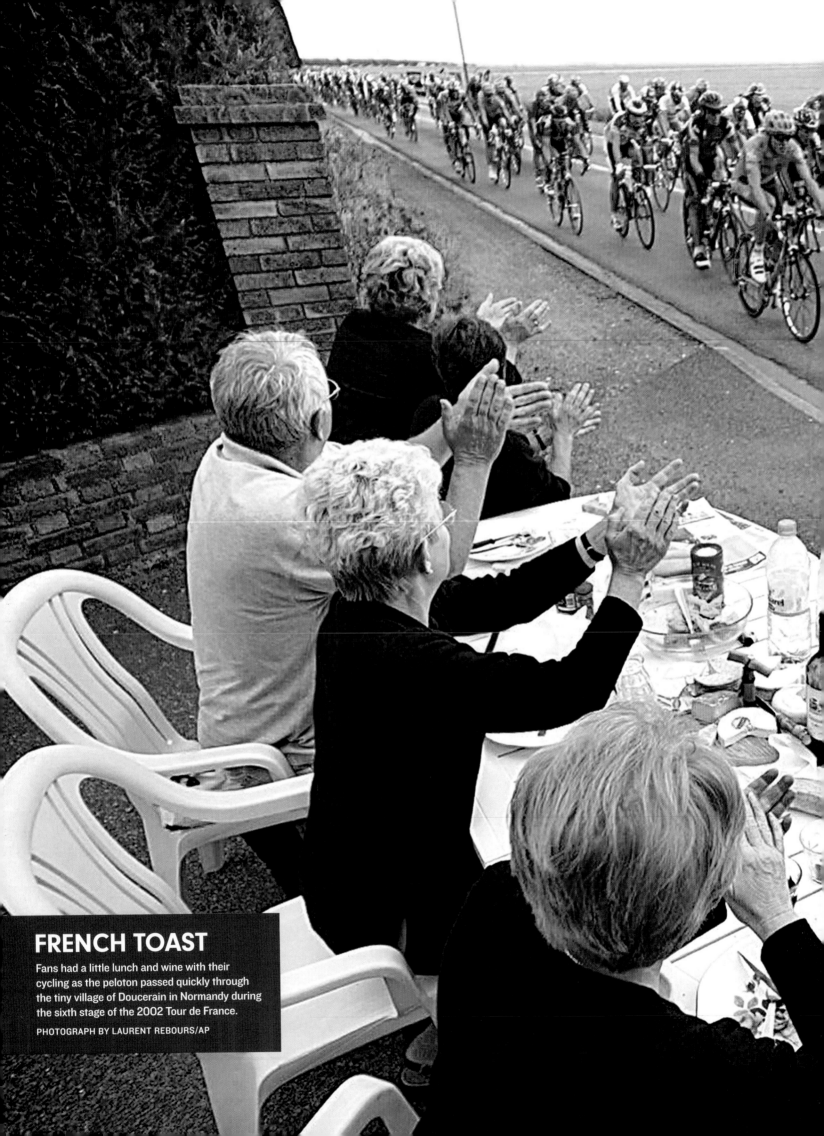

FRENCH TOAST

Fans had a little lunch and wine with their cycling as the peloton passed quickly through the tiny village of Doucerain in Normandy during the sixth stage of the 2002 Tour de France.

PHOTOGRAPH BY LAURENT REBOURS/AP

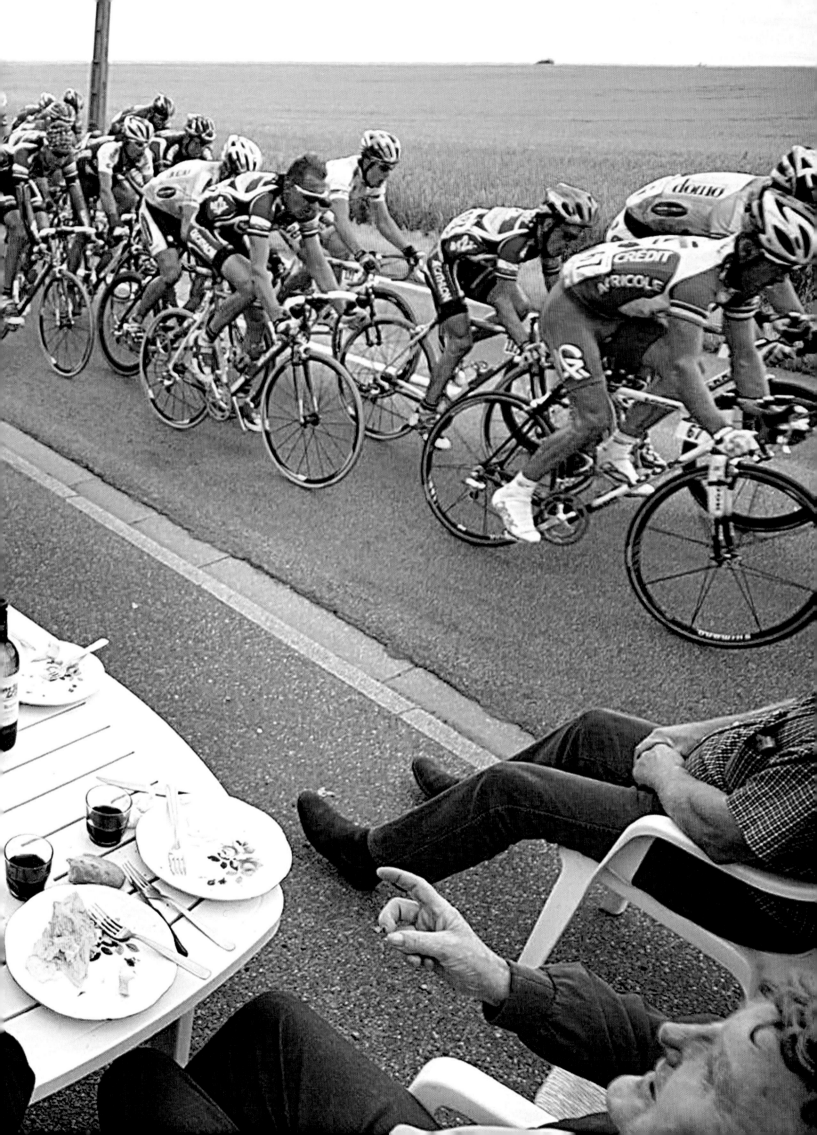

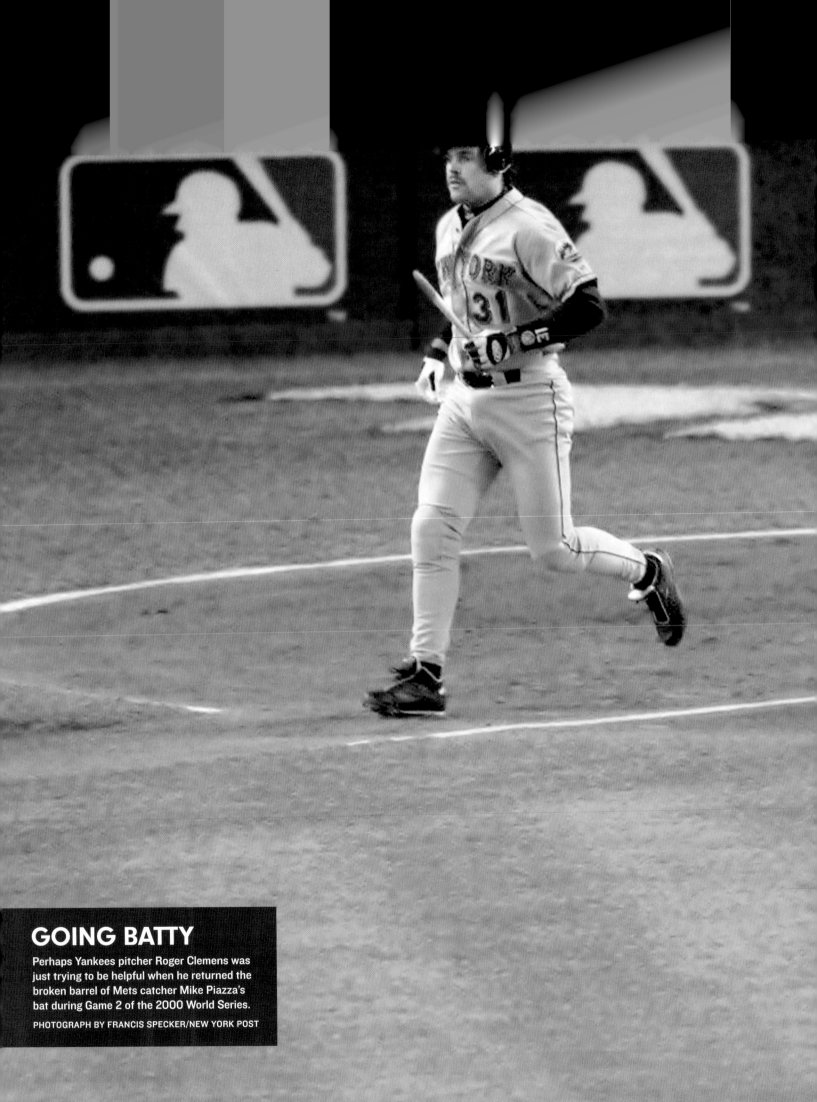

GOING BATTY

Perhaps Yankees pitcher Roger Clemens was just trying to be helpful when he returned the broken barrel of Mets catcher Mike Piazza's bat during Game 2 of the 2000 World Series.

PHOTOGRAPH BY FRANCIS SPECKER/NEW YORK POST

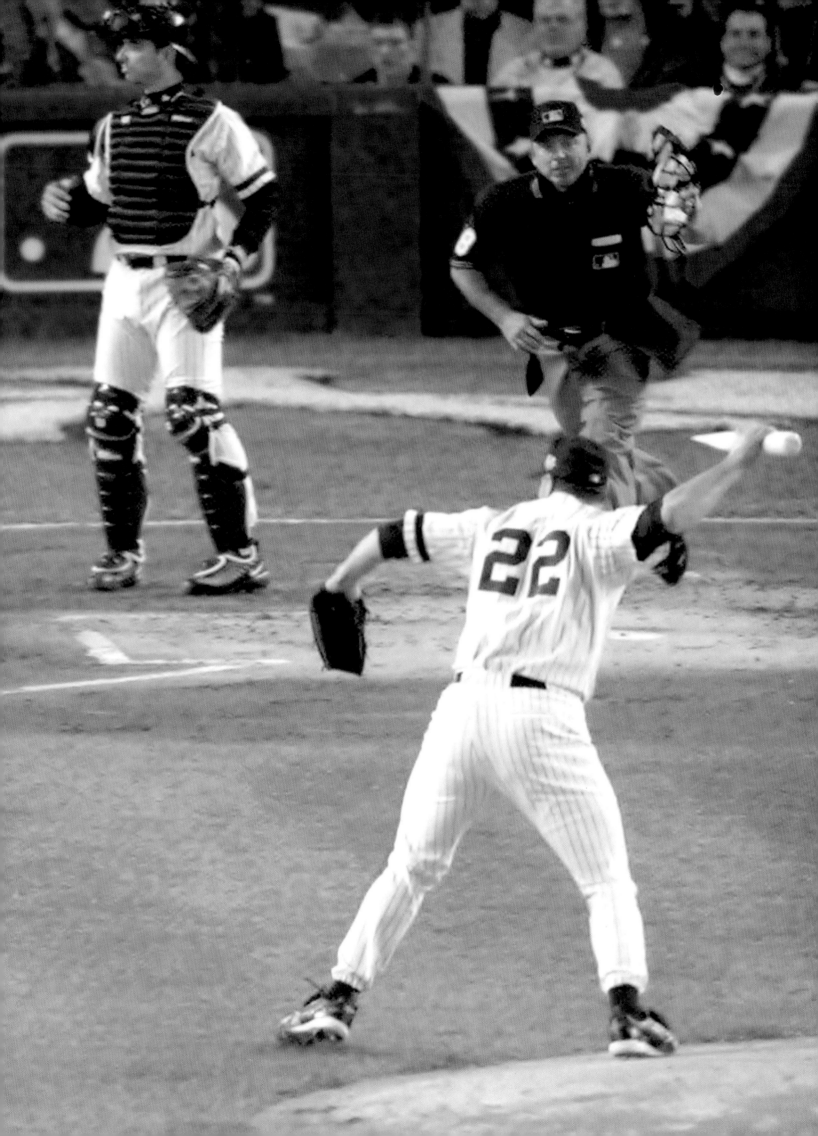

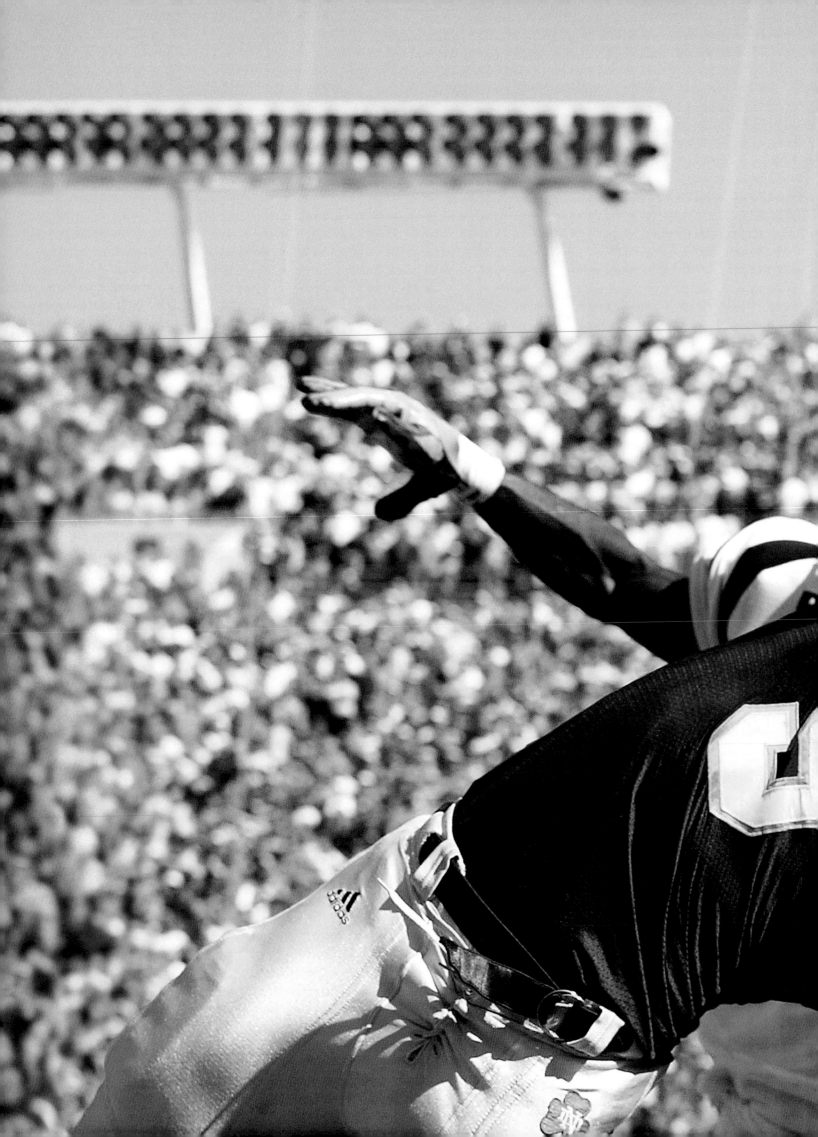

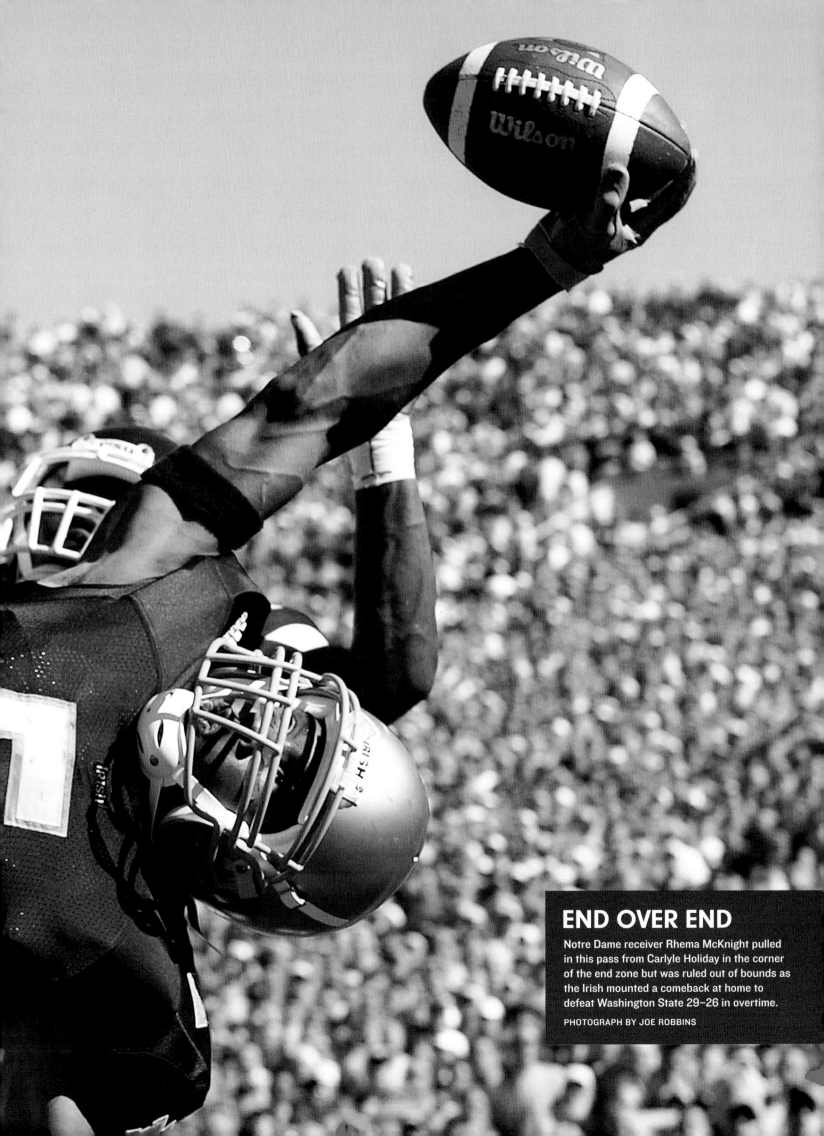

END OVER END

Notre Dame receiver Rhema McKnight pulled in this pass from Carlyle Holiday in the corner of the end zone but was ruled out of bounds as the Irish mounted a comeback at home to defeat Washington State 29–26 in overtime.

PHOTOGRAPH BY JOE ROBBINS

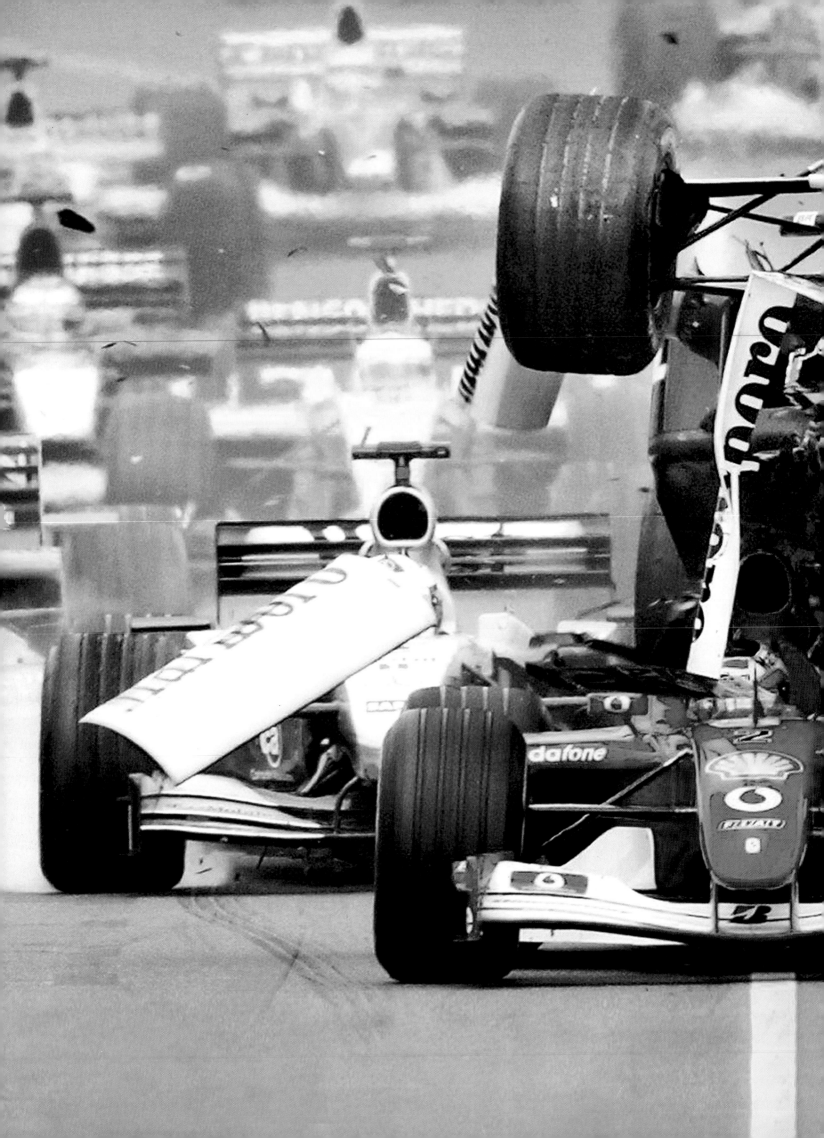

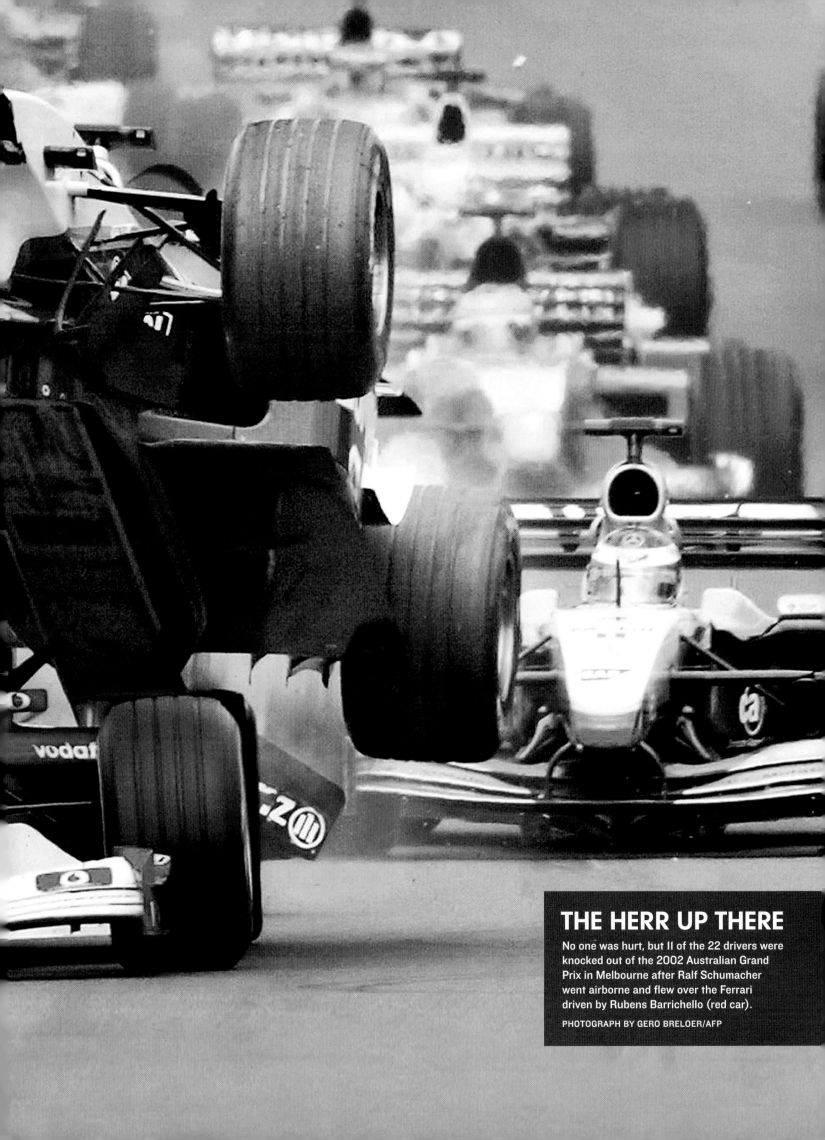

THE HERR UP THERE

No one was hurt, but II of the 22 drivers were knocked out of the 2002 Australian Grand Prix in Melbourne after Ralf Schumacher went airborne and flew over the Ferrari driven by Rubens Barrichello (red car).

PHOTOGRAPH BY GERO BRELOER/AFP

—BY TOM VERDUCCI *Sports Illustrated 11/3/03*

T ALL MADE SENSE, ONCE THE CIGAR SMOKE cleared, anyway: how the Florida Marlins could be world champions for a second time in seven years, even though they have never finished in first place. This was, after all, the postseason from hell, what with all the talk about the ghosts of New York, the curse in Boston and the dead goat in Chicago. Forget a scorecard. You needed a cauldron and a clove of garlic to follow these playoffs. And you needed the blessed ignorance of youth to win them. Before Game 1 of the World Series at Yankee Stadium the Marlins' 20-year-old rightfielder Miguel Cabrera said, "There's a lot of history here, but this isn't about the past as much as it is about the future." The kid was right, of course. One week later the Marlins were whooping it up at Yankee Stadium after Game 6, the 100th World Series game played at the old ballyard—home office of the Fall Classic—but only the seventh in which the visiting team had eliminated the Yankees. . . .

The Marlins hoist Series MVP Josh Beckett after his decisive win. PHOTOGRAPH BY JOHN IACONO

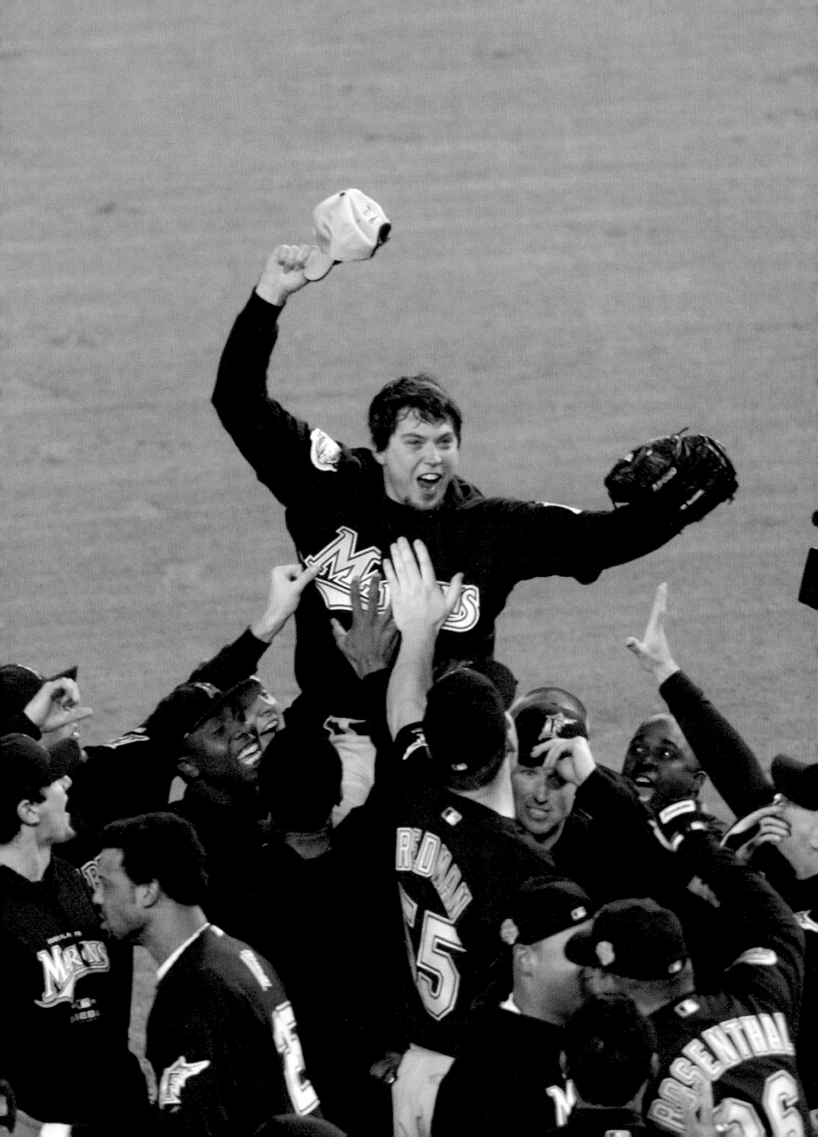

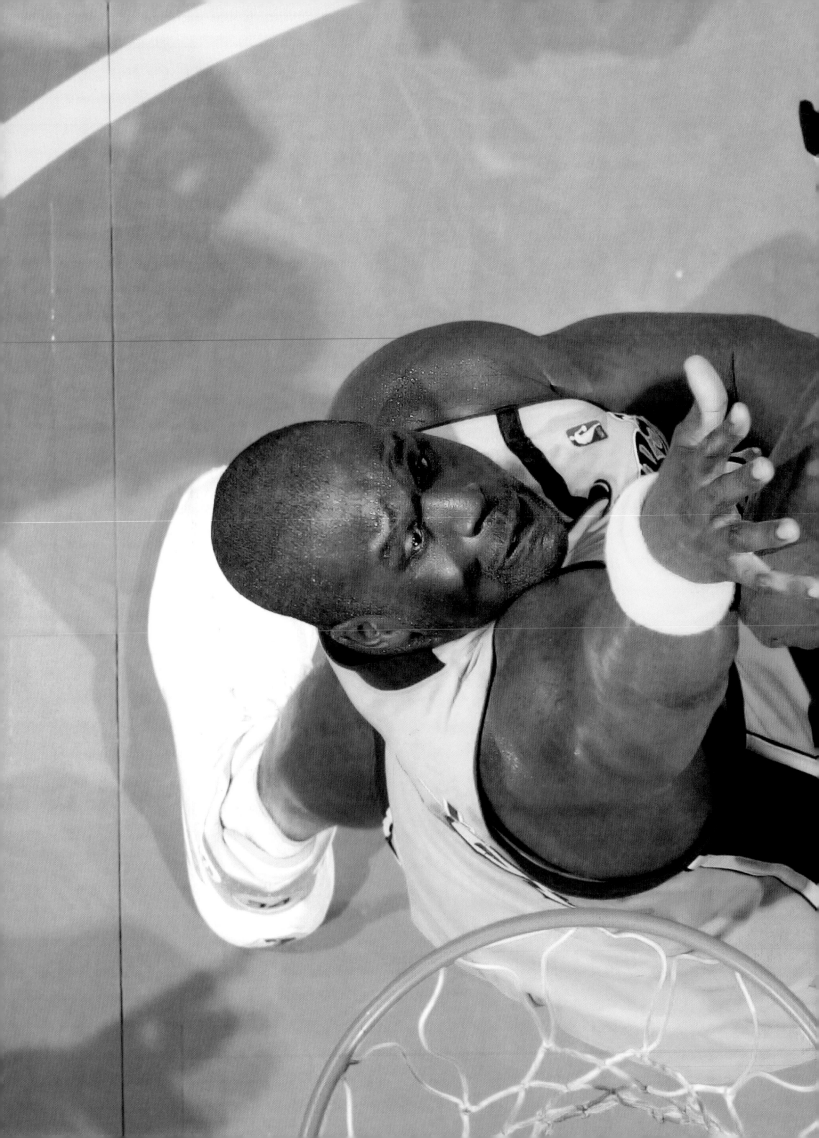

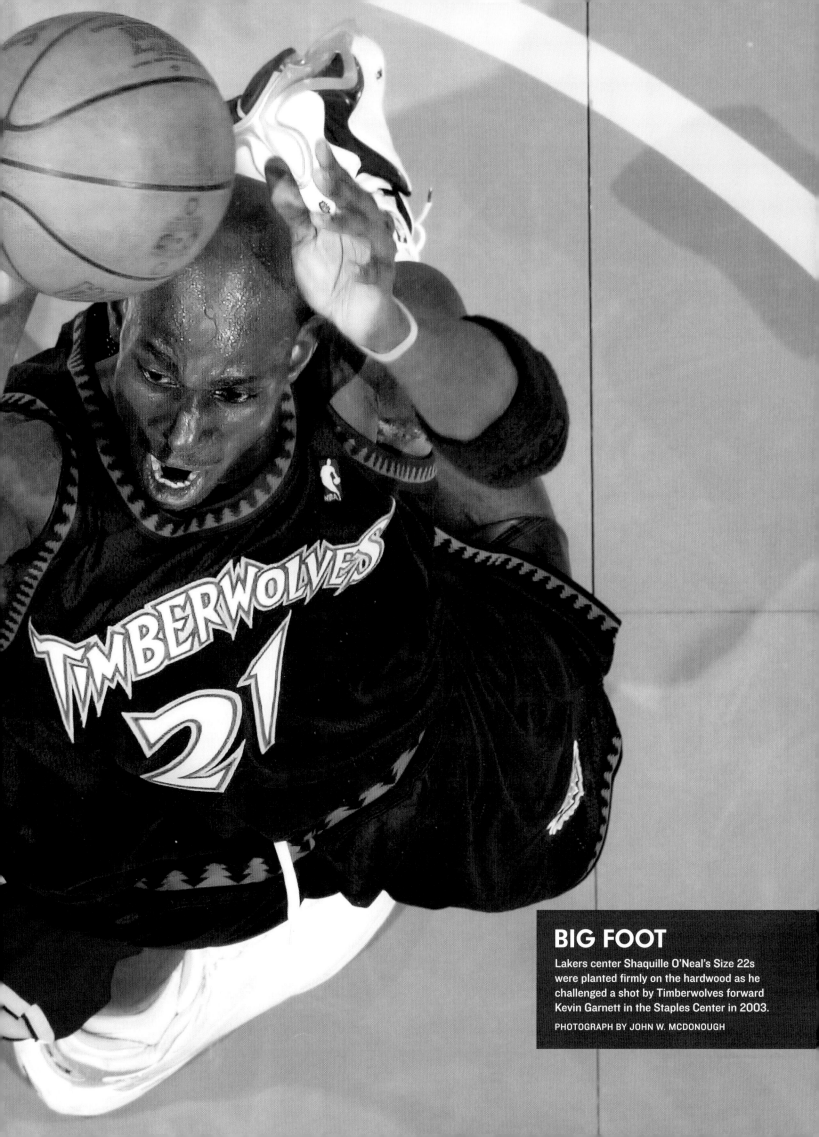

BIG FOOT

Lakers center Shaquille O'Neal's Size 22s were planted firmly on the hardwood as he challenged a shot by Timberwolves forward Kevin Garnett in the Staples Center in 2003.

PHOTOGRAPH BY JOHN W. MCDONOUGH

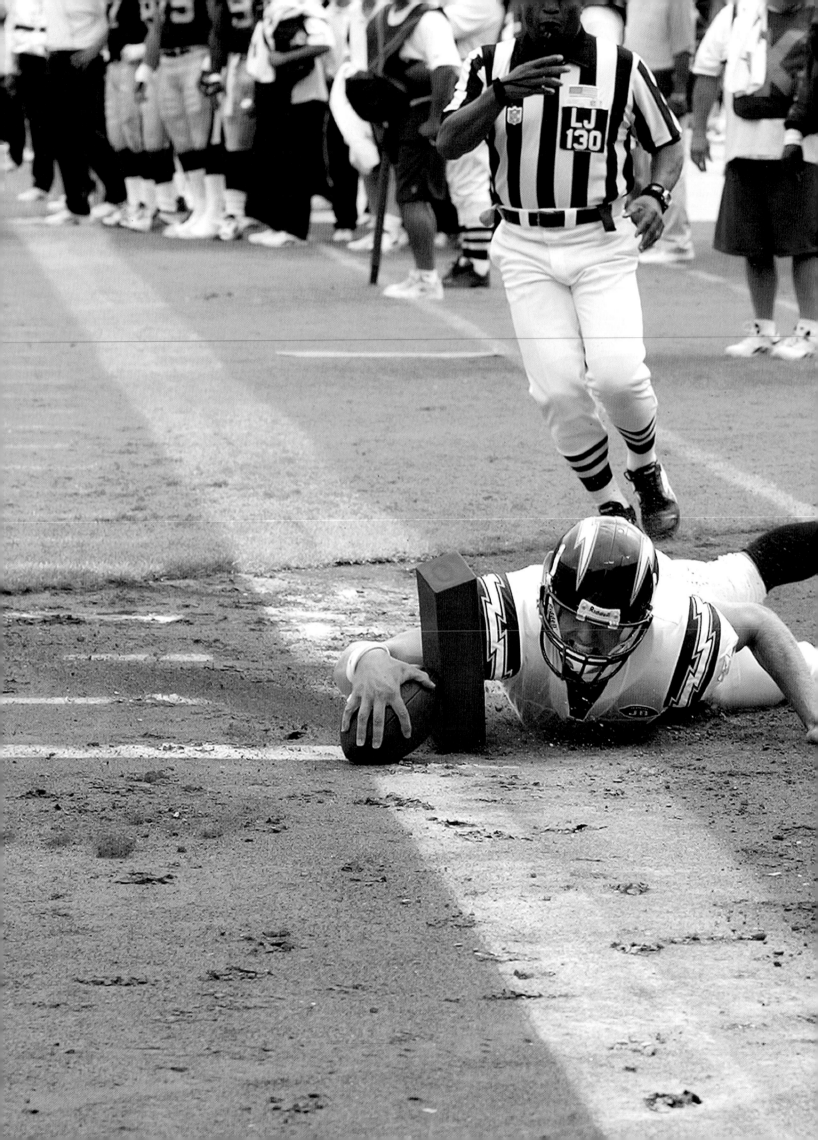

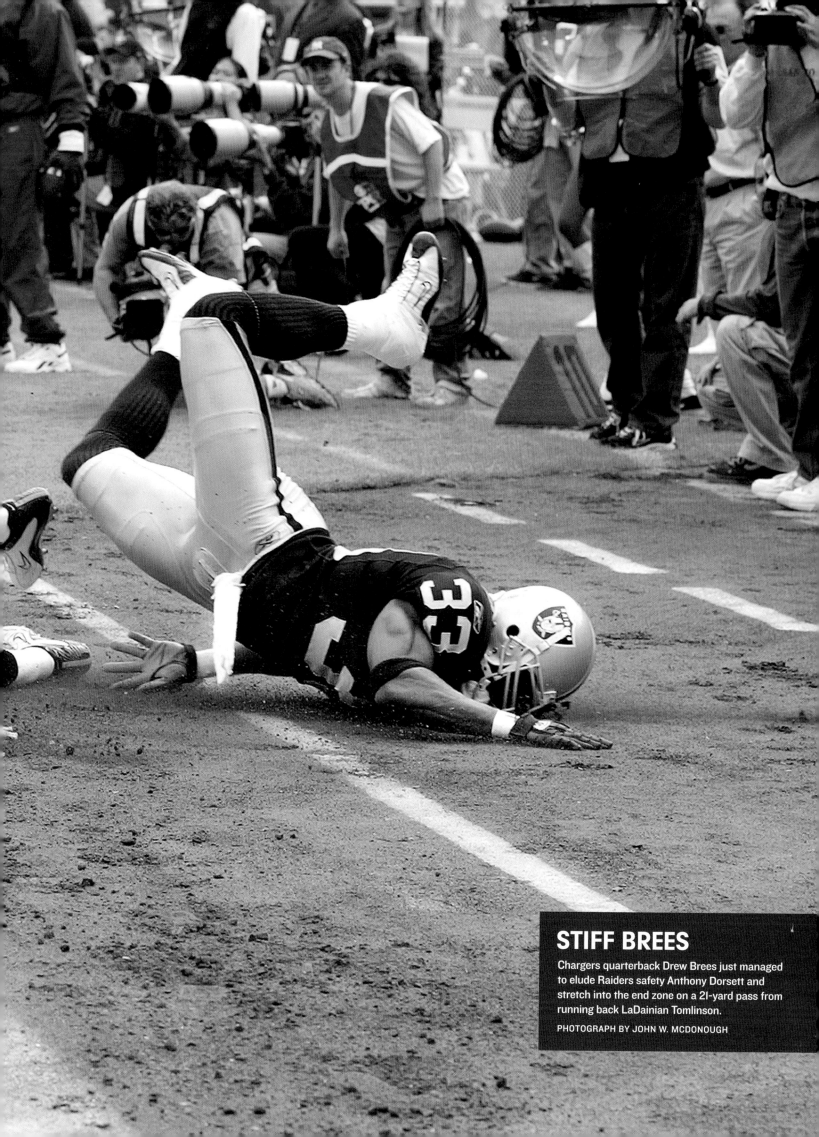

STIFF BREES

Chargers quarterback Drew Brees just managed to elude Raiders safety Anthony Dorsett and stretch into the end zone on a 21-yard pass from running back LaDainian Tomlinson.

PHOTOGRAPH BY JOHN W. MCDONOUGH

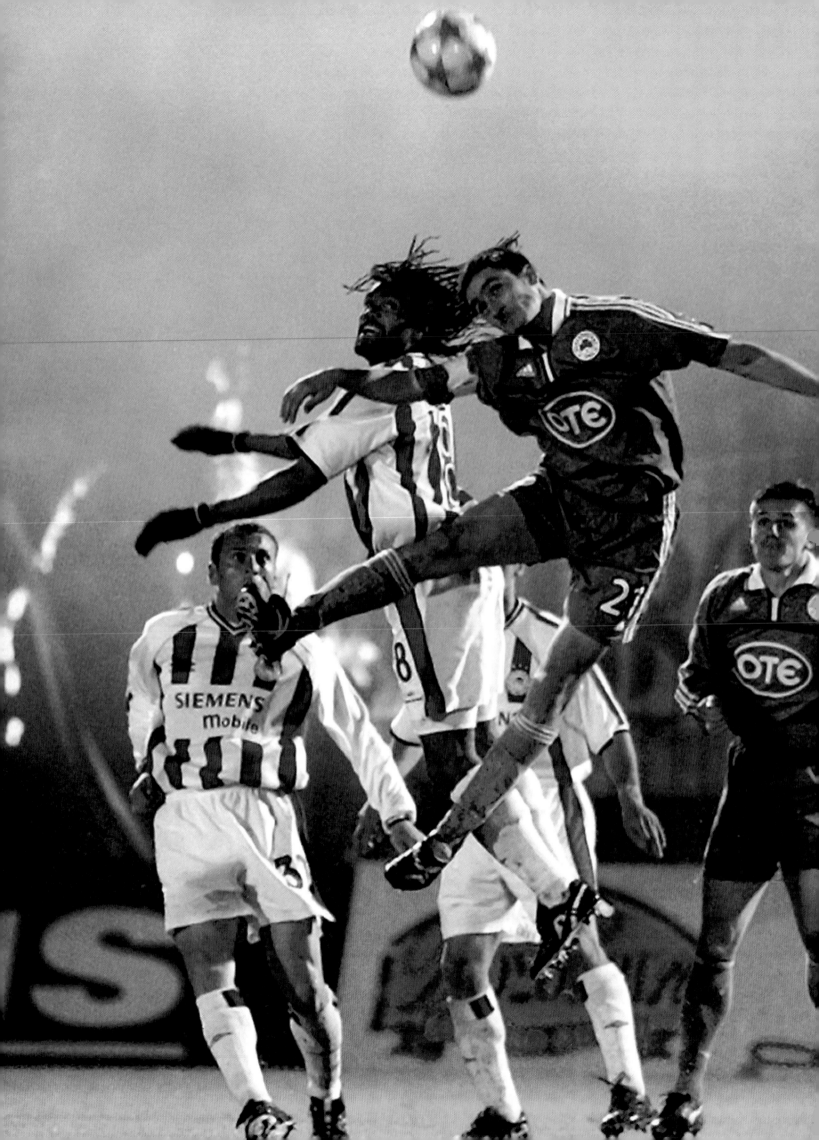

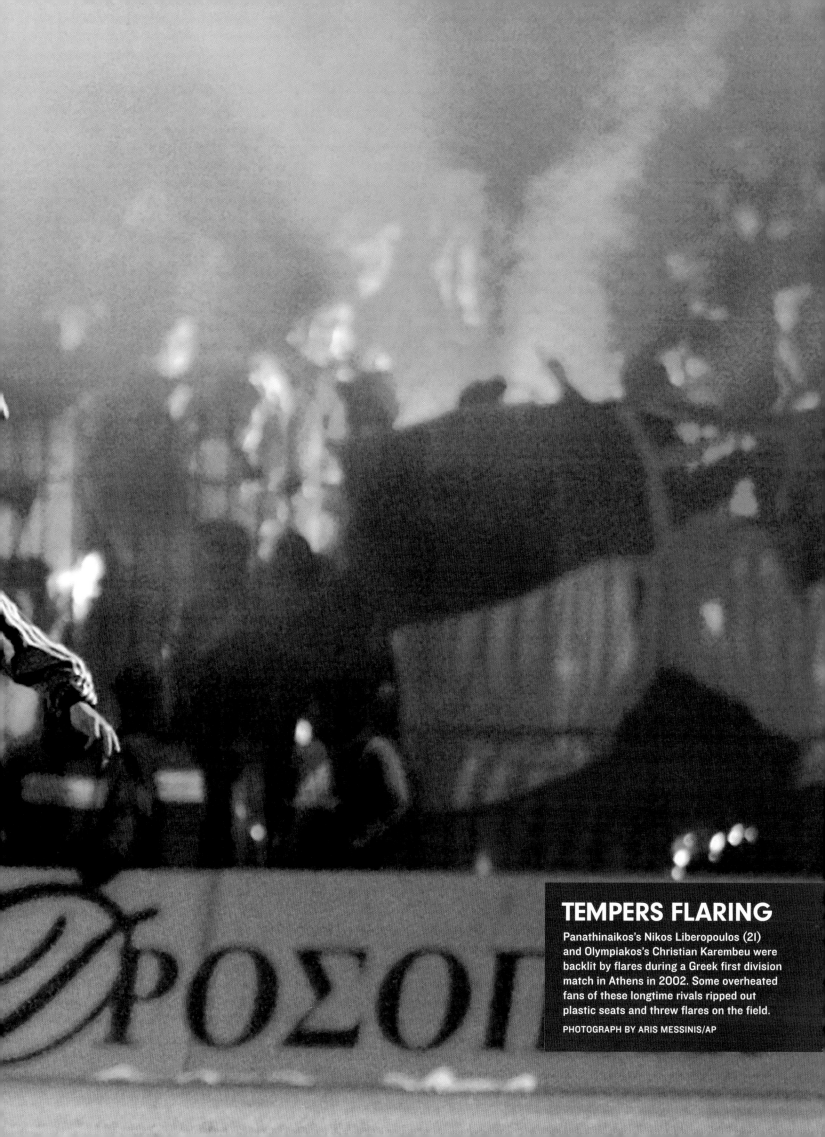

TEMPERS FLARING

Panathinaikos's Nikos Liberopoulos (21) and Olympiakos's Christian Karembeu were backlit by flares during a Greek first division match in Athens in 2002. Some overheated fans of these longtime rivals ripped out plastic seats and threw flares on the field.

PHOTOGRAPH BY ARIS MESSINIS/AP

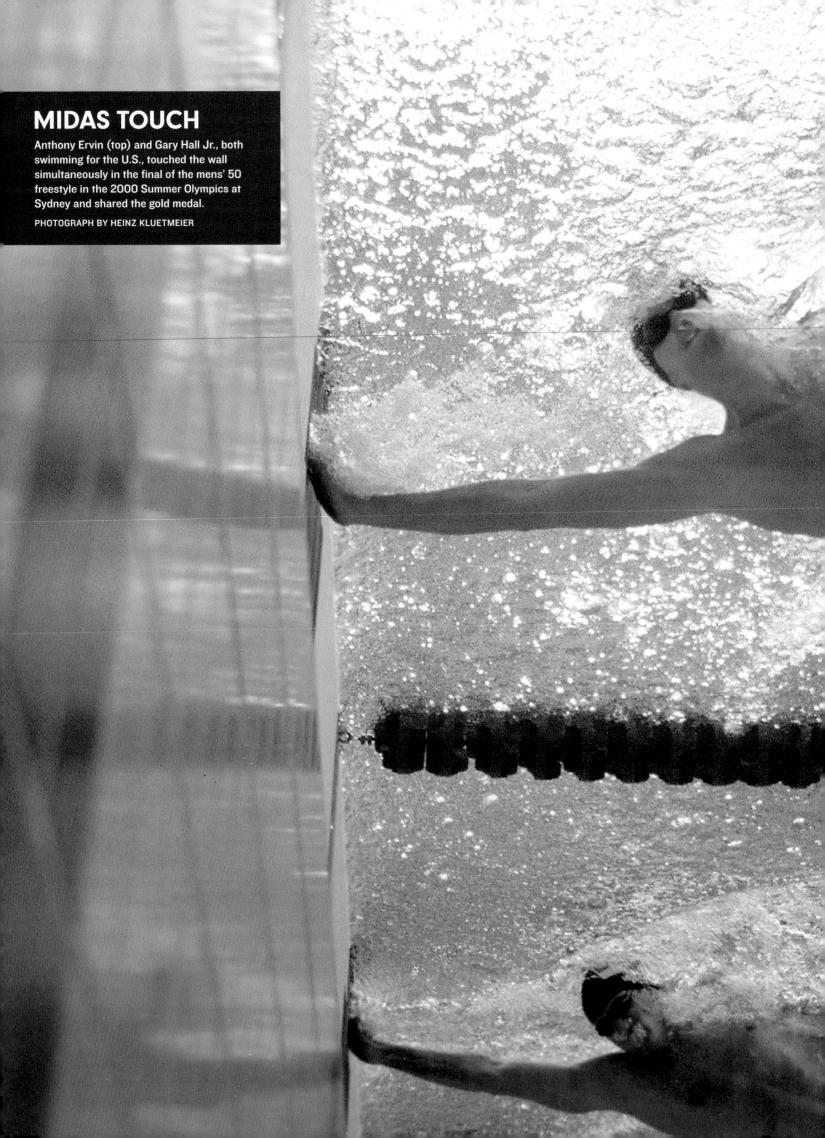

MIDAS TOUCH

Anthony Ervin (top) and Gary Hall Jr., both swimming for the U.S., touched the wall simultaneously in the final of the mens' 50 freestyle in the 2000 Summer Olympics at Sydney and shared the gold medal.

PHOTOGRAPH BY HEINZ KLUETMEIER

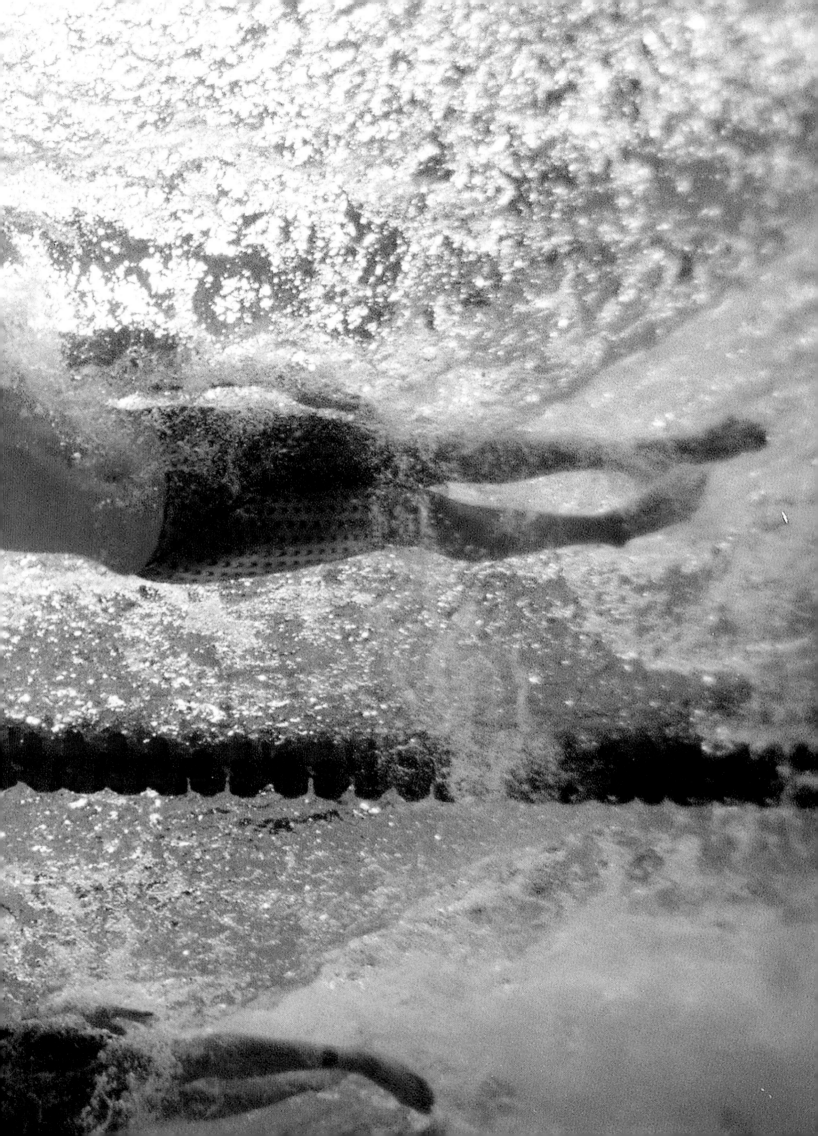

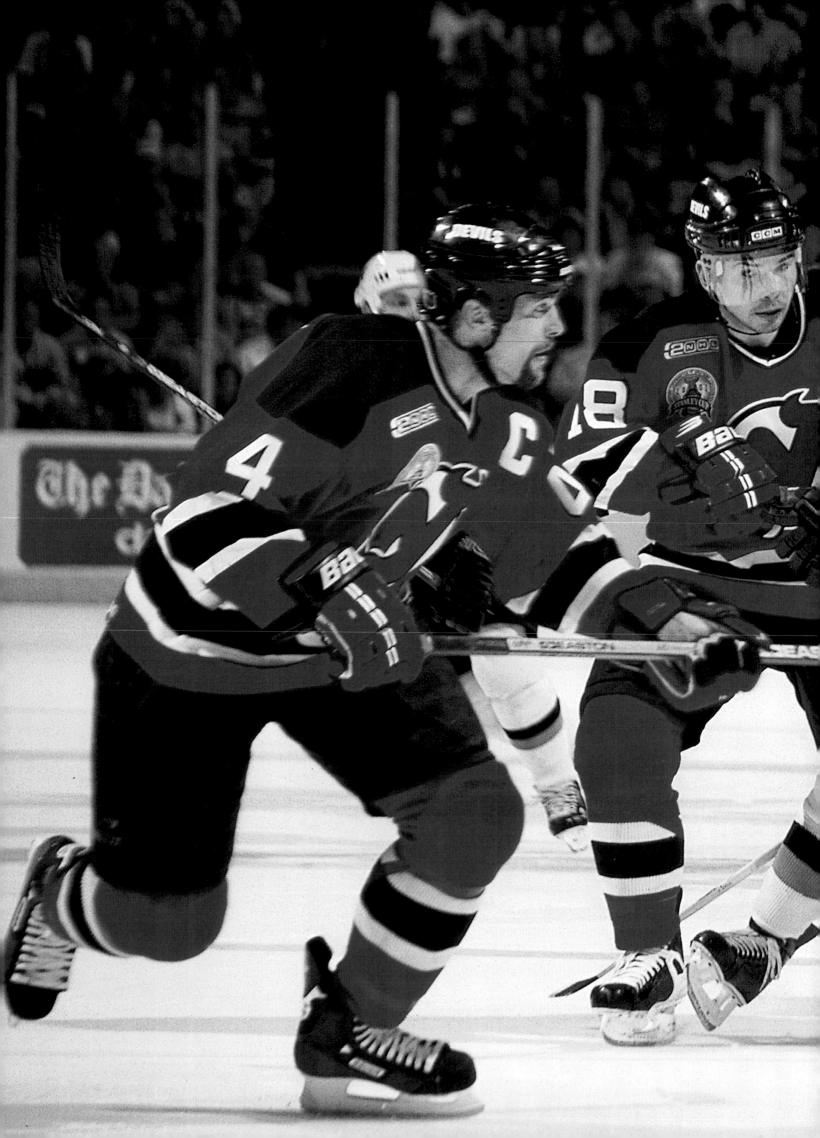

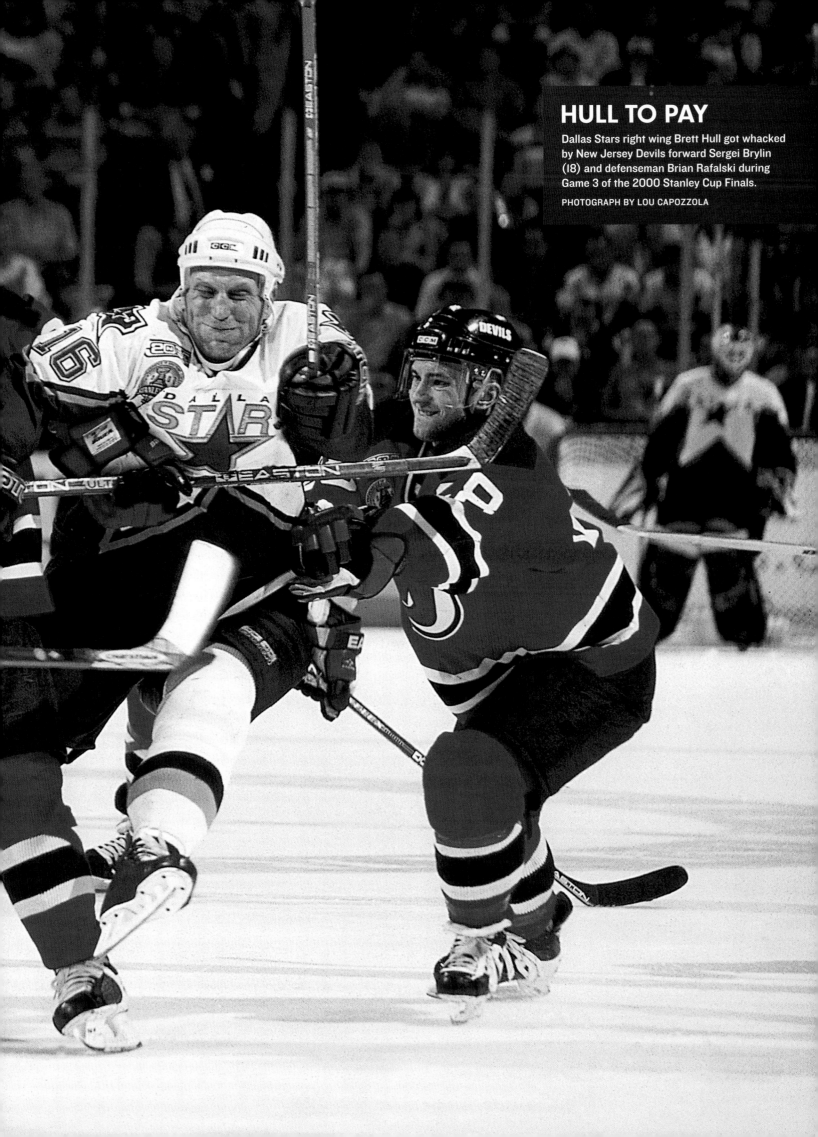

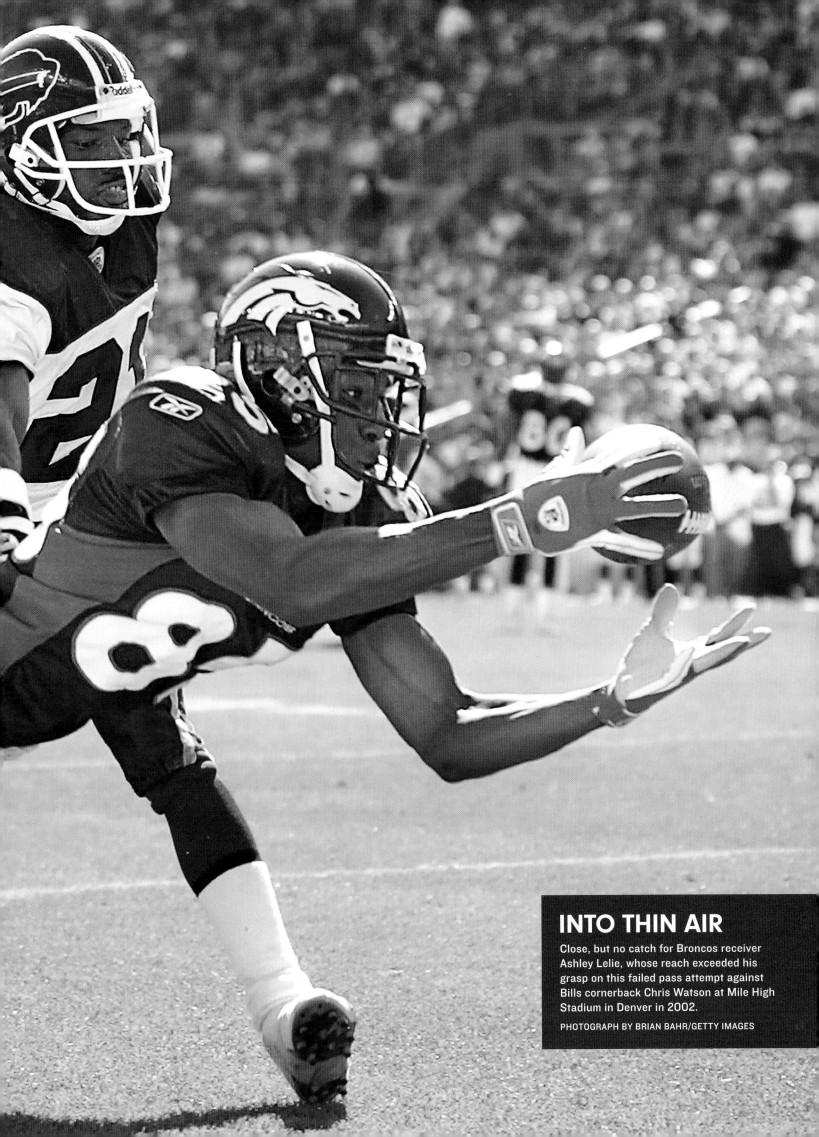

INTO THIN AIR

Close, but no catch for Broncos receiver Ashley Lelie, whose reach exceeded his grasp on this failed pass attempt against Bills cornerback Chris Watson at Mile High Stadium in Denver in 2002.

PHOTOGRAPH BY BRIAN BAHR/GETTY IMAGES

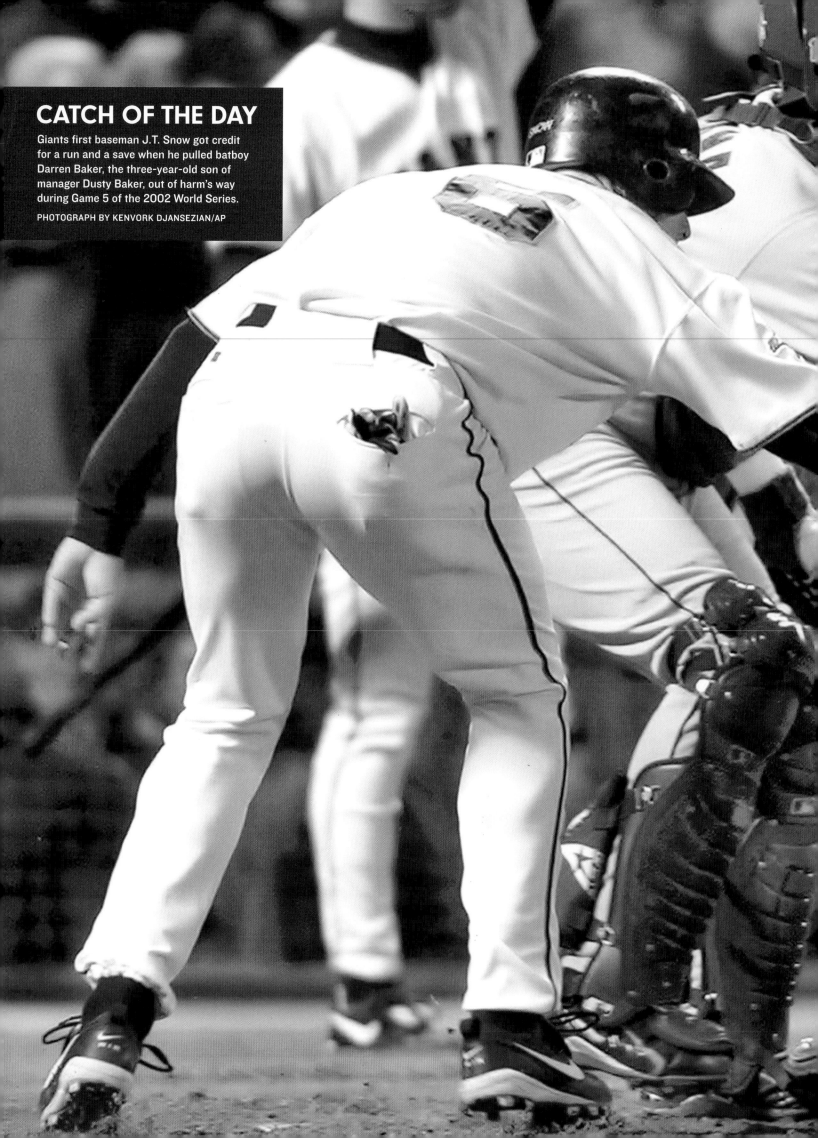

CATCH OF THE DAY

Giants first baseman J.T. Snow got credit for a run and a save when he pulled batboy Darren Baker, the three-year-old son of manager Dusty Baker, out of harm's way during Game 5 of the 2002 World Series.

PHOTOGRAPH BY KENVORK DJANSEZIAN/AP

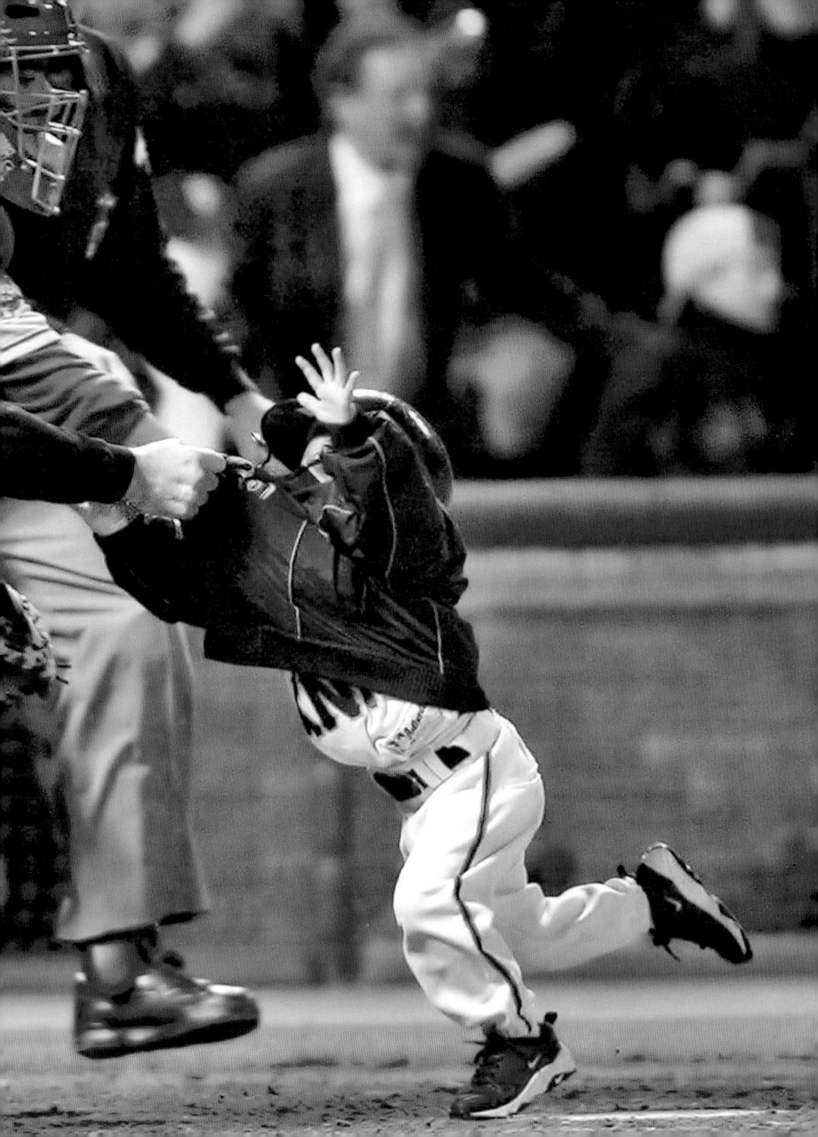

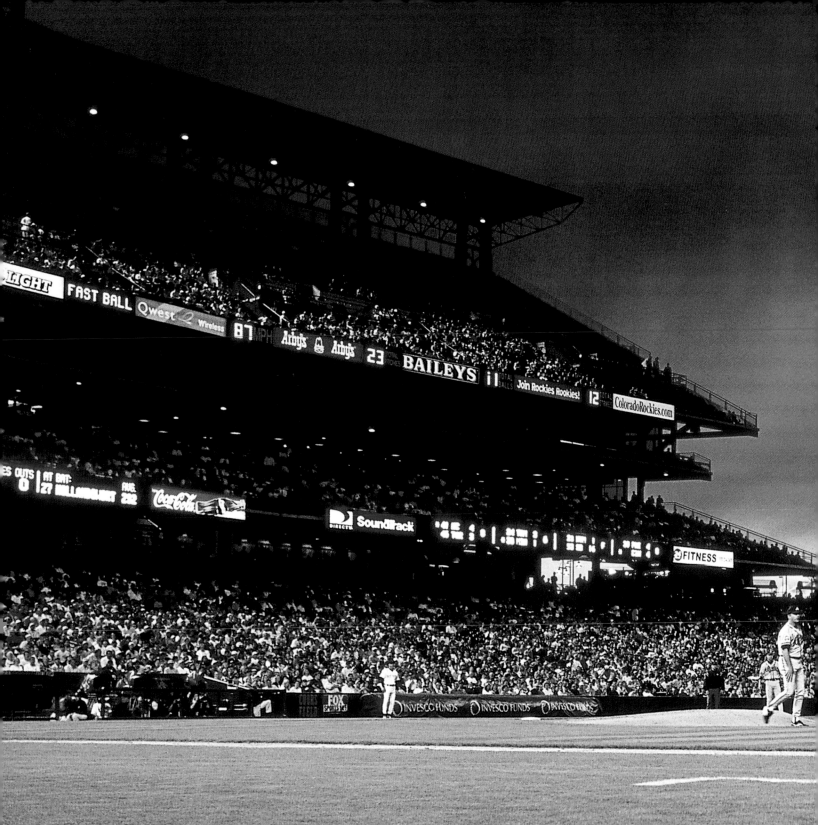

COORS LIGHT

As night settled over Denver, Rockies centerfielder Todd Hollandsworth took a long last stride to beat the peg to Braves first baseman Andres Galarraga for an infield hit at Coors Field in 2000.

PHOTOGRAPH BY BRETT WILHELM/RICH CLARKSON AND ASSOCIATES

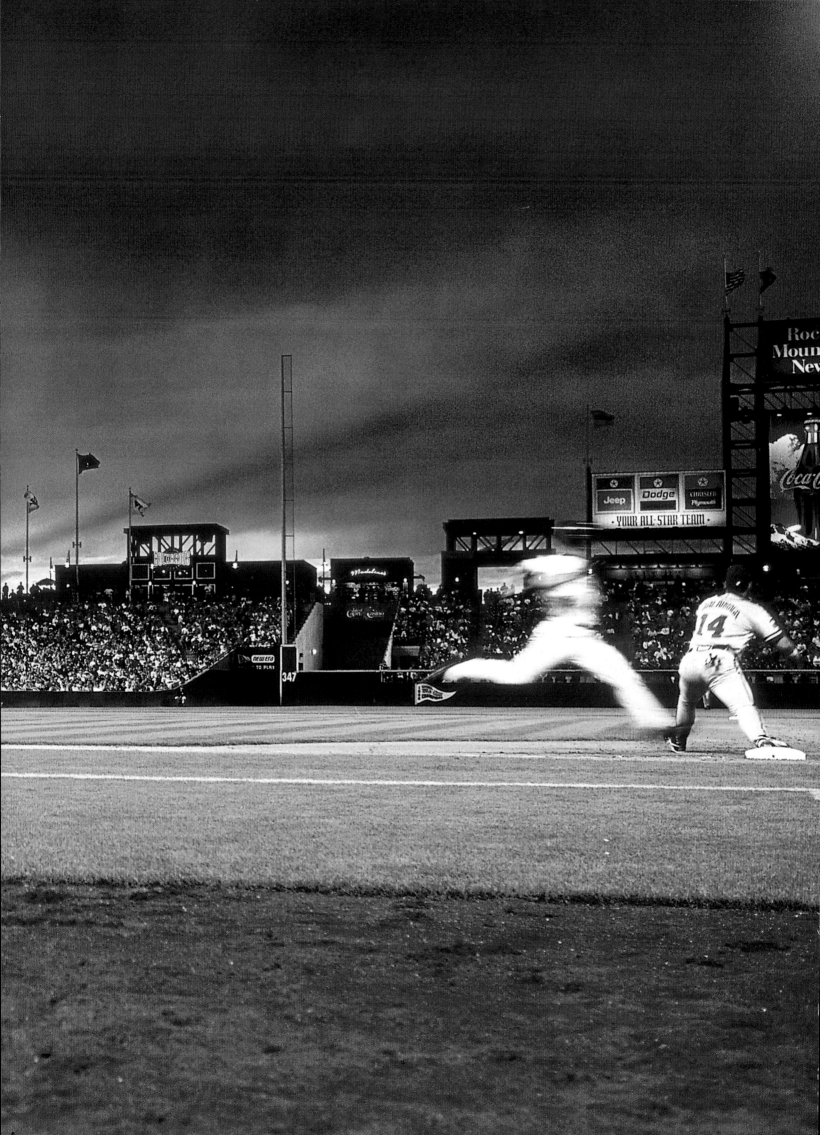

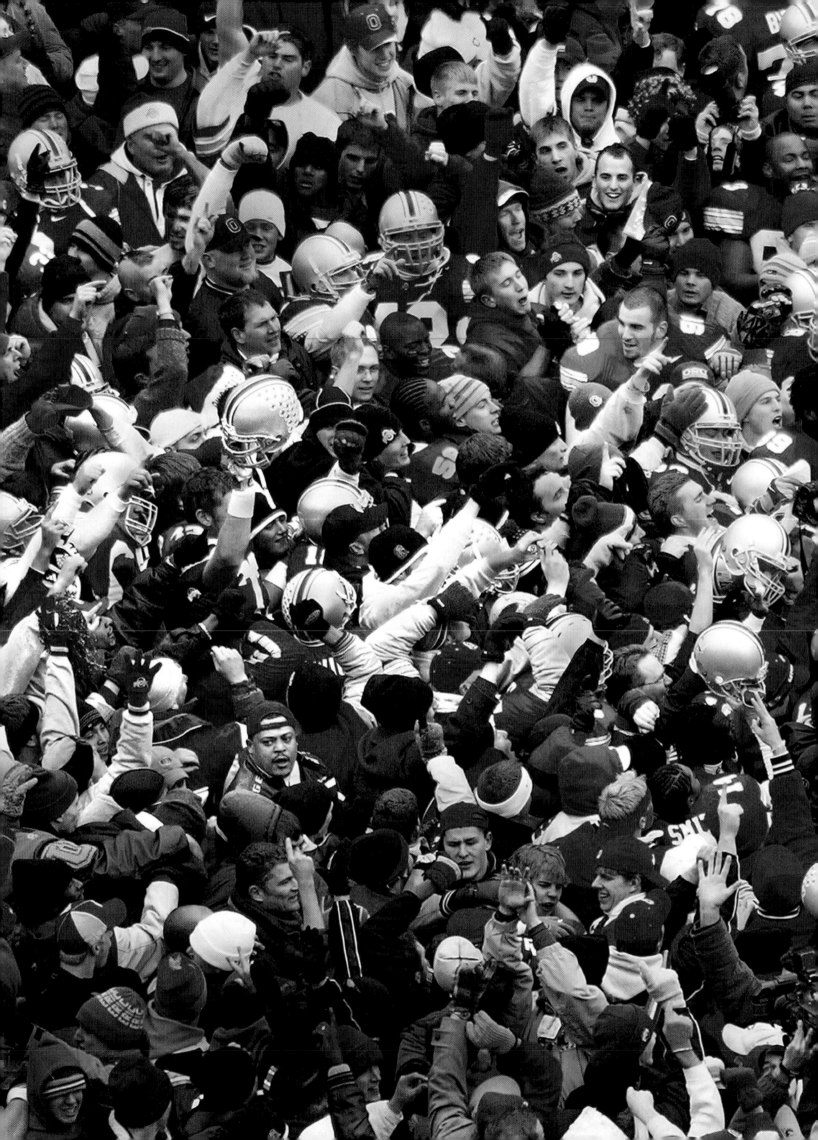

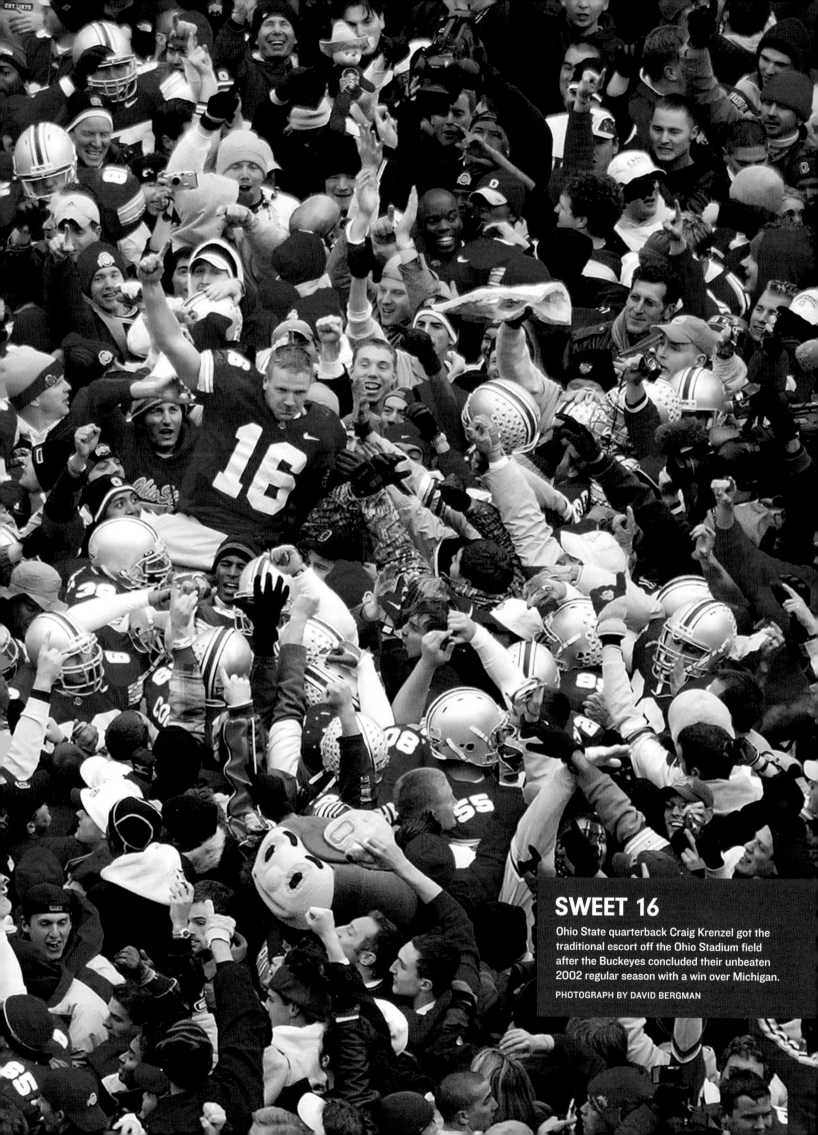

SWEET 16

Ohio State quarterback Craig Krenzel got the traditional escort off the Ohio Stadium field after the Buckeyes concluded their unbeaten 2002 regular season with a win over Michigan.

PHOTOGRAPH BY DAVID BERGMAN

Sports Illustrated

HOTSHOTS